THE BOOK OF
CLOSE-UP
Photography

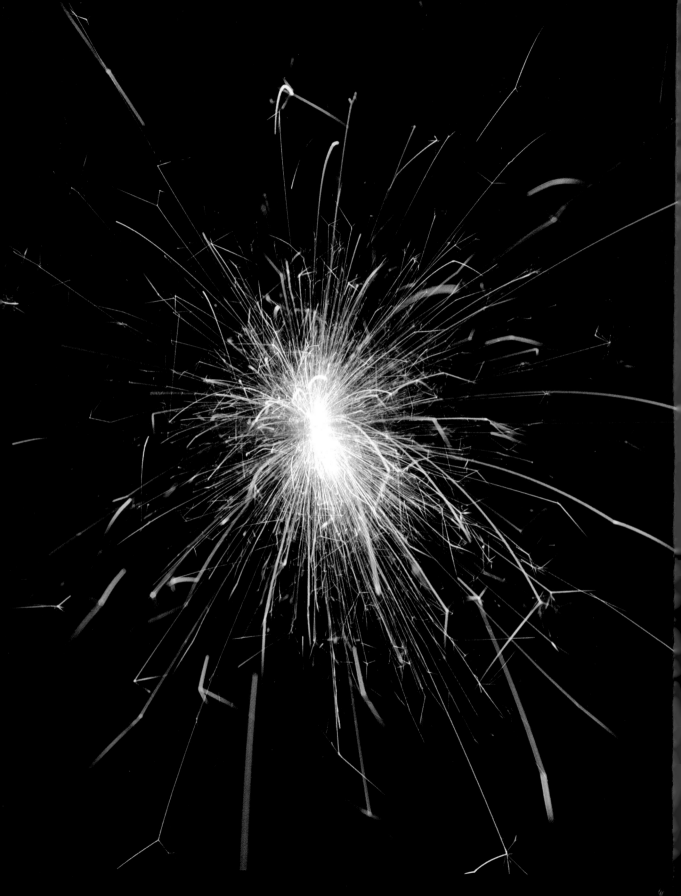

THE BOOK OF
CLOSE-UP
Photography

Text and photographs by

Heather Angel

EBURY PRESS

The Book of Close-up Photography was conceived, edited and designed by Dorling Kindersley Limited, 9 Henrietta Street, London WC2

Project Editor
Charyn Jones
Art Editor
Sally Smallwood
Designer
Jane Owen
Managing Editor
Jackie Douglas
Art Director
Roger Bristow

Published by Ebury Press
Division of The National Magazine Company Ltd
Colquhoun House
27-37 Broadwick Street
London W1V 1FR

First impression 1983
Second impression 1987

ISBN 0 85223 265 9

Typesetting by Chambers Wallace Limited, London
Reproduction by F. E. Burman Limited, London
Printed and bound in Italy by A. Mondadori, Verona

Contents

Introduction

Close-up photographs – especially when taken at magnifications larger than life-size – can make the most ordinary subjects extraordinary. Moving in close with the camera produces images that automatically concentrate the viewer's attention, either on minute subjects or on a small part of a larger, more familiar object, to reveal detail that can be easily overlooked by the casual observer. Even conventional photographic techniques can reveal features and details which are not discernible to the naked eye. More specialized techniques involving stroboscopic flash, ultraviolet light and infra-red film open up new worlds, worlds normally unseen because the events in them occur too rapidly for our eyes to grasp them or because the images are formed in wavelengths outside the visible spectrum. My definition of a close-up photograph is given on page 18, and throughout this book I have used this word in preference to macrophotography, which is often erroneously used as a synonym.

Close-up pictures are now widely used by teachers to educate, by advertisers to tempt, and by artists and designers as sources of inspiration. Biologists, geologists, doctors and dentists are among the many research workers

Color harmony ▽
These hand-thrown flower pots were stacked outside a local pottery ready for dispatch. A recent rain shower had enriched the color of all the pots, but I was particularly attracted to this group which were enhanced by clumps of green clover leaves. My assistant held a silver reflector so that additional light was thrown into the dark center of each pot.
Lens Hasselblad 80mm+ 10mm extension
Mag. on film ×0.1
Mag. on page ×0.35

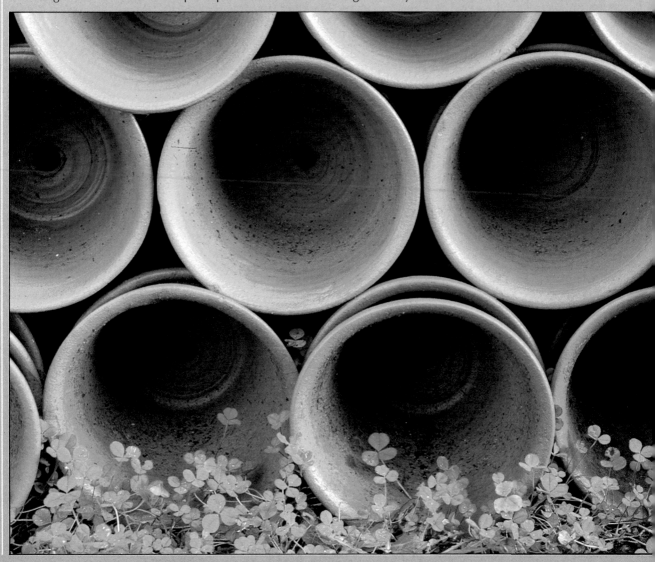

Dripping water ▷
I took this detail of a rock in Zion Canyon, Utah, with a long-focus macro lens. It is known as Weeping Rock, because water perpetually drips off it. This phenomenon arises from the porous nature of Navajo sandstone which readily absorbs water. As water permeates through the sandstone, it is forced out horizontally along a spring line wherever it hits an impervious layer of shale. I used a 1 sec exposure to record the water as continuous lines, highlighted by the direct sunlight.
Lens 200mm micro-Nikkor
Mag. on film ×0.08
Mag. on page ×0.45

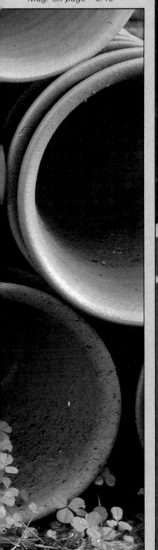

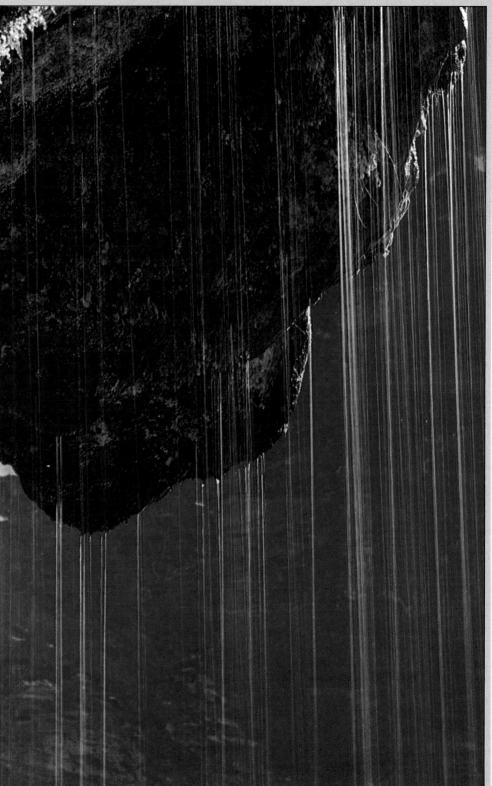

and professional people who use close-up photography in their day-to-day work. Purely scientific and clinical close-up pictures are not included in this book, although many of the techniques which I have described could equally well be applied in these fields.

The first close-up photograph was taken over a century ago, but without a large format view camera, close-ups were not easily achieved. Precise focusing and framing of the picture are extremely difficult with non-reflex cameras which have the viewfinder separated from the lens. In these instances, a discrepancy between the apparent and the recorded field of view occurs and this is known as parallax. It also occurs with a twin lens reflex camera, unless the camera is fitted with an attachment that corrects the parallax error.

The birth of the miniature single lens reflex (SLR) camera was a major advance in camera design. The recent discovery of a wooden camera used to take 35mm perforated film, made prior to 1908 by the Danish carpenter Jen Poul Andersen, is now thought to be the first known 35mm SLR camera. Today, the plethora of 35mm SLR camera systems, each with its interchangeable high-resolution lenses and close-up accessories, combined with through-the-lens (TTL) metering and portable electronic flash, have revolutionized close-up photography. I hope this book will prove that successful close-up photography is not just a question of adding extension tubes or bellows to the lens and then exposing film. The mechanics involved in taking a close-up picture are not difficult to master, but you need to combine a knowledge and understanding of the camera functions with an appreciation of composition and lighting. Available lighting needs to be appraised and studio lighting selected to suit the subject. Taking most images requires an element of spontaneous creativity, so that instant success will not be achieved by applying hard and fast rules to the composition or the lighting. This is the challenge and frustration of close-up photography, and also the source of great satisfaction when you feel you have succeeded. Close-up subjects can be interpreted quite differently by individual photographers, some of whom confine themselves to this aspect of photography. An exciting element in photography is that a dozen people can photograph the same object and no two would produce an identical close-up.

The first film that I exposed, 20 years ago, included several close-ups of marine life taken with a Domiron lens, which focused down to

◁ Effervescence
This effervescing digestion tablet was lit by two electronic flash heads placed at 45° angles behind the glass.
Lens Hasselblad 80mm+ 32mm extension
Mag. on film ×0.4
Mag. on page ×2

Internal illumination ▽
By bending a pair of fiber optics up through the base of this human skull, I was able to light it from inside so that it glowed mysteriously through the cranium and eye sockets.
Lens Hasselblad 150mm+ 32mm extension
Mag. on film ×0.2
Mag. on page ×0.8

one foot, used on an Exakta SLR camera. These early pictures kindled my passion for nature photography. So much in this area of photography relies on good close-up techniques. In those early days, my approach to photography was simple. Since I had neither flash gun nor photofloods, I took everything using available light. Apart from a set of extension tubes and a tripod, I had no other accessories. Perhaps my most astute investment was a solid tripod which I use almost constantly. Today, I have a vast array of equipment – both home-made and manufactured. Some of this equipment allows me to set up the camera and lights more quickly, while other accessories enable me to work in situations where a basic camera would be unable to record an image.

I am always surprised when embryonic close-up photographers enquire, "Where do I begin?" Potential close-ups are everywhere, all around us, in the house, garden, town or wilderness. It is up to the photographer to learn to use his or her eyes and focus attention on the minutiae. I am convinced that this ability to see actual (or to visualize staged) close-ups takes you more than halfway toward a successful picture. Early botanical and medical artists used magnifiers to ensure that details of their subjects were accurately reproduced. One way of developing a seeing eye in photography is to use close-up aids (see pp. 146–7) to study even the most commonplace of subjects.

As I become more deeply involved with photography, I constantly search for patterns

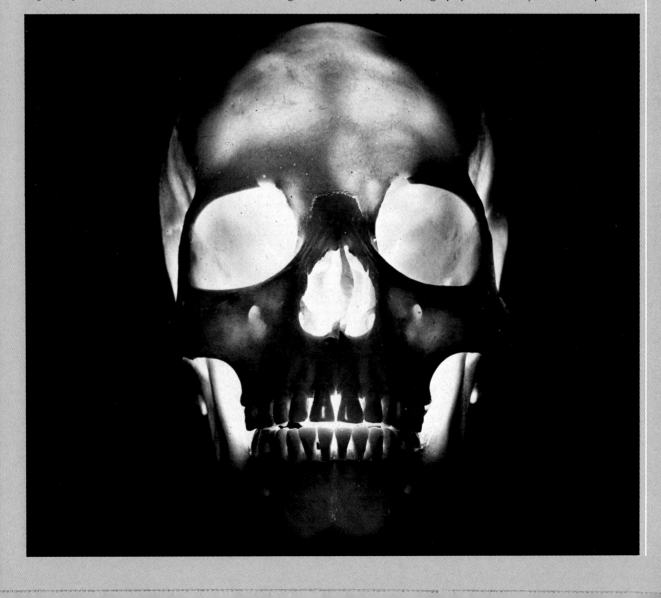

and designs – at all magnifications. As a scientist I was trained to be observant, but when I began to get in close with a camera, I looked at everything around me with a much more discerning eye! Even when you have seen a potential close-up, you must still select and vary the magnification to suit the subject. For example, it would be uninteresting to reproduce different-sized objects at life-size, unless the pictures were to be used solely as an aid to identification. You may, however, find that the camera reveals some unseen facet. I have seen things, when focusing the camera or on the processed film, which I had not noticed beforehand with my naked eye. The quantity of visual information passing into the eye can obscure interesting or significant features.

One of the many explorations into color pursued by the versatile photographer Ernst Haas has been close-up abstractions. He has found inspiration even in discarded litter; he has exploited the natural world by deliberately taking moving subjects at a slow shutter speed and panning the camera to create a blurred image. He has an artist's eye for seeing the subtle combination of color and form which can be picked out by the camera and then enlarged to produce a picture of immense esthetic appeal. Andreas Feininger, on the other hand, selected countless natural close-ups which he chose to reproduce graphically in striking monochromatic prints. He is no less artistic than Haas, but the way he sees images is expressed in his own visual language.

Seven-day old embryo ▷
I used two flashes to light this chick embryo.
Lens Hasselblad 80mm+ 120mm (55+55+10) extension
Mag. on film ×1.5
Mag. on page ×6.75

Color television ▽
A television image is composed of red, blue and green elements, as revealed in this test-card close-up, which together make white light. This is an additive process unlike the subtractive color system in modern transparency films.
Lens Hasselblad 80mm+ 120mm (55+55+10) extension
Mag. on film ×1.5
Mag. on page ×4.5

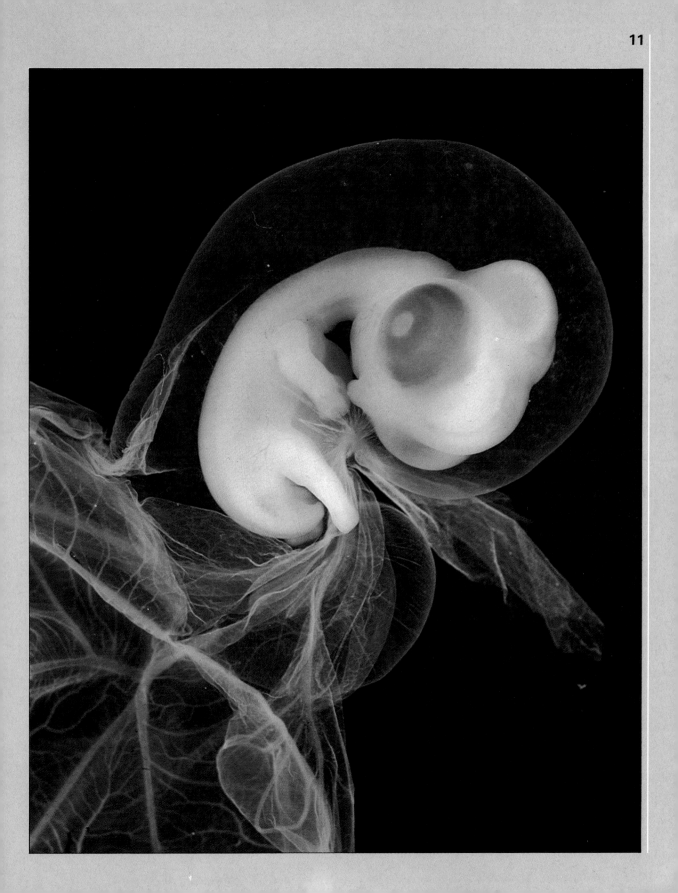

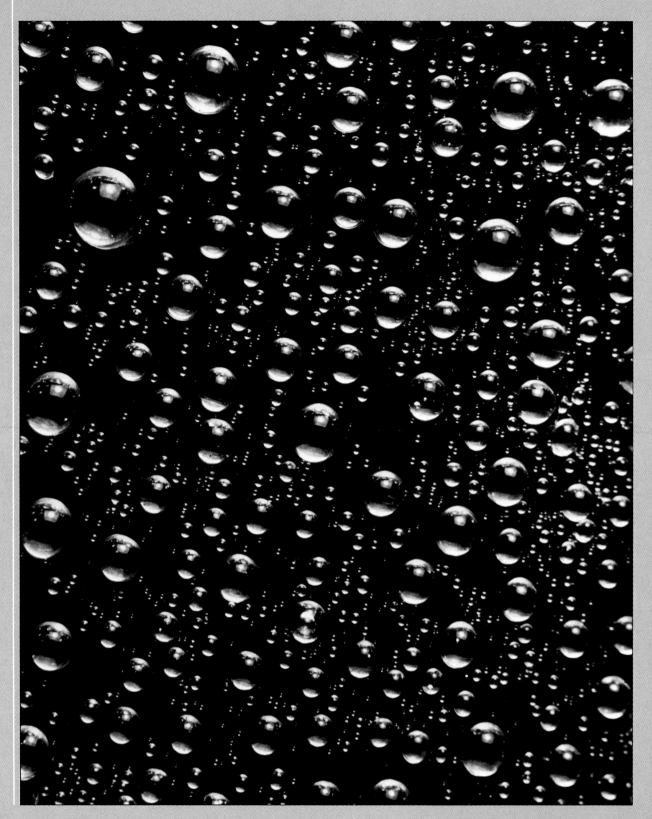

◁ **Water drop abstract**
Before spraying a silver vase with water, I smeared it with vaseline. The single diffused flash can be seen reflected in each drop.
Lens Hasselblad 80mm+ 111mm (55+56) extension
Mag. on film ×1.35
Mag. on page ×8.5

Magnetic field ▽
I sprinkled iron filings round a bar magnet on a piece of paper which I placed on glass. By moving a larger magnet beneath the glass, I made this swirling magnetic-field pattern.
Lens Hasselblad 80mm+ 32mm extension
Mag. on film ×0.4
Mag. on page ×2.5

We communicate not only by the spoken word and by the tone of our voices, but also by our behavioral patterns, facial expressions and other forms of body language. By creating pictures with paint, pen or crayon, an artist communicates ideas or concepts of form, shape and color. Photography straddles the divide between straight descriptive reportage and abstraction. By distorting the nature, scale or context of an image, close-up photography often shows a tendency towards abstraction.

The majority of pictures reproduced in this book were specially taken; many of them use relatively simple techniques, but always with careful assessment of the lighting, selection of the camera viewpoint, framing and magnification of the subject. As work on the book

progressed, my eye was tuned in to "seeing" close-ups everywhere. Working toward a deadline gave me the best possible incentive for trying out new techniques, which might otherwise have been postponed for months, or even years. The picture on page 98, showing a drop of ink falling into milk, was clearly inspired by Harold Edgerton's famous series of high-speed stroboscopic flash pictures of a milk drop falling into milk, which he took in 1938. It was my husband who hit upon the idea of dropping colored ink into milk, so it would be a more exciting image to reproduce on a colored page.

No serious photographer can afford to adopt a sloppy approach; meticulous attention to detail and to precise focusing, critical use of depth of field, and using a rigid camera support

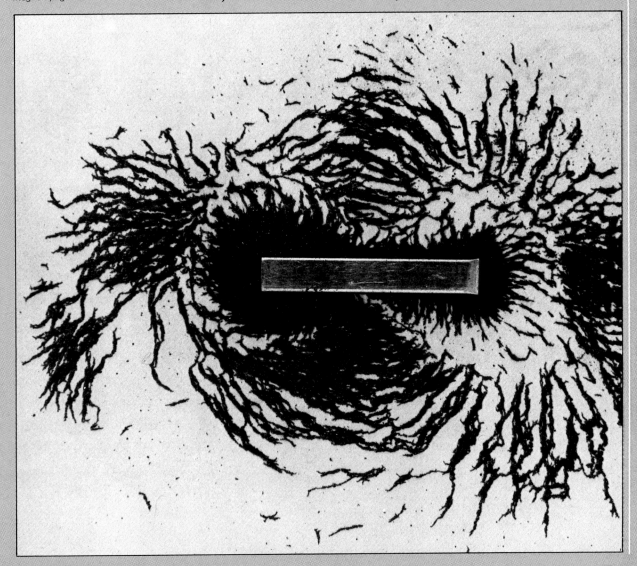

are all essential for attaining a sharp close-up photograph. The definition of a picture also depends on the quality of the lens, the grain size of the film emulsion (which relates to the speed or ASA/DIN number), the depth of field and, if electronic flash is not used, to the rigidity of the subject and the camera. Even though the depth of field is reduced with increased magnification, it is still preferable to get as big an image as possible on film, since the sharpness in an enlargement of a small portion of the negative bears no comparison with a small enlargement of the whole negative area.

Close-up photography demands careful and precise execution. No one who hopes to produce consistently good results will work without a tripod. Any photographer who claims he or she can always take good close-ups by hand-holding a camera in available light must be suspect. Surprisingly many photographers take the trouble to set up their camera on a strong tripod and then shake the system by triggering the shutter by hand rather than by cable release. Whether in the field or the studio, a tripod and a cable release are essential for ensuring high-definition close-ups without flash.

I have deliberately not singled out one camera system, because each system has some good points which aid close-ups, and some drawbacks. By reading the captions, it will become evident which systems I use extensively. All professionals seek a versatile and reliable system, since the camera is their

Water drop lens ▷
I opened the top of a burette so that a drop of water hung down from the tip. A child's spinning top on a box behind the burette is seen as an inverted image in the water — a fish-eye lens in miniature.
Lens Hasselblad 80mm+ 119mm (56+55+8) extension
Mag. on film ×1.5
Mag. on page ×7

Adding color ▽
An artificial pink flower added color to this glass.
Lens Hasselblad 80mm+ 16mm extension
Mag. on film ×0.2
Mag. on page ×0.8

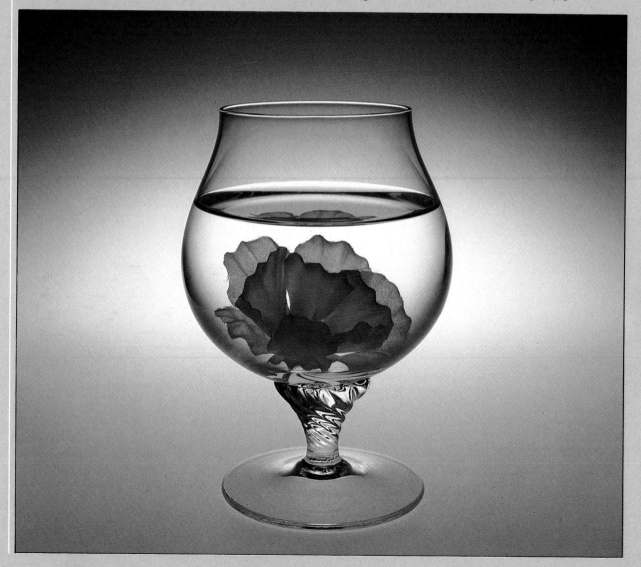

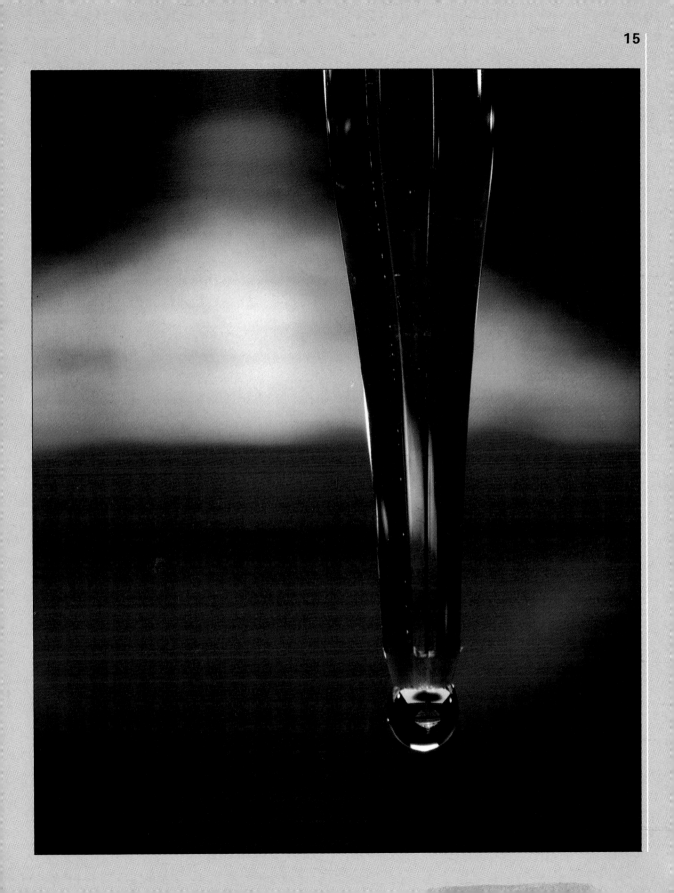

means of earning a livelihood. Thirty-five milli-meter systems are becoming more and more automated to "aid" photographers. While I welcome accurate and reliable light meters, I do not use a camera set on the automatic mode except when photographing moving subjects under changing natural light conditions. How can you be creative, if you have no control over the variable camera functions? Batteries of colored flashing lights in the viewfinder can easily mesmerize you, so that your critical appraisal of the composition of the picture in the viewfinder is inevitably reduced.

The features of a system which I favor most are: quick ways of interchanging lenses, focus-ing screens, and viewfinders; fully automatic lenses, extension tubes and bellows; inter-changeable film magazines; a lock-up mirror; double exposure facility; and needle alignment of TTL exposure rather than a digital read-out. My old-fashioned preference for mechanical rather than electronic battery-powered shut-ters stems from the bitter experience of being unable to use a camera on a fast shutter speed

after the batteries had failed in the heart of a South American rain forest.

For me, close-up photography is an exciting way of exploring objects, surfaces and sub-stances; then comparing and contrasting them. It does not matter how many times someone else may have photographed a parti-cular subject, I strive to find a new way of portraying it in close-up. It is difficult to inno-vate all the time, but at least it presents a constant challenge. Today, I experience just the same sense of thrill at seeing a transparency when it is returned from the processing laboratory as I did 20 years ago.

The type of close-up equipment used to take each picture, the magnification on the film and the size it is reproduced on the page, is given in each picture caption. Variations in the magni-fication on film taken with identical close-up equipment are the result of focusing the lens in different positions. Exposure details have not been included in the captions, since there are so many factors that can influence the com-bination of shutter speed and aperture.

Shell hinge ▽
The pair of shells of any bivalve mollusc lock together by means of an elaborate hinge mechanism. This close-up reveals the hinge detail of a prickly cockle shell. I laid the shell ribs downmost onto a piece of black velvet and lit it with a single fiber optic, which I grazed across the shell so that it highlighted the raised portions of the hinge and cast shadows in the hollows. Only a small amount of light reached the white shell interior, so that it appears in dark shadow.
Lens Hasselblad 80mm+ 72mm (56+16) extension Mag. on film ×0.9 Mag. on page ×5

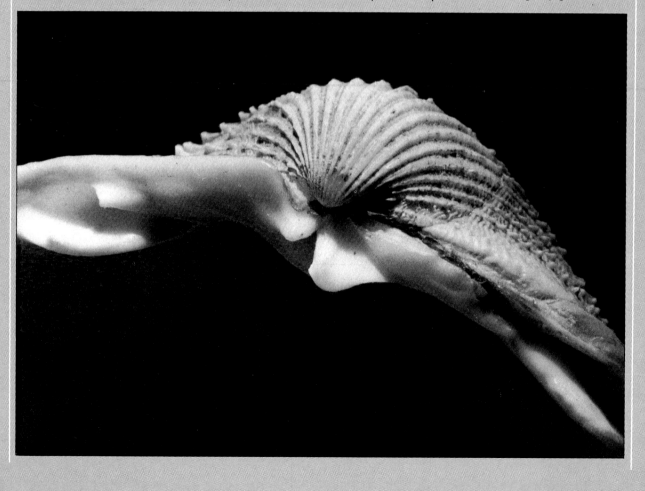

ANATOMY
OF A CLOSE-UP

What is a close-up?

A close-up photograph is usually recognized as one in which the image is reproduced at a magnification of at least one-tenth (× 0.1) life-size to life-size (× 1) on film, although sometimes the range is regarded as spanning only × 0.1 to × 0.5. In this case, the term extreme close-up may be used to define images of × 0.5 to × 1. For simplicity, I have used the word close-up throughout this book for all magnifications. In many books and articles on close-up photography, you will find the term macrophotograph extensively used to describe an image which is reproduced larger than life-size on the film. This is not strictly correct, since the prefix *macro* means large, so a macrophotograph literally means a large-sized photograph. A more accurate term is photomacrography, which is directly comparable with photo*micro*graphy, a term used to describe images which are made with the aid of a microscope (see pp. 142–4).

With the exception of the photograms reproduced on pages 72–3, 83 and 131, and the photomicrographs on pages 142–4, all pictures in this book have been taken with a camera. The majority of these I took using either a close-up lens (see p. 20), extension tubes (see p. 22), a focusing macro lens (see pp. 24–6) or bellows (see p. 28). A few pictures were taken several times greater than life-size with the specialized non-focusing macro lenses (see p. 149).

One way of getting a close-up is simply to blow up a small portion of a negative or a transparency which has been taken with a standard lens without any close-up accessory. This apparent short-cut is not feasible because it produces an ill-defined, blurred image. The simple and convenient way of getting in close is to use a close-up lens. A cheap lens may be acceptable for taking a subject in the center of the frame; any fall-off in definition around the edges would not be apparent. It will not, however, give a uniformly defined image all over the frame of a subject in a single plane.

Once you have entered the realm of close-up photography, you will inevitably want to get in closer than is possible with the most readily available close-up lenses, and you will want to experiment with extension tubes and bellows. If you do not have a bellows unit, you can increase the magnification (and the definition) by attaching a reversing ring (see p. 148) to extension tubes so the lens can be mounted in the reverse position.

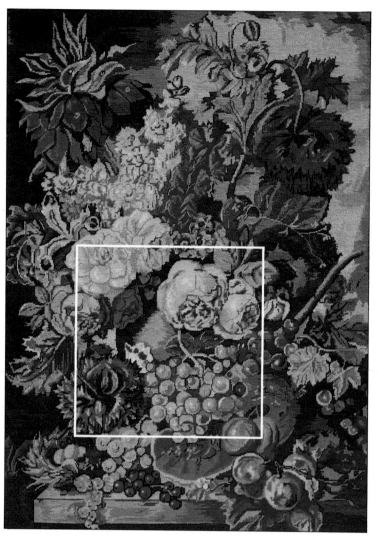

The tapestry
The protective glass was removed from this tapestry before it was photographed by available light. The tapestry was held in an upright position using a pair of clamp stands on each side of the frame, and the camera was carefully aligned on a tripod. This still-life tapestry contains 170,000 stitches and was completed by a lady when she was in her eighties.
Lens Hasselblad 80mm
Mag. on film ×0.12 Mag. on page ×0.25

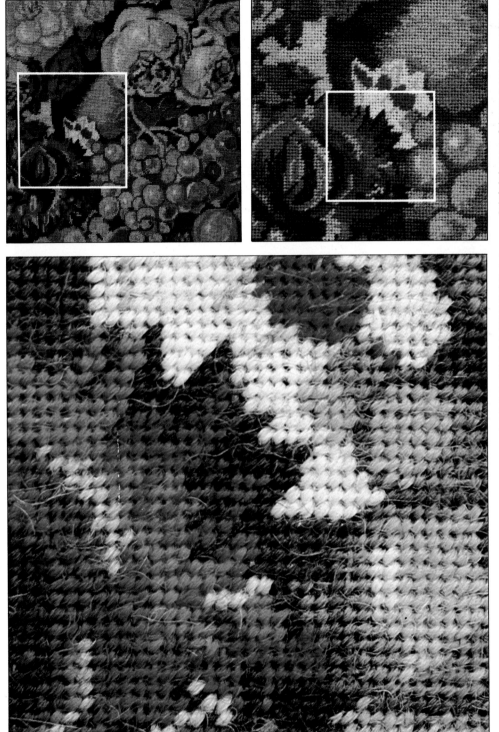

Tapestry in detail
I moved in closer to the
tapestry (far left) so that
the part outlined in white
completely filled the $2\frac{1}{4} \times$
$2\frac{1}{4}$ inch frame. The picture
on the near left shows the
outlined portion of the plate
in detail. At this magnifi-
cation the tapestry becomes
more abstract.
Framed portion
*Lens Hasselblad 80mm +
0.5 Proxar*
Mag. on film ×0.23
Mag. on page ×0.37
Detail
*Lens Hasselblad 80mm +
21mm extension+0.5
Proxar*
Mag. on film ×0.46
Mag. on page ×0.54

The stitches
This plate shows part of
the picture, top right, which
was enlarged when the
color separations were
made during the printing
process. At this larger-
than-life-size reproduction,
each individual stitch is
quite distinct and the work
that went into the whole
tapestry can be fully
appreciated.
*Lens Hasselblad 80mm +
21mm extension+0.5
Proxar*
Mag. on film ×0.46
Mag. on page ×1.13

Close-up lenses

Close-up or supplementary lenses provide an easy and inexpensive way of taking close-up pictures with any camera, since they are simply attached to the front of a prime lens. They are even available for some instant print cameras and they have the advantage of not reducing the amount of light reaching the film. They are, however, of limited use to the serious photographer because they magnify the image by only a small amount (normally less than life-size on the film) and a single lens does not cover the range of magnifications achieved by either extension tubes or macro lenses.

The strength of a close-up lens varies and is usually expressed in diopters. When a +1 diopter lens is attached to a 50mm lens set on infinity it gives a magnification of × 0.05 and a working distance of approximately 40 inches. A +2 diopter lens doubles the magnification and halves the working distance; ultimately a +20 diopter lens gives a life-size image (× 1) and a working distance of slightly less than 2½ inches. Hasselblad supplementary lenses, known as Proxars, are described in terms of focal length rather than strength (see p. 148).

It is false economy to use a cheap close-up lens on the front of a good prime lens; a crude piece of glass will detract from any high definition lens. Therefore, if possible, use a close-up lens which is an integral part of your camera system. This will guarantee you better quality images, especially if the prime lens is stopped down to a small aperture and the camera is used on a tripod. High-quality close-up lenses are now specially coated to give virtually flare-free images.

If you should require a greater magnification than can be obtained with your most powerful close-up lens, it is possible to use two in combination – preferably with the strongest lens adjacent to the prime lens.

Special kinds of close-up lens include the splitfield filter (see p. 148), which is half a close-up lens, and the zoom close-up lens with a variable focal length giving magnifications of +2 to +10 diopters.

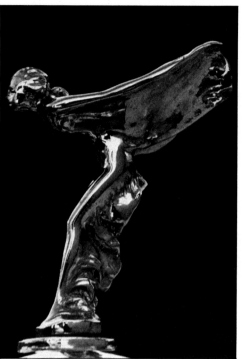

◁ **Spirit of Ecstasy**
This distinctive emblem – known as the Spirit of Ecstasy – belongs to a 1925 vintage Rolls Royce. I took the picture while the car was parked outside in the sun which shone down from the top left. The shaded wall of a garage gives a simple, but contrasting backcloth.
Lens Hasselblad 250mm + 1.0 Proxar
Mag. on film ×0.3
Mag. on page ×0.75

A Cotswold wall ▷
As I drove down a country lane in the Cotswolds on a winter morning, I noticed the fields were bordered by walls made of carefully laid flat stones. Shadow cast by the low-angled sunlight has clearly defined the outline of each individual stone.
Lens Hasselblad 80mm + 1.0 Proxar
Mag. on film ×0.13
Mag. on page ×0.5

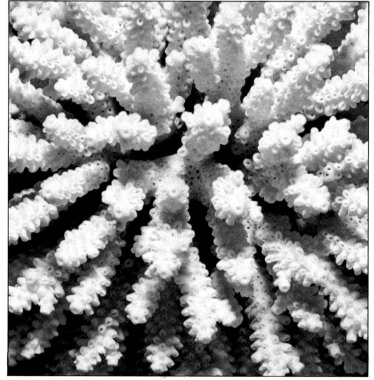

Coral skeleton ▷
I lit this white coral skeleton indirectly by bouncing a floodlight off a large white umbrella. Each tiny cup where a coral polyp once lived could be distinguished from the whole skeleton in this way.
Lens Hasselblad 80mm + 10mm extension
Mag. on film ×0.2 Mag. on page ×0.5

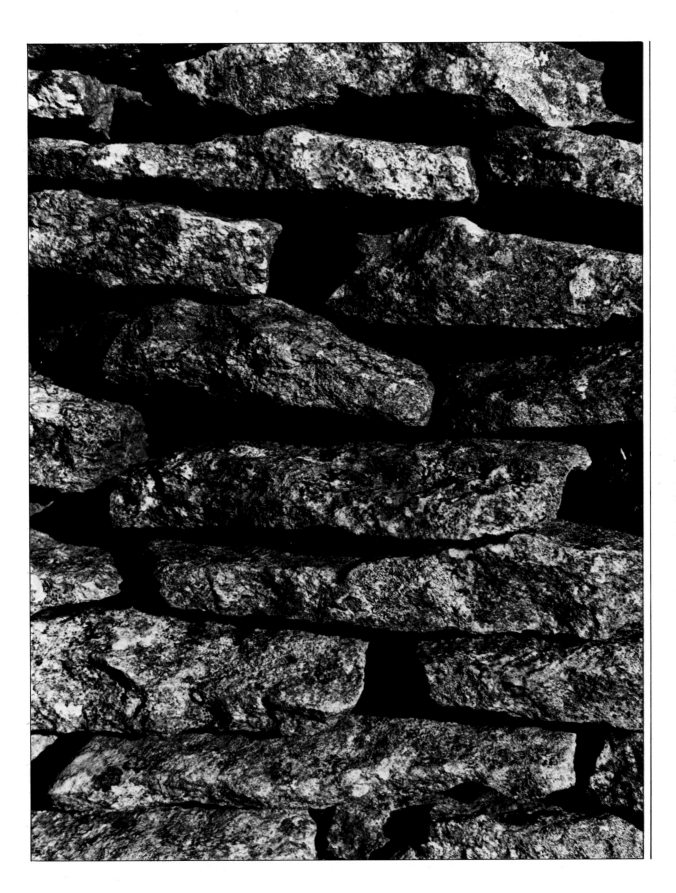

Extension tubes

Extension tubes can be used in conjunction with any single lens reflex camera which has a detachable lens; the lens has to be removed so that the tubes can be fitted between the camera body and the lens (see p. 148). Therefore whenever extension tubes are used, the lens-to-film distance is greater than it would be without tubes. This reduces the amount of light reaching the film. Such a light loss is detected by a through-the-lens meter, but you must allow for it when using a light meter remote from the camera (see p. 160).

Extension tubes may be manual or automatic. Manual tubes are cheaper, but they have to be stopped down to the required aperture by hand. Automatic tubes couple the lens diaphragm to the camera body. This facility allows the maximum lens aperture to be retained for viewing and metering until the moment the shutter is released, when the diaphragm automatically closes down to a selected aperture. Although manual tubes can

be made to function automatically by using a Z ring and a double cable release (see p. 148), automatic tubes are more convenient to use.

Within the 35mm format, extension tubes may come in sets of three or five tubes of variable lengths and can be used in any combination to gain the desired magnification. A set is usually designed to give a magnification of up to life-size (×1) with a standard 50mm lens on a 35mm format. Additional tubes can always be added if greater magnifications are required, although it may be more convenient to use a bellows extension (see p. 28) at magnifications of much greater than ×1.5.

Extension tubes can be used with longer focal length lenses (90mm, 105mm, 135mm or 200mm) for taking close-ups of more distant objects which are out of range of a 50mm lens with tubes. The magnification gained on 35mm film and a 50mm extension will change with the focal length of the lens: with a 50mm lens it is ×1, whereas with a 100mm lens it is ×0.5.

Painting pattern ▽
My young son made this pattern by sweeping a plastic comb back and forth across wet paint on cerise-colored paper. After the painting had dried, I laid it on a table beside a window and photographed part of it by indirect available light.
Lens 50mm Nikon+14mm extension
Mag. on film ×0.3
Mag. on page ×1.5

Plant power ▷

If roots of perennial plants such as this bracken extend beneath hard surfacing, the force of the upward-growing new shoots is strong enough to fracture and ultimately to break through the hard surface. I took this picture in my garden by setting up the camera on a tripod close to the ground. Focusing at this low-level viewpoint was made easier by using a right-angle viewfinder.

Lens 50mm Nikon+14mm extension
Mag. on film ×0.3
Mag. on page ×2.5

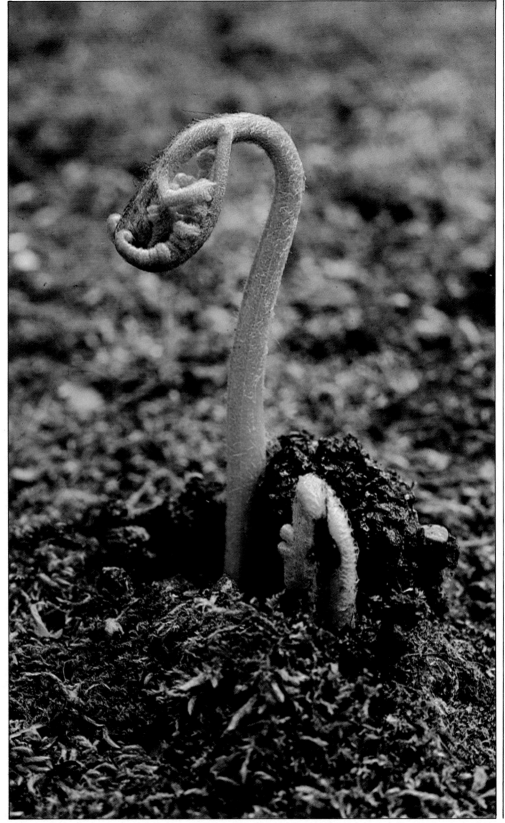

A focusing macro lens has an extension built into the lens itself which enables the lens to be used at any magnification between infinity and half life-size without any other accessory. The most widely used macro lenses – those which have a focal length of 50mm or 55mm – are covered on pp. 25–26. Other modern macro lenses have focal lengths of 105mm or 200mm: they both have a greater subject to camera working distance than the 55mm macro lens. You can also get some zoom lenses with a macro mode. This makes them invaluable for taking close-ups of wary subjects (butterflies or dragonflies) or more distant subjects (statues or leaves) or even human or animal portraits.

All the special-purpose, automatic, close-focusing lenses are easy to use and enable precise framing of every subject. The magnification is simply read off the lens barrel. They are, however, a more expensive way of getting in close than by using a lens of the same focal length with a set of extension tubes. However, no photographer specializing in close-ups could contemplate working without at least one macro lens. I use three of the micro-Nikkor range (55mm, 105mm and 200mm) which, despite the confusing use of the prefix *micro*, are in fact macro lenses. Any macro lens can be used in conjunction with extension tubes (see p. 22) or bellows (see p. 28). Whenever I work with a macro lens, I always use a tripod to ensure the sharpest possible image, especially if I am using a slow shutter speed which is so often the case when working with slow speed color film in overcast lighting conditions.

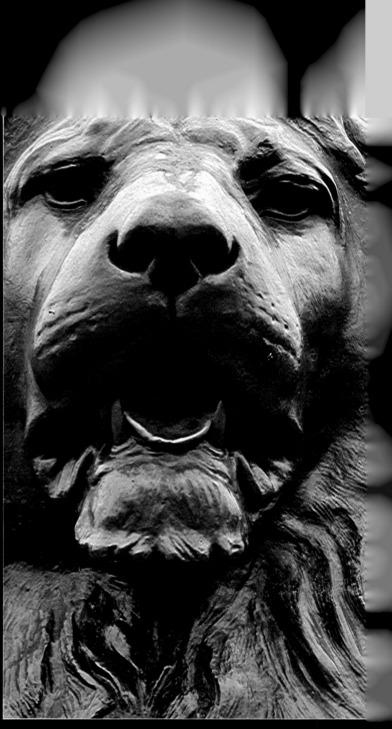

◁ A leafy mosaic
The only way I could get a reasonable close-up picture of the leaves of this tree in the Seychelles was to use a 200mm macro lens. I deliberately exposed the film so that the leaves appeared as complete silhouettes and the tiny holes which had been eaten out by small beetles were clearly visible.
Lens 200mm micro-Nikkor.
Mag. on film ×0.1
Mag. on page ×0.3

Detail of statue △
I took this picture, showing part of one of the famous lion statues in London's Trafalgar Square, from ground level, using a long macro lens to crop in on the face. I had to use a tripod for a 1 sec exposure on a very overcast day. This adds a somber feeling to the huge metallic statue.
Lens Vivitar 90–180mm macro-zoom
Mag. on film ×0.026
Mag. on page ×0.1

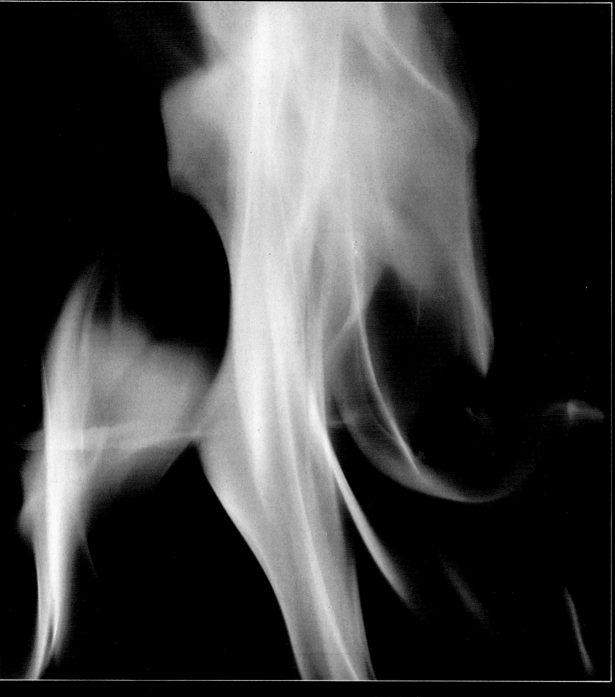

Flickering flames △
While I waited in the entrance hall of a hotel I noticed
the flames of a gas fire. It generated so much heat that it
was impossible to take a close-up picture with a 55mm
macro lens, so I decided to use a macro lens with a
longer focal length. The camera was mounted close to
the floor on a Benbo tripod and I used a $\frac{1}{4}$ sec exposure
to produce this blurred effect of the flames leaping
towards the chimney against the black recessed fireplace.
Lens 105mm micro-Nikkor
Mag. on film ×0.12 Mag. on page ×0.8

Macro lenses

Macro lenses with a focal length of 50mm or 55mm are the most popular of all macro lenses. Their optics are designed to provide the best definition at close range and they usually focus down to half life-size without any additional extension. With a maximum aperture of f2.8 or f3.5, they are not as fast as a standard lens of the same focal length. However, since they are designed principally for close-up work, this is not a limiting factor because the lens will be stopped down as much as possible to achieve the maximum depth of field. It is for this reason that these macro lenses usually have a minimum aperture of f32 – one step greater than f22 of the equivalent standard lens.

The front lens element of the 55mm micro-Nikkor lens is so well recessed that there is no need to use a separate lens hood. This was the first lens I bought with my original Nikon and I use it more than any of my 13 other lenses for this system. Although it is used primarily for close-ups of static natural history subjects, I also use it for document and slide copying.

The design of both the 55mm micro-Nikkor f2.8 and the 50mm Zuiko Auto-macro f3.5 allows the whole rear part of the lens to move in and out as the lens is focused, thus enhancing the image quality at close-up ranges and still allowing a good definition at infinity.

There are also the so-called "true" macro lenses (see p. 148) which cannot be focused and have to be used with bellows. They give very high definition at magnifications of up to 20 times life-size.

Camera circuitry ▽
I removed the top from an SLR camera to take this picture of part of the electronic circuitry. Only when you see the array of colored wires and components do you appreciate the complexity of the cameras which are the essential tools of the modern photographer. I lit this picture using a pair of fiber optics directed in at a low angle from each side.
Lens 55mm micro-Nikkor
Mag. on film ×1
Mag. on page ×6

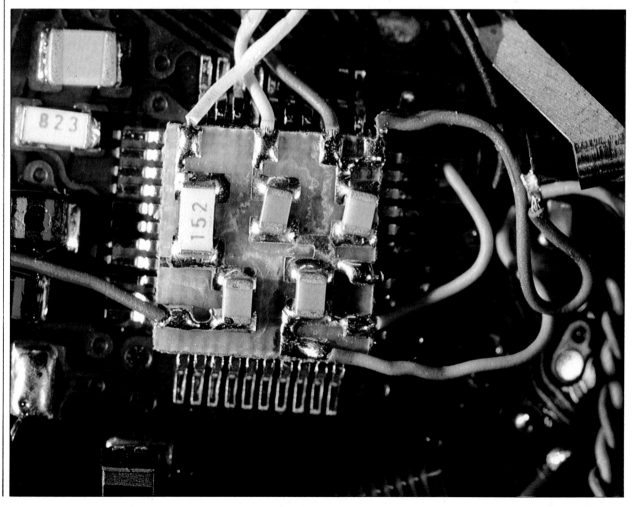

◁ **Polished petrified wood**
Within Arizona's Petrified
Forest National Park lie
huge stone tree trunks.
These spectacular plant
fossils were formed after the
fallen trees were covered
by layers of mud and
volcanic ash which
prevented their decay by
eliminating the oxygen
supply. As silica-rich
waters permeated through
the ground, the wood was
slowly replaced with silica
and so became petrified.
Collection of any petrified
wood inside the park
boundary is prohibited.
Dealers do, however,
collect elsewhere and this
picture shows a portion of
a polished section which I
bought. It was taken inside
by indirect available light.
The range of colors
originate from minerals
which are deposited at the
time the wood was turning
to stone.
Lens 55mm micro-Nikkor
Mag. on film ×0.5
Mag. on page ×3

Bellows

Bellows extend the lens further away from the camera than extension tubes, to give greater magnifications (up to × 3.5 with a 50mm lens). The concertina fabric construction also provides a continuously variable magnification. The cheapest bellows units are non-automatic and simply move the lens backwards or forwards. On more expensive units, both the front and back of the bellows can be adjusted, while a separate focusing rail serves as a focusing slide (see p. 152). Once the magnification has been set on the bellows (by moving them so the required amount of extension reads off the millimeter scale), the whole unit – camera, bellows and lens – can be moved forwards or backwards on the focusing rail until the subject appears in focus. Greater magnifications and better definition will be gained if you mount the lens in the reverse position by using a reversing ring (see p. 148).

A few bellows units, including the Nikon PB4, have additional movements which allow the front end to be shifted 10mm to the left or right and also pivoted through 25°, which can be useful when taking close-ups of an object at an angle to the film plane. Like automatic extension tubes (see p. 22), auto bellows stop down the lens to the preselected aperture. Non-auto bellows can either be stopped down manually or automatically by using a double cable release (see p. 148) which closes the lens diaphragm just before the shutter is fired.

When bellows are used with TTL cameras, direct TTL readings can be made, although with some units the lens must first be stopped down to the chosen aperture.

Nylon pantie hose ▷
I cut out a square from some old pantie hose, stretched it over a piece of glass and held it in position with scotch tape. Dark field illumination (see p. 54) was used to show up the characteristic kinky strands of stretched nylon.
Lens Leitz 25mm Photar+ bellows
Mag. on film ×6
Mag. on page ×15

Color printing ▷
When a printed color plate in a magazine or book is viewed with a strong magnifying glass, you see a mass of tiny colored dots. It is the relative size of each colored dot which is the intrinsic factor in recreating a replica of the original color transparency. To achieve this, I used a color proof of a picture of a dormouse. I cut out the head, scotch taped it to a flat surface below an overhead camera and lit it with a single flash and a reflector. The dots represent the nose of the dormouse and the base of the whiskers.
Lens Leitz 12.5mm Photar +bellows
Mag. on film ×10
Mag. on page ×25

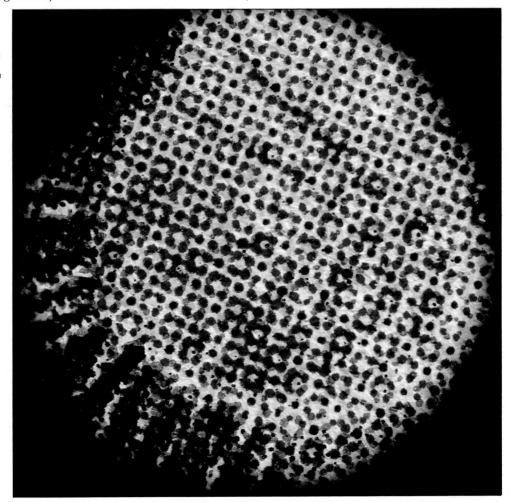

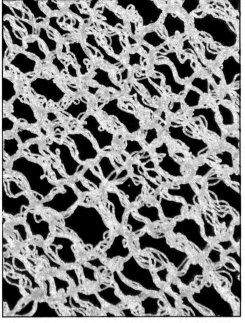

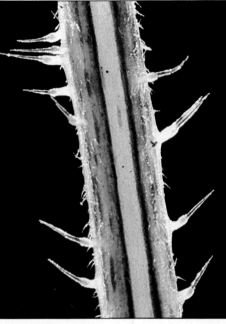

◁ **Nettle hairs**
I used dark field
illumination (see p. 54) to
highlight the structure of
the needle-like hairs on the
stem of a stinging nettle. It
is the sap contained within
the swollen base of these
hairs which causes the
swelling and pain of a
nettle rash.
*Lens 55mm micro-Nikkor+
bellows*
Mag. on film ×3
Mag. on page ×12

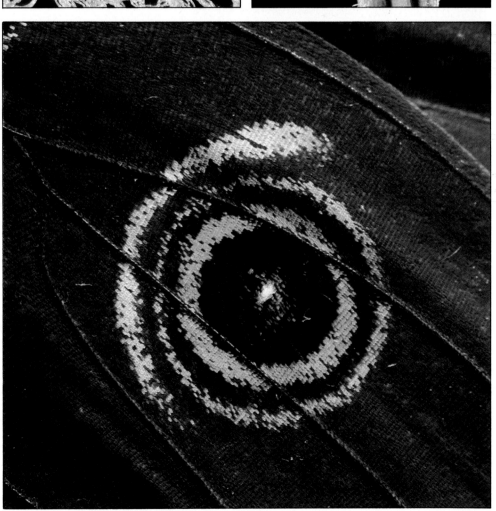

Nikon bellows unit on
macro copy stand.

◁ **Butterfly scales**
Many butterfly and moth
wings sport false 'eyes'
which serve to alarm a
potential predator. When
these eye-spots are
enlarged, it is easy to see
how they are made up
from different colored wing
scales arranged in such a
way that they produce a
distinctive pattern for each
particular species. Here I
photographed with a single
flash a pinned specimen
collected from Guiana.
*Lens Hasselblad 80mm+
bellows*
Mag. on film ×3
Mag. on page ×8

Depth of field

Depth of field is the zone in front of and behind the plane of focus where the image appears sharply defined. Being able to understand and exploit depth of field to the maximum is essential when taking close-ups, since the more you magnify a subject the smaller the depth of field becomes (see p. 161). It is also decreased by opening up the lens aperture; conversely, reduction of image size or the lens aperture increases the depth of field. When taking close-ups, I invariably aim to use a macro lens at one stop above the smallest aperture to retain good definition; for example, f22 with an f32 lens. When working in available light with a slow speed color film, small apertures are possible only if a slow shutter speed is used, or if the light level is boosted by additional lighting.

The way in which the depth of field changes with the aperture can be seen either by stopping down a non-automatic lens or depressing the depth of field preview button with an automatic lens. When a subject is 3.5 feet away, or closer, the depth of field increases almost equally on each side of the plane of focus. You can therefore ensure the best use of the depth of field available by focusing slightly beyond that part of the subject nearest to the camera. This should bring the subject completely into focus as the lens is stopped down. For a sharply defined image the precise plane of focus will need to be selected for each subject depending on the chosen magnification and aperture, but you can always check the depth of field either by viewing the subject through a stopped-down lens, or by using a macro lens which has a close-up depth of field scale printed on the lens barrel.

A useful way of isolating a close-up subject from a confusing background is to throw the background out of focus, which may mean decreasing the depth of field by opening up the aperture. If you wish to isolate one object among many similar ones, you can do this by means of differential focus whereby with careful focusing and aperture selection everything else is thrown out of focus so the eye is automatically led toward the defined subject.

A single plane ▷
I collected these crab's-eye seeds in Barbados and carefully grouped them in a shallow petri dish so they would create a greater impact in a mass. I took the picture with the camera mounted overhead, using a spirit level to check that the film plane was parallel with the layer of seeds. It was then easy to ensure the seed mosaic was sharply defined within the one plane.
Lens 55mm micro-Nikkor
Mag. on film ×0.5
Mag. on page ×3

Selective focus ▽
I wanted to draw attention to the first open pussy willow catkin on this branch, so I stopped down the lens and then while keeping the depth of field button depressed I slowly opened up the lens. In this way I could see precisely how many catkins were sharply in focus. I also deliberately chose to off-center the point of focus.
Lens 105mm micro-Nikkor
Mag. on film ×0.4
Mag. on page ×2

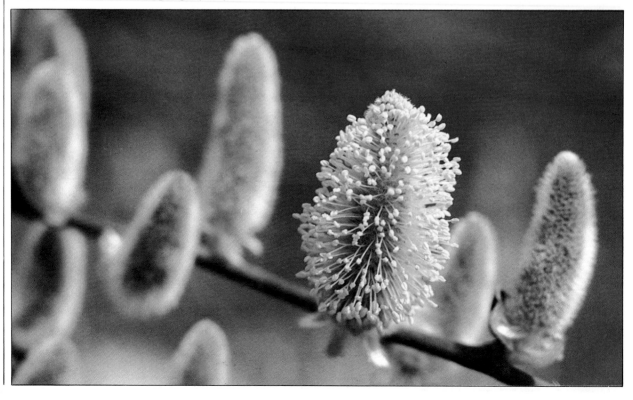

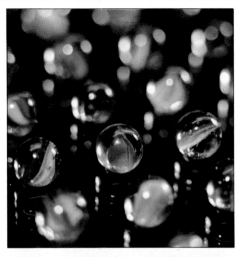

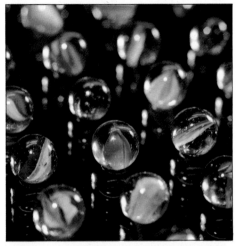

Improving the definition

Using a pair of spotlights, I took a group of marbles on a solitaire board with the lens set on the widest aperture at f4. The result can be seen in the top left picture, where only the red marble appears sharply in focus. Keeping the camera position and lighting constant, I then stopped the lens down to f8 (center left) which brought each marble on either side of the red one into focus. It also reduced the size of the highlights in the marbles which are out of focus. Finally, I stopped the lens down to f32 to bring all the marbles into focus and reduce the highlights still further. The set-up below illustrates the extent of the depth of field (shaded in gray) for each aperture.
Lens Hasselblad 150mm + 103mm (55+32+16) extension
Mag. on film ×0.6
Mag. on page ×1

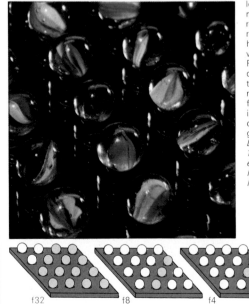

Backgrounds

Critical appraisal of the background color or tone, texture and shape, is paramount for achieving a successful close-up picture. If a pastel-colored subject is taken against a brightly colored background, the latter will compete for attention. Even out-of-focus highlights on water or wet surfaces may detract from a close-up subject. Success or failure depends on the relative size of the subject and the individual highlights, which I always check with the depth of field button.

When working outside with static subjects, a different viewpoint may help to improve the background. I often lie down to get a lower viewpoint and I have even resorted to carrying a stepladder on top of my automobile to gain a higher viewpoint. Opening up the aperture to decrease the depth of field (see p. 30–31) can help to throw a distracting background out of focus.

Artificial backgrounds can be inserted behind an outside subject, though somehow it never looks authentic. A useful technique for separating a sunlit subject from its background is to cast a shadow on the background behind the subject (see p. 38–9). A polarizing filter (see p. 40) can be useful for increasing the intensity of blue sky in both color and monochrome films. Contrast filters can be used with monochrome films to help to separate a subject from its surroundings. For example, when a red flower is photographed surrounded by green leaves, everything is reproduced in a gray tone, but if a green filter is used, the red flower appears much darker.

For studio photography, I keep a good stock of backgrounds ranging from colored materials and artists' boards, to black velvet, wood, cork, slate, sand, gravel, glass, plexiglass, black plastic sheeting and mirrors. I also improvize with anything which helps to offset the subject, including leaves or even soil. Textured backgrounds are usually not ideal, since they tend to compete with the subject. When using pale backgrounds make sure strong shadows from direct light sources are not too distracting. They can be eliminated by shining the light through a light tent, by bouncing it off a reflector or by raising the subject above the background on a glass sheet and lighting it from above with a pair of lights angled down at 45°. A useful technique for tonally separating a subject from its background is to shine a strong light onto the background.

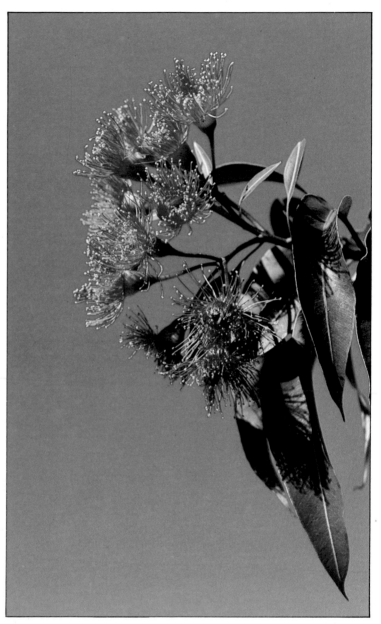

Using sky as a natural backcloth △
I waited several days for these vibrantly colored eucalyptus flowers to open. On a sunny clear day, I used a low viewpoint so that the red flowers would be set off against the blue South African sky, which I deepened by using a polarizing filter.
Lens 105mm micro-Nikkor
Mag. on film ×0.25
Mag. on page ×1.25

Selecting a natural surround ▷
An old hollow tree trunk was the inspiration behind this picture of my son pretending to be an owl. I lowered him feet first through the tree hole which was three feet off the ground. As he peered out, I quickly composed the picture so that the old trunk completely filled the frame and thus created a natural surrounding to this portrait.
Lens 105mm micro-Nikkor
Mag. on film ×0.05
Mag. on page ×0.4

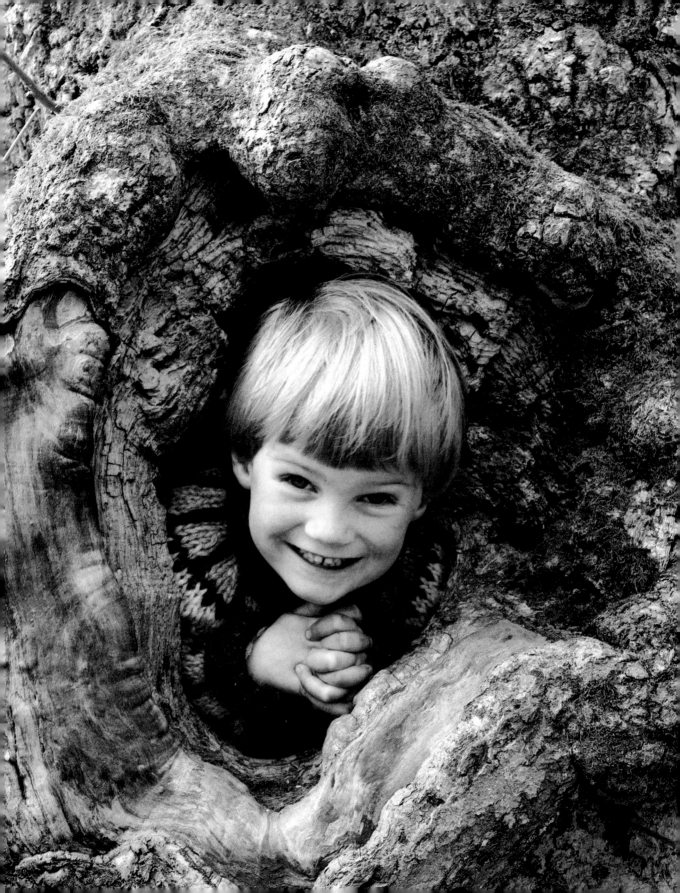

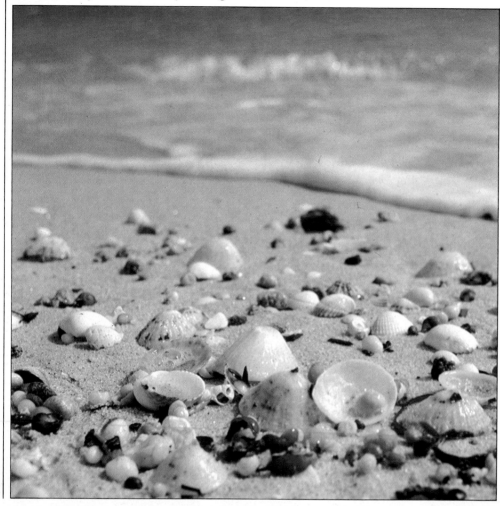

◁ **A watery backcloth**
By lying flat on a sandy beach I was able to get the sea as a background in the upper part of the frame. Water is more often used to offset a foreground subject by working at a higher viewpoint and looking down, but in this case I wanted to illustrate the way in which the shells had been beached on the shore by the encroaching waves.
Lens 55mm micro-Nikkor
Mag. on film ×0.15
Mag. on page ×0.7

Varying the background
All three pictures of this horse brass were taken using the same lighting and camera set-up, to show the effect the color or texture of a background has on a subject. On the left, I used a piece of smooth green slate. The original block was a gray-green color, so I rubbed some olive oil into the surface to make it appear a darker green. In the center, the brass is resting on black velvet, while for the right-hand picture I used a rope mat. I lit the brass by directing a pair of spotlights through diffuser screens.
Lens 80mm Hasselblad+42mm (21+21) extension
Mag. on film ×0.6 Mag. on page ×0.7

LIGHTING

Exploiting daylight

Both the direction from which daylight strikes the subject (front, side, overhead or back) and the quality of the light itself (direct or diffuse) provide the photographer with a wide variety of natural lighting. Even though the creative use of daylight is most often regarded as the basic tool of the landscape photographer, it can nonetheless be used creatively for close-ups. Not only does the angle of the sun, and hence the direction of the shadows, change with the time of day, but the color temperature also changes. Close to dawn and dusk, the low-angled sunlight appears reddish because much more of the blue light is absorbed by the atmosphere. As this lighting casts extreme shadows, it is generally unsuitable for close-ups.

Unlike artificial lights which can be moved at will, sunlight has to be exploited when it provides the optimum lighting conditions for a particular close-up subject. Having found an immovable subject, you need to anticipate the time of day when daylight will enhance its appearance by emphasizing its texture or even by revealing some otherwise hidden facet.

Front lighting will render a three-dimensional subject flat and featureless, whereas side lighting helps to model it by creating shadows, thereby accentuating any surface relief. Direct sunlight helps to add sparkle on wet, rain-splattered or dew-covered objects – notably wet pebbles, metallic surfaces, glass, spiders' webs, leaves and flowers. Providing the subject is carefully selected, back lighting can be the key to producing some striking images. A profile, for example, may be greatly enhanced by rim lighting, or simplified into a silhouette. Colored, translucent subjects such as glassware, crystals, red wine in a clear glass, stained glass and leaves all appear to glow when they are lit from behind. On cloudy or misty days, the non-directional, muted light casts no shadows and can be an advantage when photographing white or pastel-colored objects, which might otherwise be spoilt by harsh direct lighting.

Taking close-ups of moving subjects at a magnification of life size, or even greater, with a slow, fine-grain color film may be impossible with available light. If a faster shutter speed has to be used, there will not be enough ambient light for the lens to be adequately stopped down. Static subjects, however, can be taken with a slow shutter speed, but the color balance may be upset with long exposures.

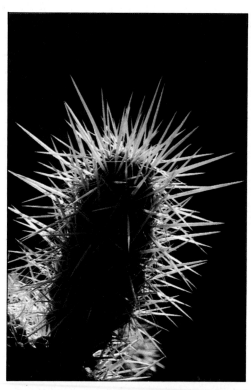

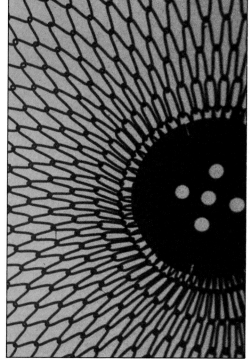

Transillumination ▷
The full impact of the luminous colors of stained glass can be appreciated only when they are lit by direct sunlight from behind. I waited until the sun shone before I metered the light streaming through this church window.
*Lens 200mm micro-Nikkor
Mag. on film ×0.2
Mag. on page ×2*

◁ **Back lighting for effect**
Whenever possible, I aim to photograph cacti early or late in the day so I can use the low-angled sun to highlight the spines. To take this silver cholla cactus in Arizona, I metered the light directly through the camera on the opposite, sunny side of the cactus and used this reading to make the exposure so that the silvery spines glowed against the shadowy background.
*Lens 55mm micro-Nikkor
Mag. on film ×0.25
Mag. on page ×0.75*

◁ **Creating shadows**
I saw this shadow pattern of an empty salad basket as the sun shone through my kitchen window. The photograph was taken outside on patio steps using a clamp stand to hold the basket at an angle to the orange background (see diagram below) to give the sharpest shadow. The camera was supported on a Benbo tripod.
*Lens 55mm micro-Nikkor
Mag. on film ×0.4
Mag. on page ×1.5*

Controlling daylight

When working with available light, the type of lighting at the time you are taking the photograph may not suit the particular subject. For example, shiny metallic or glossy painted surfaces will reflect direct sunlight in a concentrated area; this can be very distracting in a close-up. Strong sunlight can be softened by using a diffuser such as a sheet or two of cheesecloth, or a white Lastolite reflector/diffuser (see p. 152).

More often with close-ups though, there will not be enough available light, or else it may not evenly illuminate the subject. Reflectors can then be very useful to help boost low light levels. I use both silver and gold (this gives a warmer light) 40-inch diameter Lastolite reflectors for illuminating large areas. I usually carry a small purse mirror and a piece of board

covered with aluminum foil for lighting shadow areas on small objects. When I have been really desperate I have used a metal camping mirror or a silver Hasselblad dark slide for the same purpose.

The problem of direct sunlight striking the lens and producing flare is much less likely to occur in a close-up than in a landscape picture. However, it can be controlled by always using a lens hood and, if necessary, a multi-coated skylight filter.

Rarely do I have the problem of too much available light when taking a close-up with a slow-speed color film. I can, however, recall a time when I had to use a neutral density filter to reduce the overall light level reaching the film so I could use a one second exposure to take water flowing over stones.

Boosting the light ▷
A woodland stream flows continuously into this roadside grating. In such a sombre setting I employed a silver Lastolite reflector (see p. 152) to boost the natural light; I still had to use a 1 sec exposure with Kodachrome 25 film. This long exposure portrayed the moving water as a blurred white cascade which contrasts well against the dark metal grating and the green mossy growths.
Lens 55mm micro-Nikkor
Mag. on film ×0.08
Mag. on page ×0.4

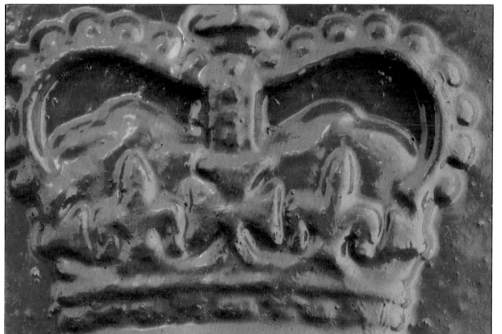

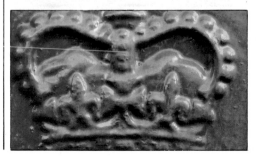

Diffusing the light
I took this embossed crown on a mail box lit directly by the winter sun (left). This direct sunlight created some highlights on the glossy paint, so I decided to soften the light by using two diffusers. A large circular one was held at the side of the mail box and a small faceted one was held above the camera attached to a tripod, as shown in the set-up on the right. This resulted (above) in a uniform soft lighting which was more restful to the eyes, but which still portrayed the embossed structure.
Lens 55mm micro-Nikkor
Mag. on film ×0.3 Mag. on page left ×0.6; above ×1.3

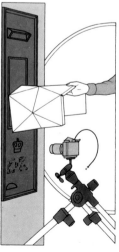

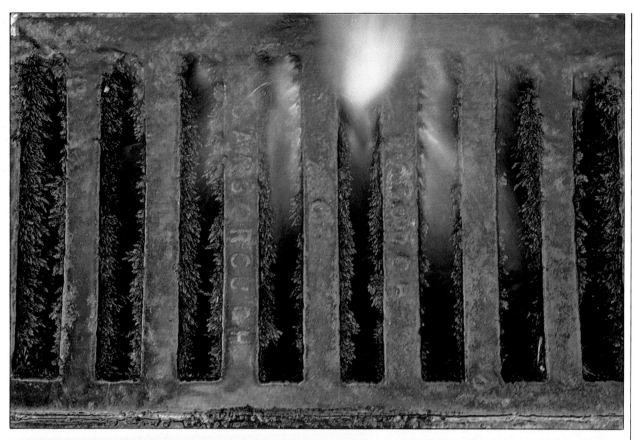

Casting a shadow

The small inconspicuous flowers of this heath cudweed do not easily separate out from a natural grassy background (above). As I had no flashes with me, I could not override the natural light, so I asked my husband to stand in such a position that his shadow lay behind the plant (left), thereby producing a simplified, albeit unnatural, backcloth. This is a very useful technique for eliminating cluttered backgrounds, and it can be achieved simply by propping up a rucksack or a piece of wood in a strategic position.

Lens 55mm micro-Nikkor
Mag. on film ×0.2 Mag. on page above ×0.4; left ×0.6

Filtering light

Filters alter the nature of light and are used either to give a more realistic color or tonal rendering to the image or to falsify it (see p. 132). A filter is usually attached in front of the lens; by screwing it directly onto the front mounting, inserting it into a lens hood or placing it in a filter holder (see p. 152). For very close-up work it may be preferable to attach a filter to the back of the lens. The cheapest filters, which are made of gelatine, are easily damaged, so they are best used for experimentation before buying a more robust glass filter.

For close-ups, I find a polarizing filter is most useful for color and monochrome work. I use it to remove reflections in non-metallic surfaces – especially glass and water; for removing distracting highlights on shiny fruits and leaves;

and for increasing the color saturation of subjects – especially a blue sky. As the filter is rotated in its mount, the precise effect can be seen by viewing through an SLR camera.

I also always carry a range of blue color-correction filters (10CC, 20CC and 30CC blue) to use when photographing blue flowers. Blue flowers are especially difficult to record accurately on color film, since they reflect some red and infra-red light which our eyes do not detect, but which is recorded as a mauve color on film. A blue CC filter will help to correct this unnatural-looking color, but it will also give a blue cast to any green leaves or grass included in the frame.

Removing reflections
I first took these seaweeds without using any filtration (bottom right). Then I decided to use a polarizing filter to eliminate the distracting skylight reflections on the shiny surface. The picture below left shows the transformation of the dominant serrated wrack. The colors of all the seaweeds and also the honeycomb worm reef are greatly enhanced by using this filter. Before exposing any film, I varied the camera angle many times.
Lens 55mm micro-Nikkor
Mag. on film ×0.16
Mag. on page right ×0.6;
below ×1

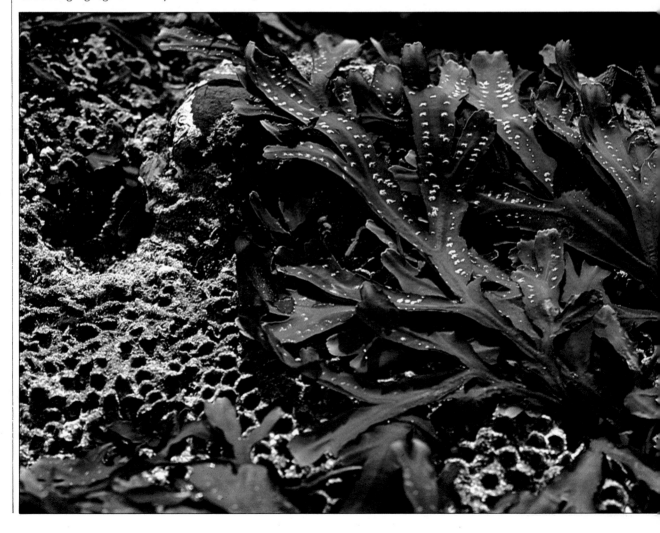

Correcting color
The picture above of a raw egg and parsley shows the strong yellow cast which you get when you use daylight film with tungsten lights. I used the same filmstock, Ektachrome 64 daylight, to take the picture on the left together with an 80B (blue) color conversion filter. This filter, which is designed for use with daylight color films and tungsten lights, increases the color temperature from 3,400°K to 5,500°K, thereby eliminating the yellow cast. I lit the egg using a pair of photofloods each directed through a diffusing screen.
Lens 55mm micro-Nikkor
Mag. on film ×0.3
Mag. on page above ×0.8;
left ×3

Using flash outside

Portable flash units are essential for lighting nocturnal subjects and in dark situations where there is no regular supply of electricity such as inside forests, tunnels, ruins or caves. They are also useful for arresting movement, filling in shadows and isolating a subject against a dark background. Electronic flash guns, although initially more expensive than bulbs, will ultimately prove more economical.

Versatile, portable flash guns permit you to vary the direction and angle of the flash beam and also the duration of the flash. When buying an electronic flash, find out whether it takes rechargable batteries (more economical than disposable batteries) and whether it can be plugged in and charged for studio use.

You will achieve better modeling of the subject by moving the flash off the camera, but if it has only a hot shoe flash connection, an adapter will be needed so that you can insert a flash extension lead. When I use flash for active subjects, I mount it on a hand-held camera support (see p. 158); I can therefore move both towards the subject as a single unit. For stationary subjects I use tripods, lighting stands or simply a wooden stick topped with a ball and socket head and flash shoe connector for positioning flashes remote from the camera.

Determining the correct exposure when using flash with close-ups is not possible with conventional computerized flash guns unless a close-up sensor is attached. If the flash position and magnification are kept constant, the correct exposure can be determined by doing a test run of bracketed exposures. When the flash position is changed, or when multiple flashes are used, a flash meter (see p. 160) is a useful aid. I often use a Polaroid back on my Hasselblad to check the exposure and the position of the shadows. Dedicated flash guns, which link up with the camera electronics, and TTL cameras, which measure the light off the film (OTF) plane, are not designed to be used at distances closer than two feet. However, it is possible to use these systems at close range if the flash is used remote from the camera and, if necessary, the light level is reduced with a neutral density filter.

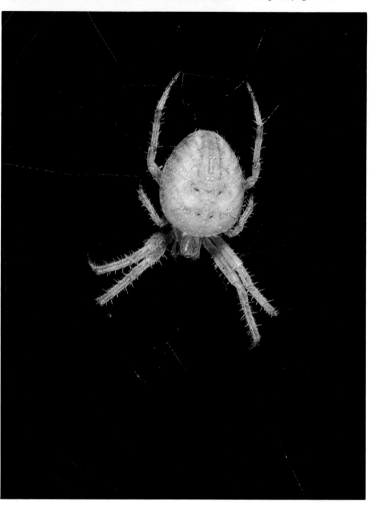

◁ **Lighting a cave**
To take this picture of beadlet sea anemones on a cave wall, I had to wait until the sea level dropped low enough for me to wade through the cave with my camera, tripod, flash and head lamp. I used my head lamp to find the best group of sea anemones and to focus the camera on a tripod. As water constantly dripped down from the cave walls I had to make sure the flash synchronization lead stayed dry. After taking several flash pictures, I prudently retreated before the rising tide cut off the cave entrance.
Lens 55mm micro-Nikkor
Mag. on film ×0.08
Mag. on page ×0.2

A nocturnal light ▷
On a warm night in southern France the light of my head lamp picked out this colorful spider resting in its web. I used a pair of small flash heads mounted on a boomerang flash bracket (see p. 158) to light the spider.
Lens 55mm micro-Nikkor
Mag. on film ×0.5 Mag. on page ×2.5

Sunlit statue ▷
I photographed this lichen-encrusted statue late on a winter's afternoon as the sun was sinking behind the trees. I used two flash heads to light the statue and to synchronize them with the daylight exposure. The available light reading gave me an exposure of 1 sec at f8. I then calculated the distance from the statue for the main Vivitar 285 flash set on one quarter power. This was 15 inches to the right of the statue. I used a Benbo tripod for this flash while my assistant held a second Vivitar 285 (as a fill-in) on a monopod 30 inches to the left (as shown in the set up above). The result was a correctly exposed, well-lit statue and a blue sky.
Lens Hasselblad 150mm + 8mm extension
Mag. on film ×0.2
Mag. on page ×0.7

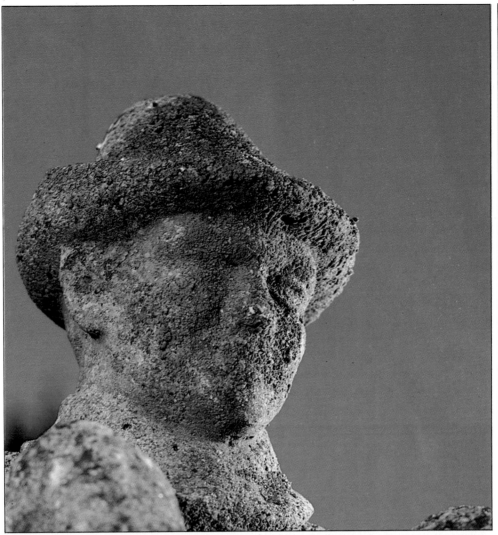

Boosting the light ▷
I used a flash to highlight part of a bicycle reflector so I could stop down the lens and be sure of a sharp picture at a magnification several times greater than life size. The bicycle was propped up against a garage wall and the camera set up on a tripod. I used a small clamp stand to hold a Vivitar 285 flash to one side of the reflector.
Lens Leitz 50mm Photar + 55mm Hasselblad tube
Mag. on film ×2.5
Mag. on page ×10

Using flash inside

Electronic flash is a useful light source for taking many kinds of studio close-ups. It will arrest movement (see p. 96) and boost low light levels so that the aperture can be stopped down to increase the depth of field (see p. 30). Most modern 35mm SLR cameras have focal plane shutters which have to be set at 1/125 or 1/60 seconds (or slower) to ensure flash synchronization. Camera systems – such as the Hasselblad – with between-the-lens shutters, synchronize at any shutter speed. A single direct flash will give harsh shadows unless it is positioned with care, or the shadow areas are softened by using a reflector (see p. 152). Another solution is to use a second fill-in flash, triggered either by connecting each flash to a multiple adapter on the camera (see p. 160) or by using a slave unit (see p. 160) to fire the second and successive flash guns. Some flashes now have built-in slave units. You can still take multi-flash pictures with a single flash, by using the open flash technique, providing the room lights are dim and a slow speed film is used. Keeping the shutter open, fire the flash manually each time it is moved. Dramatic effects can also be achieved by creative use of flash (see p. 136).

Crystallized close-up ▽
Brown sugar crystals were arranged on a piece of clean glass and laid on top of a small table with a central hole. The camera was mounted overhead. Four small flashes at each corner of the table illuminated the sugar from below so that the crystals resembled tiny gold bars. The flashes gave enough light for the lens to be fully stopped down to give crisp images.
Lens Hasselblad 80mm+128mm bellows extension
Mag. on film ×1.5 Mag. on page ×1.8

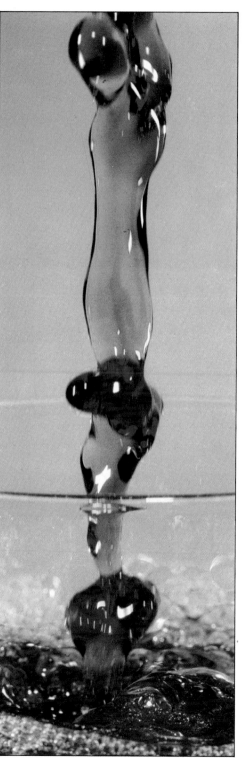

◁ **Stopping the flow**
I set up three flashes – two to light the glass on the table and one to light the backcloth – as shown in the set-up above. Before I exposed any film, I pre-focused the camera on a pencil held upright in the center of the glass. As my assistant poured blackcurrant juice into the glass, I waited until the moving liquid came into focus before taking the picture. The short duration of the flashes (1/25,000th sec) has frozen the moving liquid so that it appears to be a glassy column with encapsulated air bubbles.
Lens Hasselblad 80mm+ 32mm extension
Mag. on film ×0.5
Mag. on page ×2.5

Pet portrait ▷
Although this golden retriever was lying quite contentedly on the floor, I decided to use flash so that it would freeze any possible movement of its head. I arranged two Multiblitz Minilite 200 flash heads on either side of the dog's head so that they lit it indirectly by bouncing off umbrella reflectors. No matter what direction the dog turned its head, these twin flash heads would give naturalistic lighting without any harsh shadows.
Lens Hasselblad 80mm+ 16mm extension
Mag. on film ×0.25
Mag. on page ×1

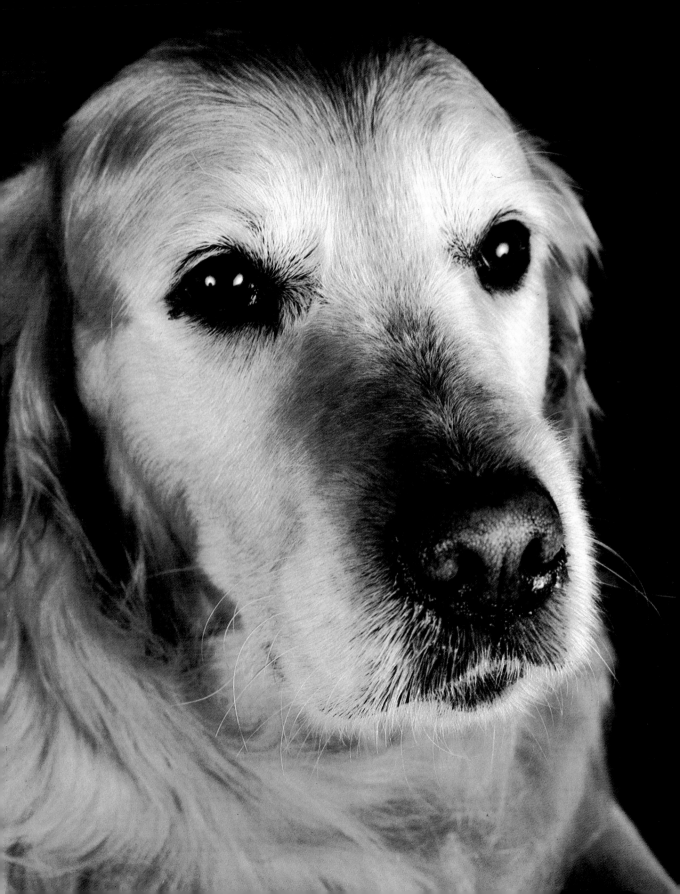

Ring flash

Ring flashes are usually separate flash units designed to fit like a collar around the camera lens. Most models consist of a circular tube covered with a diffusing screen, but one unit, known as a Texturelite, has four separate flashes arranged in a square unit around the lens. It is possible to make your own ring flash by setting up three or four small flash guns on a bracket around the lens.

Ring flashes provide front, shadowless, axial lighting without generating much heat. They are quick and convenient to use, particularly when you require a large number of exposures of similar-sized close-up subjects. Front lighting may be the only way of lighting recessed spaces. This is why their primary use is for medical, dental and scientific photography. Some modeling can be achieved with a ring flash by masking off portions with black paper or tape. I also use a ring flash remote from the lens to produce transmitted lighting by placing it *beneath* an active translucent subject.

There are now many ring flash units available for 35mm SLR camera systems. Larger models for medium format cameras include the Hasselblad ringlight and the Quadmatic Ring- lite, which has a 5-inch internal and a 15-inch external diameter.

A few specialized lenses have their own built-in ring flash (see p. 47) as an integral part of the lens. These lenses, although marketed as medical lenses, can be used for a variety of close-ups. The Medical-Nikkor has an optional data button which, when depressed, auto- matically imprints the magnification on to the film for easy reference.

Macro ringlight SM-2 △
This ring flash has a bayonet mount which connects to the back of the lens when it is mounted on the camera in the reverse position. The flash, which can be powered by either a unit run off electricity (shown above) or one powered by batteries, can be used at full power or at quarter power. There is also a built-in focusing light.

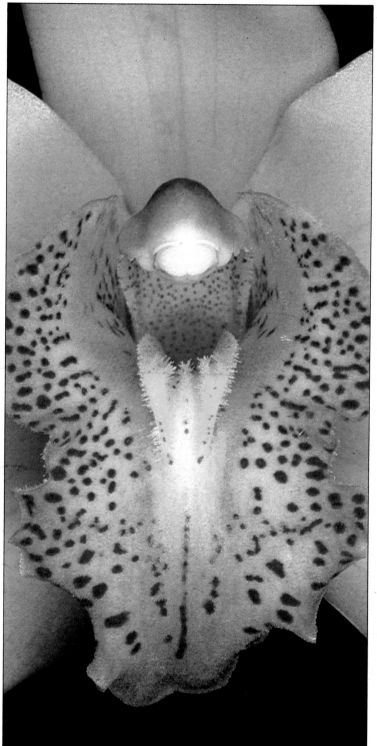

The heart of a flower ▷
Most orchids have deep- throated flowers which are difficult to light when a flash is used remote from the camera. I placed this flower in a vase and secured the stem with a piece of modeling clay pushed into the narrow neck of the vase. I reversed the macro lens on the camera body, before attaching a ring flash to the back of the lens. After viewing the orchid with the built-in modeling light, I decided to mask one part of the ring flash with black paper.
Lens 55mm micro-Nikkor (reversed)
Mag. on film ×0.8
Mag. on page ×4.8

Medical-Nikkor 120mm f4 1F △
This special macro lens has a built-in ring flash. Once
the film speed has been selected, the correct aperture is
automatically set as the lens is focused, since the
diaphragm and focusing ring are coupled.

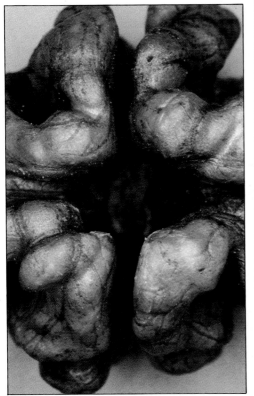

Convoluted kernel △
I placed this walnut kernel in an upright position beneath
the camera by pressing it down onto a small piece of
modeling clay. The camera was roughly focused by
winding it down the support column of the overhead
copying stand, and critically focused by moving it on a
focusing slide. I decided to use a ring flash so that the
recessed parts of the walnut would be illuminated.
Lens 55mm micro-Nikkor (reversed) +27.5mm extension
Mag. on film ×0.75 Mag. on page ×3

Eyeball ▷
I used a medical Nikkor lens with its own built-in ring
flash to light my husband's eye. The back of his head
was well supported in an upright chair. I hand-held the
lens, checking the focus with the built-in modeling light.
Notice the almost circular reflection of the ring flash in
the dark central pupil. I took this picture as a horizontal
format to include the whole eye; only the central portion
is reproduced here.
Lens 120mm Medical-Nikkor
Mag. on film ×0.5 Mag. on page ×5.5

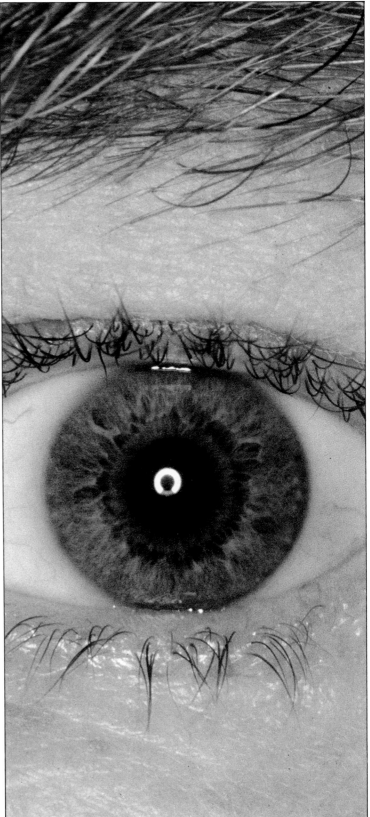

Tungsten lighting

Continuous lighting is useful for studio photography of stationary close-up subjects because the effects of light and shadow can be viewed directly through the camera. Photofloods with large reflectors are not ideal for precise close-up illumination, since they light too large an area. A wide beam can be concentrated by a snoot – a funnel-like attachment for producing a narrow directional beam. Snoots can be made quite simply from an open-ended cone of black paper.

I use a variety of tungsten lights in my studio, not all from photographic suppliers. They include microscopic lamps, each with a variable diaphragm (see p. 156) and a variable light output, anglepoise lamps, tungsten halogen spotlights, household reflector bulbs, photographic light boxes and fiber optics (see p. 52). One disadvantage of using lights not specifically designed for photography is that they may not have the right color temperature to give the correct color balance with color filmstock. For instance, low wattage (40–60W) household bulbs have a much lower color temperature than the studio floods which are balanced for use with tungsten light films. Therefore, unless blue filters (82B and 82C) are placed over the lens, color pictures lit with household bulbs will have a reddish cast.

Powerful tungsten lights give off considerable heat which may result in delicate natural specimens drying out or wilting. Direct heat from such bulbs can be reduced by placing a special heat-absorbing glass filter or a clear glass aquarium filled with water between the light and the subject.

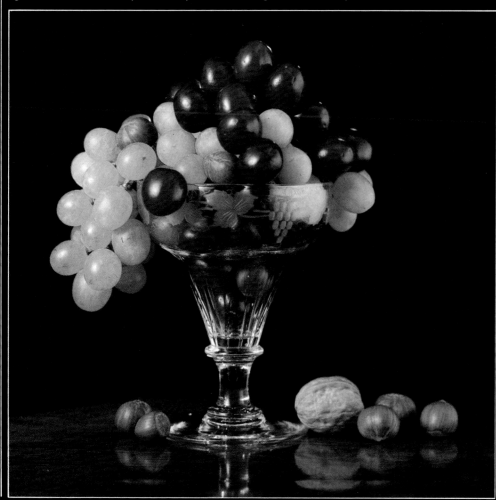

◁ **Still life**
I arranged the fruit, nuts and lighting so that the final effect resembled a painting. The polished top of an antique sewing table was chosen to reflect the base of the glass and the nuts. From the left I directed a pair of tungsten spotlights through a large sheet of tracing paper; this softened the highlights in the fruit. I shone a third spotlight onto a Lastolite reflector (see p. 152) on the right to fill in the shadows, while a single fiber optic gave tiny catchlights to the red cherries, helping to separate them from the black velvet background.
Lens Hasselblad 150mm+ 32mm extension
Mag. on film ×0.25
Mag. on page ×0.6

Watermark ▷
This distinctive bull's-head watermark was present on a sheet of hand-made paper. I placed the paper on a lightbox and took the picture simply by metering the light passing through the paper. A watermark can also be photographed by available light by attaching the paper to a window, or by flash or floodlight by scotch taping the paper to a piece of vertical glass.
Lens Hasselblad 80mm+ 42mm (21+21) extension
Mag. on film ×0.6
Mag. on page ×1

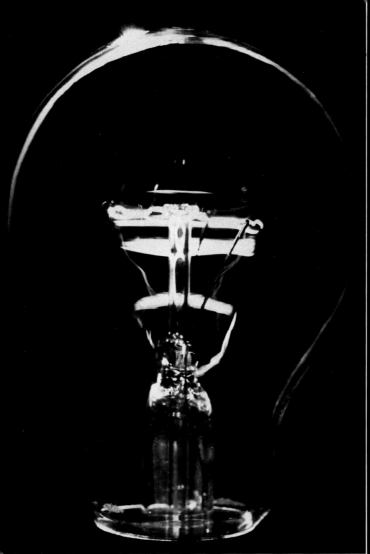

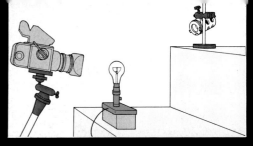

◁ **A glowing bulb**
For this picture of an internal glowing filament, I used a 40-watt electric light bulb, connected to a dimmer switch. The bulb and dimmer were placed in front of a black velvet backcloth and I used a microscope lamp (as in the set-up above) to highlight the outline.
Lens Hasselblad 80mm+37mm (21+16) extension
Mag. on film ×0.5 Mag. on page ×1.6

Bony sutures ▽
A single spotlight covered with a white diffuser was used to light the top of a red deer skull, showing clearly the convoluted junctions of the skull plates.
Lens Hasselblad 80mm+42mm (21+21) extension
Mag. on film ×0.5 Mag. on page ×1

Lighting coins
I took this mint Seychelles coin using axial lighting by shining a microscope spotlight onto a piece of glass at 45°, as shown in the set-up on the right. This molded the relief of the orchid flower design on the coin, which was based on one of my photographs. I eliminated reflections in the glass by using a matte black mask (see p. 124).
Lens Hasselblad 80mm+ 55mm extension
Mag. on film ×0.7
Mag. on page ×2

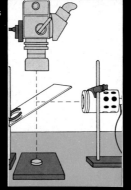

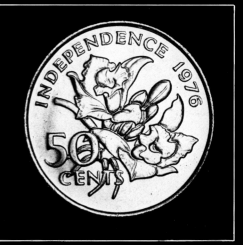

Grazed lighting

Grazed lighting is when a light source is positioned so that the beam strikes the surface of the subject at a very low angle. Low-angled light is particularly effective for revealing details of a textured surface, since it highlights only the raised parts though at the same time casting shadows in all the dips and depressions.

Grazed lighting is ideal for showing the texture of stonework, basketwork, carpets, fabrics, the sculpturing on seashells and the surface relief of rough bark. The resulting effect can sometimes create a double illusion when one moment the hollows are seen as prominences and at the next glance switch back to appearing as hollows.

Depending on the magnification scale selected, the light sources used to create grazed lighting in the studio can be spotlights, flashes or even fiber optics. When working outside, a small electronic flash can provide

grazed lighting for a close-up at any time of the day. Large photoflood reflectors will not be suitable because they do not produce a narrow glancing beam of light.

When using a continuous light source, the effect of altering the angle of light can be appraised quite easily and often only a minor adjustment can make a striking difference. When using a flash, however, appraisal of the effect can be seen only by using a flash with a built-in modeling light or if a flashlight is taped onto the flash.

Low-angled lighting which skims the surface casts shadows on one side of the raised relief. These shadows will be more consistent in size, shape and intensity if the light source is not placed too close to the subject. An aluminum foil reflector or a mirror positioned opposite the light source can help to reduce the contrast by filling in and easing the dark shadow areas.

Pencil points ▷
I bought five packs of colored pencils and arranged them in five rows with the colors in the same order in each row. Scotch tape was used to hold each set of pencils together and also to bind each row slightly out of register with the adjacent one. I then made a cardboard box into which the pencils fitted exactly. With the camera set up on an overhead copying stand, I shone a pair of fiber optics across the tips of the pencil points from opposite sides of the box.
Lens 55mm micro-Nikkor
Mag. on film ×0.5
Mag. on page ×4.8

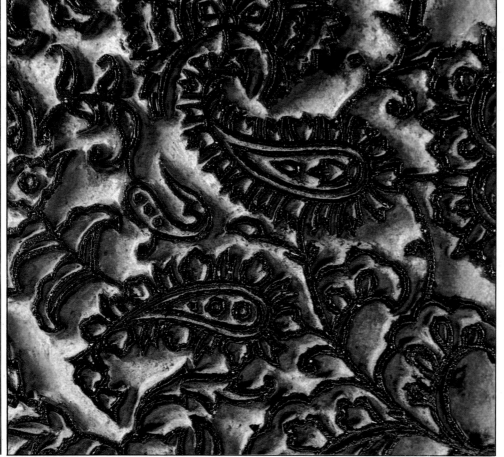

◁ **Fabric block detail**
This is a portion of an Indian silk printing block hand-carved from hardwood. The camera was mounted on a copying stand above the block which was lit by a single spot shining across the carved surface. I wrapped a black paper cone around the light to provide more directional lighting. Wiping the surface with a damp cloth enriched the ink-stained carving so that it contrasted with the dusty background.
Lens Hasselblad 80mm+ 55mm extension
Mag. on film ×0.7
Mag. on page ×1.75

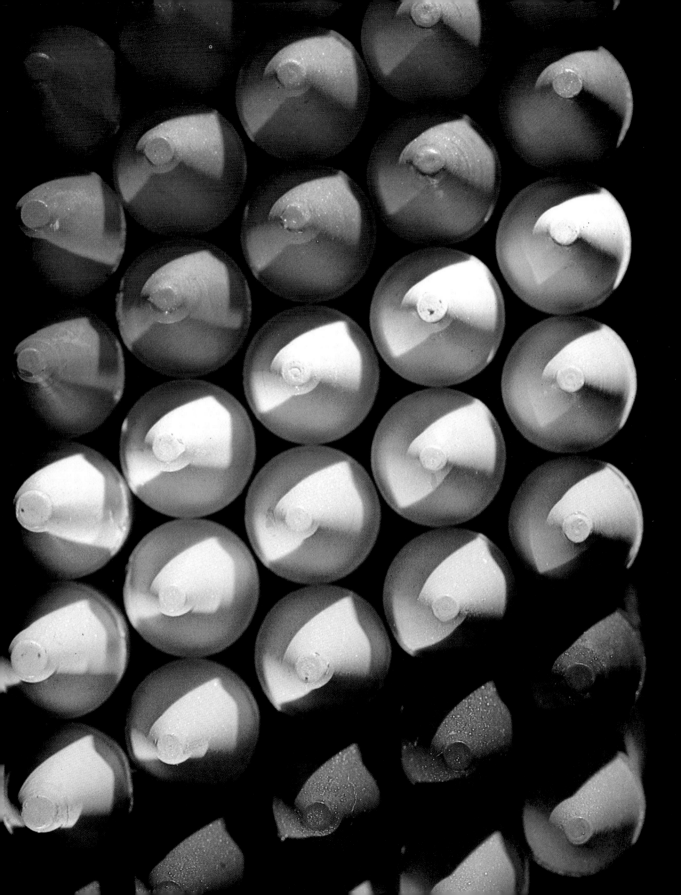

Fiber optics

For many years fiber optics, incorporated in endoscopes, have been used to examine and photograph inaccessible parts of industrial machinery, as well as human organs. Only recently have they become available as a continuous light source for close-up photography. They provide a powerful cold light for precise spotlighting of small static objects. Thousands of fibers are contained within a flexible arm which can be bent so as to strike the object at any angle. Some arms are self-supporting, while others have to be secured in a clamp.

Several fiber optic units are now available, some are much more versatile than others. My own model – an Intralux Volpi – takes a 15-volt, 150-watt projector tungsten halogen lamp, has a variable light intensity control and a powerful cooling fan. When the light intensity is turned up, I can use daylight color film. An optional push-on focusing lens fitted onto the end of each arm provides an even more concentrated and intense light source. The color of the light can be changed by inserting a colored filter between the lamp and the base of the arms. Fiber optic units utilizing flash instead of a continuous light will also be available shortly.

Neat knitting ▽
This is a small part of the repeating border pattern on a Peruvian alpaca wool dress. I tied a pair of fiber optics together so their combined beams shone onto the part of the dress beneath the camera. The alternating bands of white and brown wool made a very striking monochrome photographic print, which is reproduced here as a duotone.
Lens Hasselblad 80mm+ 69mm bellows extension
Mag. on film ×0.85
Mag. on page ×5

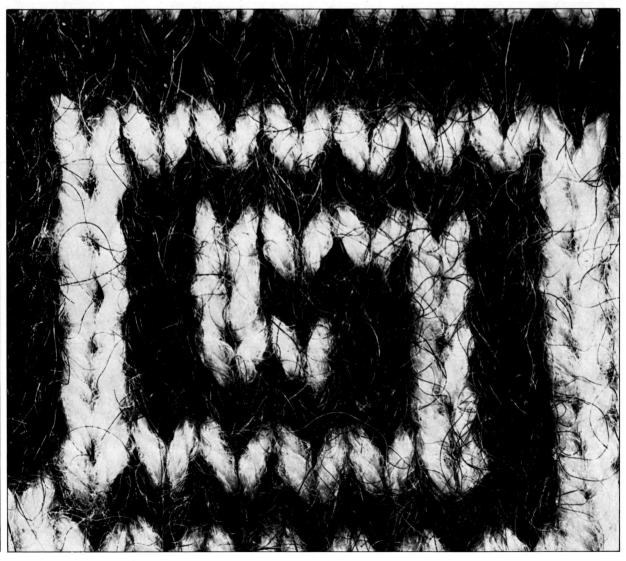

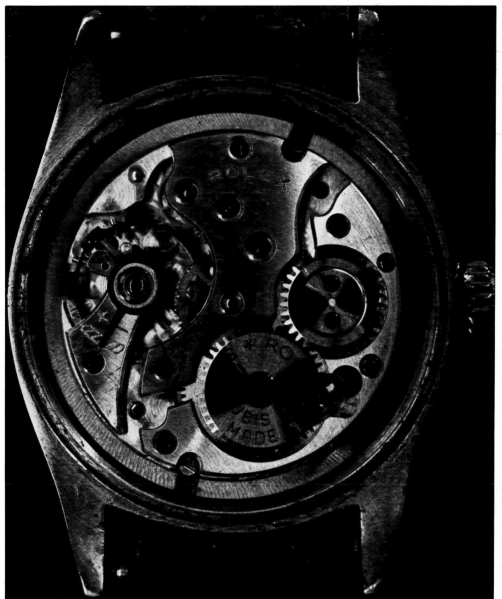

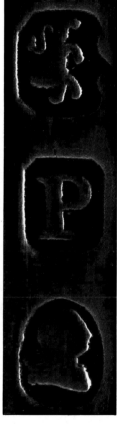

◁ **Watch interior**
This clockwork watch was mounted on a copying stand, laid beneath the camera, and lit using two fiber optics. I viewed it through the camera as I moved the fiber optics around the watch and also altered their highlights by bending gooseneck stems. Finally I settled on placing them opposite each other.
Lens Hasselblad 80mm+ 111mm bellows extension
Mag. on film ×1.12
Mag. on page ×4

◁ **Grazing a fruit**
I found this dried lotus lily fruit in a London florist. The ripe seeds had long since been dispersed, leaving behind the dark unlit holes which were arranged in a striking radial pattern. I decided to light the surface of the fruit by grazing (see p. 50) a single fiber optic across it and I placed a piece of aluminum foil on the side of the fruit opposite to the fiber optic to ease the shadows.
Lens Hasselblad 80mm+ 32mm extension
Mag. on film ×0.4
Mag. on page ×1.2

Highlighting a hallmark △
The hallmark is the official impression of a British assay office. The letter and symbols stamped on gold or silver objects denote the location and date of the assay office. This hallmark was on the reverse of a silver Georgian salt spoon stamped in 1810 in London. I pressed it upside down into modeling clay and placed a collar of tracing paper around the spoon to act as a miniature diffuser for a pair of fiber optics.
Lens Hasselblad 80mm+ 143mm bellows extension
Mag. on film ×2
Mag. on page ×10

Dark field illumination

Dark field illumination is a special kind of transmitted lighting that lights subjects from below so they appear to glow with a brilliant luminosity against a black background. It is ideal for emphasizing hairy or spiny edges as well as finely branched subjects, and for revealing the internal structure of translucent subjects. Continuous tungsten lights can be used in dark field set ups, although electronic flash is essential for active subjects.

The simplest way to set up dark field illumination is to lay a black paper mask with a central hole, having a diameter slightly larger than the subject, on top of a piece of glass. The glass and mask are then raised some six inches above a black velvet background. Either lay the subject directly on the bare glass or, if it is an aquatic organism, place it in a shallow glass dish on the glass. Arrange two or more light sources so that they are directed up toward the subject, but are outside the field of view of the camera. The black mask will screen out all direct light rays passing toward the camera lens, and the subject is lit up by rays which are refracted by it.

As a slight refinement to the set-up described above, I often use a series of small tables, each with different-sized diameter holes. A pair of strip lights secured beneath the table on two opposite sides provides a continuous light source to aid focusing. I make the exposure using two, or sometimes four, small electronic flash guns. When taking photomicrographs (see p. 142), a black circular stop inserted into the back of the condenser gives a dark field illumination.

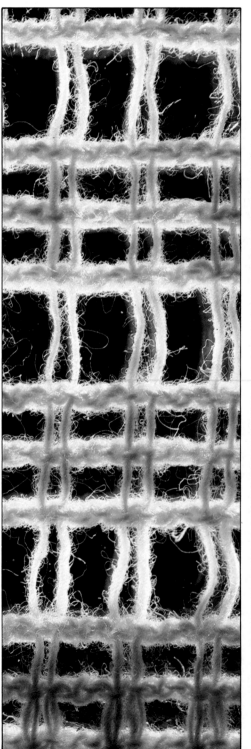

Highlighting an open weave ▷
A loosely woven cloth makes a good subject for photography by dark field illumination because the color intensity of each individual thread becomes highlighted. The pattern of the warps and wefts can also be clearly seen at this magnification. To take this picture I cut a piece of cloth and attached it with scotch tape to a square of glass so the cloth was completely parallel to the film plane in the same set-up as for the young trout.
Lens Hasselblad 80mm+77mm (55+22) extension
Mag. on film ×1
Mag. on page ×4

Revealing the blood vessels ▽
These live young trout, each with their large yellow
yolk-sac, came from a trout hatchery. I filtered the cold
river water into a small petri dish which I placed on a
piece of black velvet over a central hole in a small table,
as shown in the set-up on the right. Two small flashes
placed below the table and angled toward the fish
illuminated their translucent bodies, showing the way a
major red blood vessel branches across the yellow
yolk-sac.
Lens 55mm micro-Nikkor
Mag. on film ×0.75 Mag. on page ×5

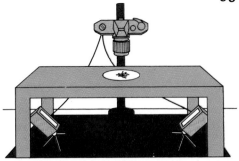

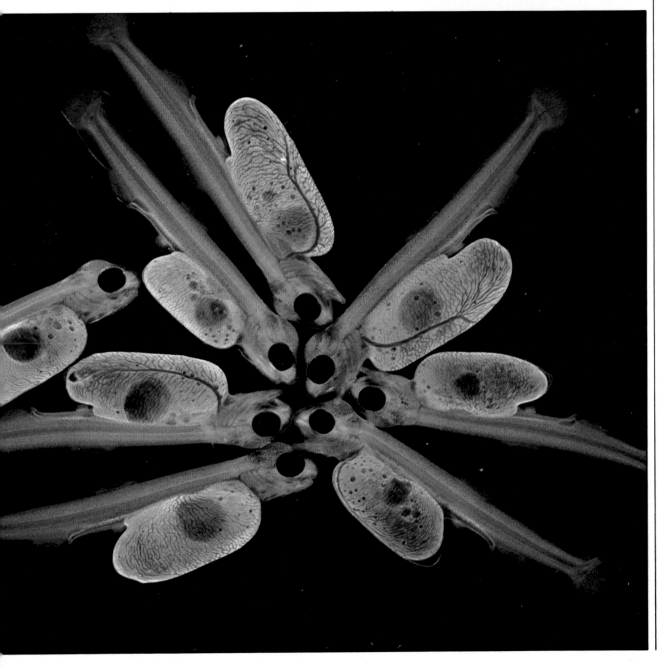

Seeing the unseen

At either end of the visible spectrum used to take conventional black and white or color photographs, images can be made within a band of short ultra-violet (UV) and long infra-red (IR) wavelengths. UV light sources for photography include "black" fluorescent tubes (which emit a weak, visible, purple light), mercury vapor lamps (used by entomologists to attract night-flying moths) and electronic flash. Gemstone suppliers sell portable UV lamps for examining minerals which fluoresce when they are subjected to UV light. These lamps can be used for photographing minerals.

All filmstock is sensitive to UV light, but special black and white and color films have to be used for IR photography; the IR color film records objects in bizarre false colors. These films are so sensitive to fogging by light and heat that they have to be stored in a freezer and after thawing loaded into a camera in complete darkness. Filters used for taking black and white IR photographs may be red (Wratten 25) or black (88A). Since the latter blocks visible light, it is impossible to focus the camera, which must be prefocused on a tripod; even then it will not be precisely focused for long IR wavelengths. With black and white IR films, this problem can be overcome by adjusting the visible focus distance to the IR mark now printed on many modern lenses. But when a Wratten 12 filter is used with IR color film, much visible light reaches the film, so no shift in focus is necessary. Electronic flash (covered with a Wratten 87 filter) can be used as an IR light source for indoor color photography.

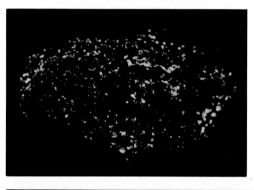

◁ **A fluorescing mineral**
I first took a piece of autonite in visible light (left). Using a yellow filter, I then photographed the mineral in a darkroom as it fluoresced under black ultra-violet lights (below).
Lens Hasselblad 80mm + 32mm extension
Mag. on film ×0.3
Mag. on page ×1

Ultra-violet light pattern ▽
In visible light, an evening primrose appears as a uniform tone (below left), but when photographed in ultra-violet light a dramatic pattern appears (below right). I took this picture using an ultra-violet emitting mercury vapor lamp with a Wood's glass (OX1) filter over the camera lens. This visually black filter cuts out so much light, an exposure increase of 12 stops is required.
Lens Hasselblad 80mm + 0.5 Proxar
Mag. on film ×0.25
Mag. on page ×1

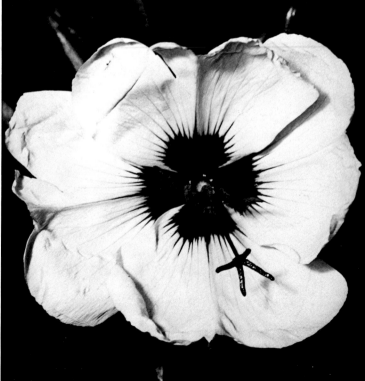

◁ **Fluorescent abstract**
One day when I was looking at minerals beneath an ultra-violet lamp, I noticed that parts of my hands were faintly glowing. Moments before I had mopped up a yellow-colored bubble bath solution which had spilled on the bathroom floor. I poured the remains into a dish to check that it did indeed fluoresce. To take this picture, I bought a new bottle and squirted it in a random pattern onto yellow blotting paper. In visible light it was difficult to separate the yellow bubble bath solution from the paper, but as soon as I placed it beneath the black ultra-violet lights, it glowed brightly against the non-reflective background which appeared black. I used a yellow filter over the camera to take the picture. Several weeks later, the pattern on the paper still fluoresced.
Lens Hasselblad 80mm + 32mm extension
Mag. on film ×0.3
Mag. on page ×2

Creative lighting

Experimentation with a wide variety of light sources other than the conventional photoflood or flash (see p. 136) can produce some imaginative and startling effects. When working with color film, lights can be colored either by filtering the light sources, or by using single or multi-colored filters on the camera. Using a pair of polarized screens – one below and one above the subject – may give unexpected color patterns (see p. 140). More recent light sources available to the photographer include fiber optics (see p. 52) and colored laser beams. When fiber optics are contained inside flexible "gooseneck" arms they can produce dramatic internal lighting as in a skull, for example.

A small spotlight or a fiber optic will selectively light a small portion of a subject in totally unlit surroundings to produce a low key picture.

For color work, you should expose for the lighted area or areas so that the colors are rich and well saturated. High key pictures are ones in which the pale colors and tone predominate and strong colors – especially black – do not exist. This effect, which can be deliberately created by overexposure or by photographing into the light, is generally not suitable for close-up work, whereas low key close-ups can be most effective.

Many aspects of the physics of light such as reflection, refraction, interference, polarization, and the production of additive or subtractive color, can be explored by using mirrors, prisms, filters or liquids of different colors or optical density.

◁ **Abstract fish**
I placed a dimension disk, a circular plastic novelty which reflects rainbow-colored hues from its structured surface, beneath the camera. Using a pair of fiber optics set up as shown above, I spun the disk and used a $\frac{1}{4}$ sec exposure to record the colors flowing into one another. To my surprise, the final image resembled a fish.
Lens Hasselblad 80mm + 37mm (21+16) extension
Mag. on film ×0.4
Mag. on page ×1.2

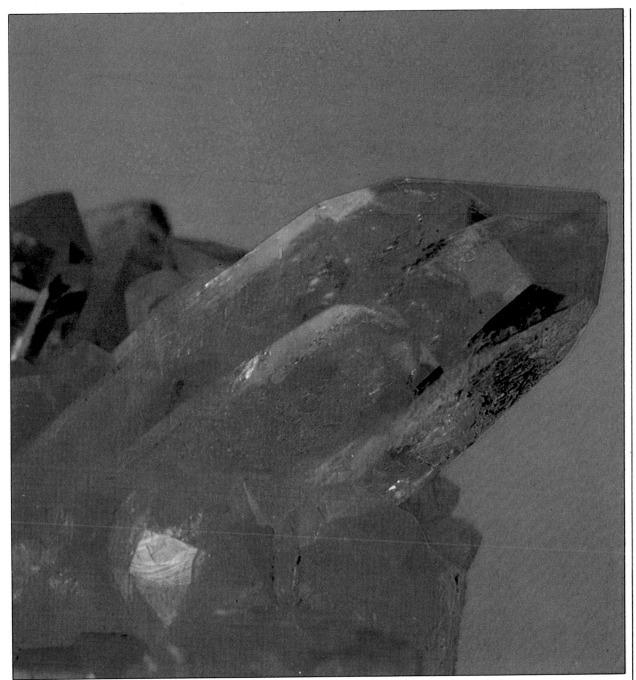

Dramatizing crystal △
I decided to enliven a colorless quartz crystal with a
colored light source. After some experimentation, I placed
the crystal on a circular mirror on a table and lit it with a
small microscope lamp filtered through red gelatin. The
background color was achieved by using a spotlight to
illuminate a green board which was set up at an angle
behind the mirror (see set-up on the right) so that the
green was reflected and recorded in the mirrored surface
behind the crystal.
Lens 55mm micro-Nikkor
Mag. on film ×0.5 Mag. on page ×4

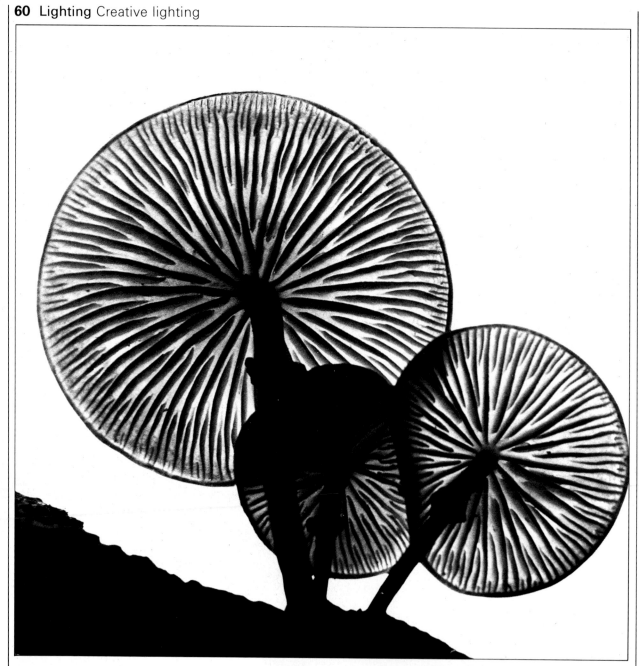

Dramatizing a fungus
The beech tuft fungus typically grows high up on the branches of old beech trees. It can therefore be photographed from ground level only by using a long lens (right). The three fungi above, however, were growing from a fallen branch so I lay on the ground to take this striking, transilluminated picture with the sky as background.
Lens Hasselblad 80mm+42mm (21+21) extension
Mag. on film ×0.5 Mag. on page ×2

CREATIVE
CLOSE-UPS

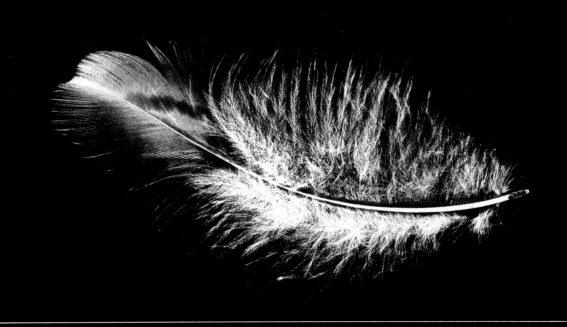

Emphasizing texture

Texture is used to describe the relatively small-scale surface character of objects, and is related to our sense of touch. Hence surfaces are described as being smooth, silky or rough. Texture as a theme links totally different objects through the similar nature of their surfaces. Smooth surfaces are considered textureless and are reflective – though smooth surfaces which appear rough, such as the grain of polished wood, are also described as being textured. Rough textured surfaces are non-reflective and are best shown up by oblique lighting which highlights the raised portions but leaves shadows in the depressions. The 'feel' of a picture in which texture is an important element may be quite different when a long-range picture is compared with a close-up of the same subject. Think, for example, of the contrast between the furrow pattern of a plowed field and the soil in close-up; between a cable-ribbed sweater and the individual stitches; between the ripple marks on a sandy beach and the sand grains.

Magnification plays an important rôle in the appreciation of natural scale and, hence, how we identify things. I have a pair of slides which, apart from their color, look almost identical; yet one was taken with a standard lens and the other with a macro lens. The former shows weathered sandstone and the latter a portion of a decaying oak trunk. Both pictures illustrate how close-ups of texture, with no obvious clue as to the identity of the subject, appear to be abstract designs. This abstraction can be emphasized by unusual lighting or, physically, by dusting with powder, snow or ice.

There is no shortage of subjects for texture close-ups. You can get endless variety from stonework, carvings, brickwork, lace, wire, tapestries, collage, mats, basketry, rope, wallpaper, paintwork, food, and even textured photographic prints. Natural textures are just as abundant and include skin, fur, feathers, shells, scales, bark, fruits, shells and crystals.

Because lighting must be very carefully controlled to emphasize texture, this type of close-up photography is best done in the studio where the lights can be precisely positioned. Grazed lighting, for example, is one way of revealing very fine surface textures in the studio (see page 50).

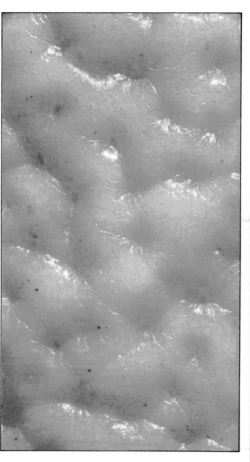

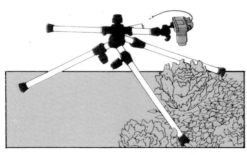

A living texture ▷
I found this exciting image of an ornamental cabbage in the garden of a South American orchid farm. The intricate way in which the wavy-edged leaves radiate from the center, their textured surface enhanced by the late afternoon sun, immediately caught my eye. For this overhead view, I mounted the camera on a tripod directly above the cabbage (as shown in the diagram above).
Lens 55mm micro-Nikkor
Mag. on film ×0.2 Mag. on page ×2

◁ **Sculptured skin**
To take this picture, I sliced a piece of lemon skin and placed it on the base of a copying stand beneath the camera. I positioned a small electronic flash so that the light grazed across the lemon surface, thereby accentuating the pits.
Lens Leitz Photar 25mm
Mag. on film ×4
Mag. on page ×10

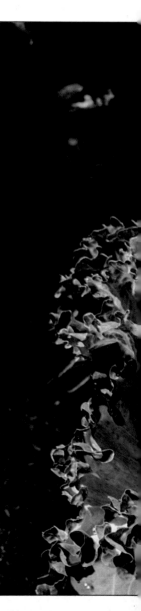

Sculpturing shapes

Careful appraisal of lighting – either by changing the camera viewpoint (see p. 78) with fixed lights or by moving the lights themselves – is essential for conveying a three-dimensional shape in a two-dimensional photograph. Strong side or cross lighting molds shapes by casting shadows, and for minute sculpturing, grazed lighting (see p. 50) is an extreme case of side lighting. Lighting which renders an object as a silhouette, however, flattens it to such an extent that only the outline shape is apparent.

One of the best ways of appreciating the way in which lighting models shapes is to take a simple object such as an egg and place it on a white card. See how the "feel" of the egg changes as you move a single direct light from above to one side, then in front and from behind. Notice also the differences brought about by lighting the egg indirectly, either by bouncing the light off a white reflector or by shining it through a light tent (see p. 153).

You can achieve a feeling of depth by making a shadow picture. Simply place a multi-layered object on a light box so that it is lit from behind.

◁ **Creating a pot**
I decided to reinforce the window light by directing a floodlight in from behind (see set-up above), so that the potter's hands would be highlighted by the back lighting. Even with this additional light, I had to up-rate Tri-X to 1200 ASA so that I did not have to use the lens at the maximum aperture.
Lens Hasselblad 150mm + 1.0 Proxar
Mag. on film ×0.2
Mag. on page ×1

Suckling ▷

For this simple study of a six-week-old baby feeding at her mother's breast, I used the soft window light, with a bedside lamp to fill in the shadows.
Lens Hasselblad 80mm+8mm extension
Mag. on film ×0.2 Mag. on page ×0.6

◁ Solidified lava

This abstract shape is a minute part of a huge lava field on the island of Santiago in the Galapagos Archipelago. The hard equatorial light was ideal for molding the convoluted surface, formed as a result of the molten lava continuing to flow beneath the surface as it cooled down and formed a skin.
Lens Hasselblad 80mm + 0.5 Proxar
Mag. on film ×0.2 Mag. on page ×0.4

Sand and wood ▽

While I was photographing flowers on a sandy shore, my son was dropping sand on a beached tree trunk. As the pale sand filled the crevices, it revealed the sculptured shape of the weathered wood. I used available light for this simple still-life study which was originally taken as a color transparency and then copied onto black and white negative film using a slide copier.
Lens 55mm micro-Nikkor
Mag. on film ×0.25 Mag. on page ×0.75

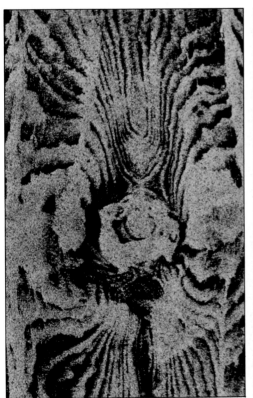

Peeling paint ▷

The low-angled light of a winter's morning accentuated the paint peeling off our garage door. I had to race against time to take the picture before the sun dipped down beneath a high hedge beside the garage. I deliberately off-centered the most interesting part — the circular knot.
Lens 80mm Hasselblad+0.5 Proxar
Mag. on film ×0.4 Mag. on page ×1

Seeing patterns

Patterns and designs exist all around us; within the close-up range they are especially abundant. Regular patterns may be circular, rectilinear, polygonal or simply a repetition of any basic shape or object. Repeating lines, shapes, colors or tones can all produce exciting patterns, notably packing patterns of triangles, polygons or spheres and man-made fabric and textural designs.

Honeycomb, cracked mud, snowflakes, crystals, leaf skeletons, soap bubbles, stone walls and basketry all exhibit a structural pattern; oil on water, swirls of smoke eddies and rippling water are abstract patterns. Symmetrical radial patterns, which are based on the circle, abound in nature especially among flowers, fungi, sea anemones and starfish, and man imitates these shapes in the manufacture of wheels, cogs, plates, bowls and glassware. Totally unrelated subjects can be grouped together simply because of their inherent pattern.

Seeing a pattern is one thing, but creating a worthwhile picture is another. Composition, and hence precise framing, is all important in pattern photography so that flexibility in the choice of magnification will greatly simplify the problems of creating a picture with a compelling design. Consequently the use of a continuously focusing macro lens will be much more convenient than a set of extension tubes. Format shape is also important for recording pattern. A square format works well with radial images, as for example with the pair of peacock feathers or with flat daisy-like flowers. Since the most convenient way to hold a 35mm camera is horizontally, rectangular pictures are most often taken as a landscape format. Other pattern pictures are better fitted to a vertical format. I always use a tripod head which easily turns through 90° so I can quickly assess the best format for the particular pattern.

Artistic creations by man are often based on pattern and design, including the work of primitive man on walls and also in facial decorations. In more recent times fabric designers have repeatedly turned to nature's patterns for their inspiration.

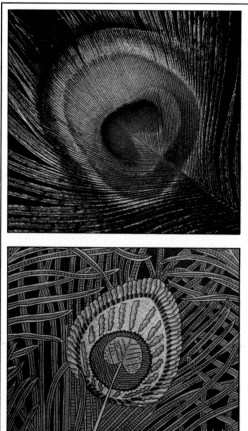

The real thing
Only when the peacock erects his tail fan during the courtship display can the magnificent eyespot pattern be fully appreciated. I took this single eyespot by laying a feather on the velvet-covered baseboard of an overhead copying stand and lighting it with one spotlight so that the iridescent pattern showed to best effect against a black background.
Lens Hasselblad 80mm + 76mm (55+21) extension
Mag. on film ×0.7
Mag. on page ×0.9

Silken design
The eyespot on a peacock feather was the inspiration for this silk scarf design by Liberty's of London, shown here in detail. Before taking this picture, I ironed the scarf and then laid it beneath an overhead camera, lighting it with a pair of spotlights angled downwards at 45°.
Lens Hasselblad 80mm +32mm extension
Mag. on film ×0.4
Mag. on page ×0.5

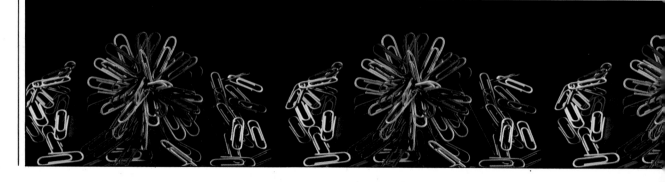

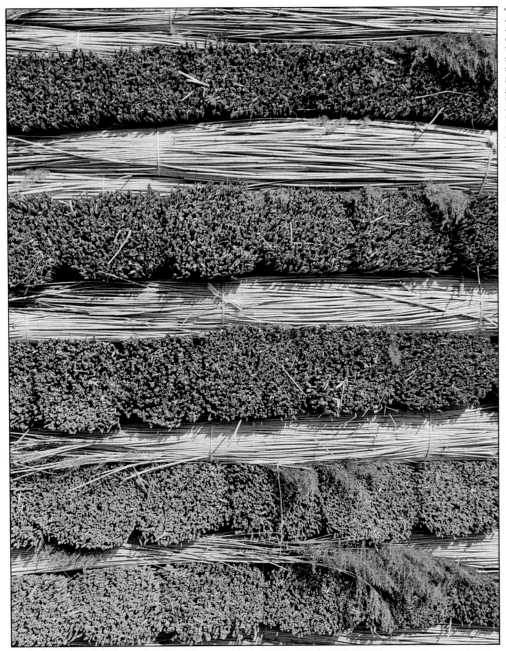

◁ **Stacked reeds**
An ordinary subject such as cut reeds can be completely transformed by the way in which they are stacked. The edge of this stack provides a fascinating pattern created by the juxtaposition of the dry reed bundles which are arranged in such a way that a rectilinear design of the bundle sides alternates with the circular pattern of the bundle ends. I used available light for this picture which was a bonus at the end of a day working in a fenland reserve.
Lens Hasselblad 150mm +21mm extension
Mag. on film ×0.05
Mag. on page ×0.15

A paperclip frieze ▽
I arranged colored paper-clips into a radial pattern on a black magnetic base on a black velvet background. The set-up was lit from both sides with a spotlight and a piece of aluminum foil was used to reflect additional light into the shadows. Only when the film was returned from processing as a continuous strip did I appreciate the intriguing pattern of the repetitive frames which have been reproduced here as a frieze.
Lens 55mm micro-Nikkor
Mag. on film ×0.3
Mag. on page ×0.6

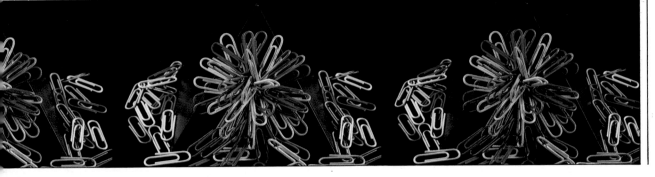

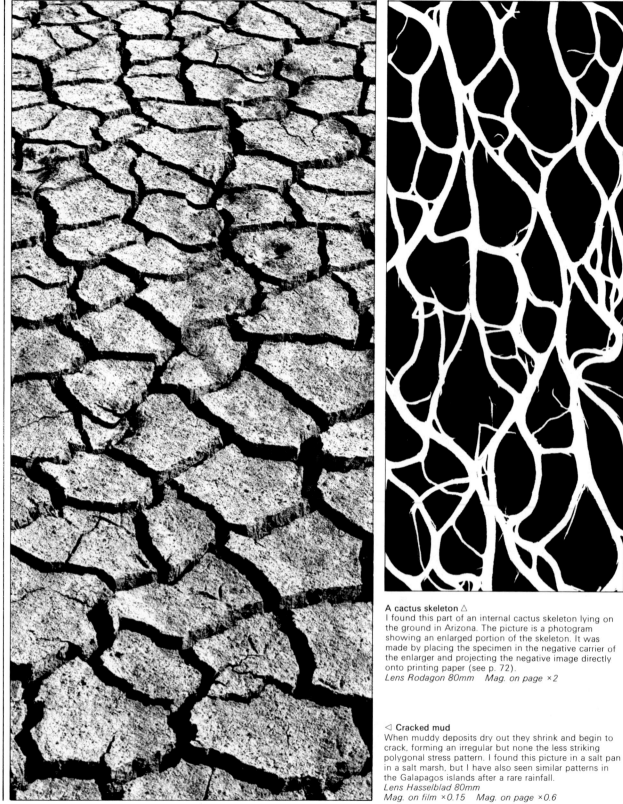

A cactus skeleton △
I found this part of an internal cactus skeleton lying on the ground in Arizona. The picture is a photogram showing an enlarged portion of the skeleton. It was made by placing the specimen in the negative carrier of the enlarger and projecting the negative image directly onto printing paper (see p. 72).
Lens Rodagon 80mm Mag. on page ×2

◁ **Cracked mud**
When muddy deposits dry out they shrink and begin to crack, forming an irregular but none the less striking polygonal stress pattern. I found this picture in a salt pan in a salt marsh, but I have also seen similar patterns in the Galapagos islands after a rare rainfall.
Lens Hasselblad 80mm
Mag. on film ×0.15 Mag. on page ×0.6

Packed seeds ▷
This picture shows only a small part of the spiraling pattern of a sunflower seed head. Each seed is tightly packed between six others, the central dark spot marking the position where the base of the yellow floret was attached. I used a cut seed head for this studio picture illuminated by two small spotlights.
Lens Hasselblad 80mm +92mm (55+21+16) extension
Mag. on film ×1.2
Mag. on page ×7

A foamy layer ▽
I whipped up a concentrated solution of detergent in an electric food mixer, scooped up a teaspoonful of foam and sandwiched it between two sheets of clean glass. The bubbles were lit from beneath the glass by electronic flash because the pattern constantly changed as the bubbles began to burst.
Lens Hasselblad 80mm +76mm (55+21) extension
Mag. on film ×1
Mag. on page ×4

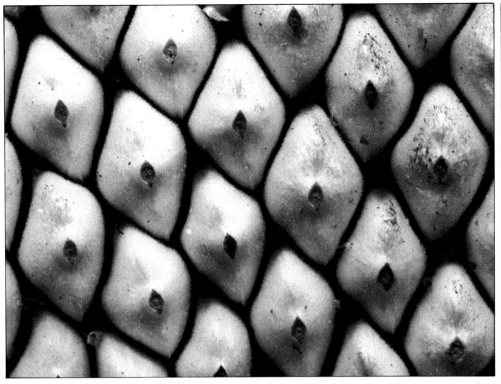

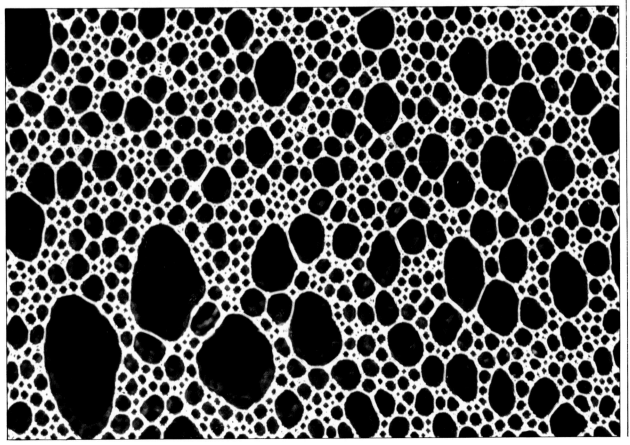

Iridescent sheens

Iridescence is the term used to describe the rainbow-like colors which change as they are viewed at different angles to the light. This phenomenon, which is characteristic of interference colors, appears in everyday objects such as soap bubbles, oily layers and when heat is applied to polished steel or copper. The iridescent hues seen in these objects range through red, blue, copper, gold, bronze, green, blue and violet. The intensity of the colored hues in a soap bubble depends on the thickness of the soap film around the bubble and the angle at which it is viewed. A beam of light is reflected both from the outer and the inner surface of the film. This results in some of the wavelengths being in phase and therefore intensified, and others being out of phase and therefore cancelled out. As the bubble film thins out, so the colors change.

In the natural world, most colorations result from pigments produced by the plants from the uptake of minerals or by animals from their diet. Iridescent colors are produced by physical structures within, for example, feathers or scales, which cause light to diffract. Many animals sport iridescent colors, often as a means of attracting a mate. As a peacock struts in front of a peahen with an erect tail fan, the iridescent eye-spots on the feathers (see p. 66) glisten in the changing light. Other examples of iridescent colors in the animal kingdom can be seen in the male Indian jungle fowl (the ancestor of the domestic chicken), sunbirds, neon and cardinal tetras, dragonfly bodies, various metallic-looking beetles – notably the South American gold chafer – the tropical Morpho butterflies and abalone shells. Most splendid of all are the tiny humming birds or "flying jewels".

Bird feathers and butterfly wing scales will retain their iridescence long after the animal has died, providing the feathers or the scales are not damaged. However, the brilliant iridescent colors of the eye of a living horsefly soon begin to fade after the insect dies.

Photography of iridescent colors admirably illustrates the way in which the direction light strikes a subject can make or mar a close-up.

An oily road ▷
I noticed this strange colored patch on the road and took this stunning picture created simply from oil which had spilt on the road's surface. The picture was taken on an overcast day using a Benbo tripod to support the camera.
Lens Hasselblad 150mm+ 10mm extension
Mag. on film ×0.1
Mag. on page ×0.5

Before the bubble bursts ▽
I mixed glycerine with concentrated household detergent and blew the bubbles onto a piece of glass laid on top of black plastic sheeting. I used four electronic flashes, each directed through a diffusing screen, to capture the rapidly changing interplay of colors on the front face of the bubble.
Lens Hasselblad 80mm+ 172mm (55+56+32+21+ 8) extension
Mag. on film ×2.5
Mag. on page ×18

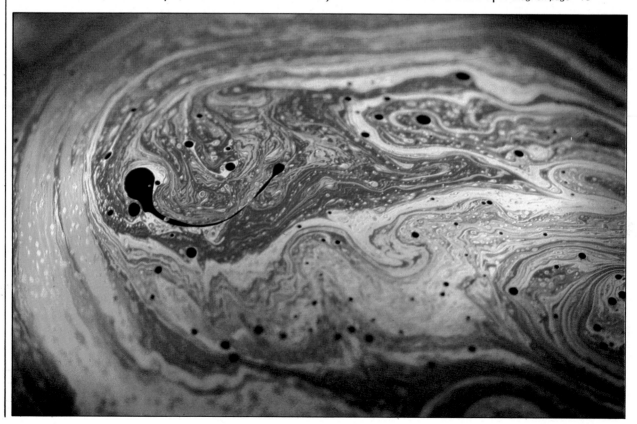

ings. A photogram is simply an image made without a camera by placing one or more objects in contact with light sensitive paper and exposing a point source of light onto it. After the paper has been processed, the image appears as a silhouette in reverse because all solid parts block light and so appear white, while any transparent and translucent parts appear black or as various shades of gray, depending on how much light passes through and fogs the paper.

If you have a darkroom, the easiest way to make a photogram is to use printing paper with the enlarger lamp as the light source and then develop and fix the paper in the normal way. You will achieve best results – particularly with three-dimensional subjects – by stopping down the enlarger lens. When the light source is placed directly above the subject it will be precisely reproduced in a life-size outline, but if the light is moved to one side, or more than one light is used, or if the subject is raised up above the paper on a sheet of glass so the paper can be bent during the exposure, distorted images will result. Graphic images can be derived from photograms by using darkroom techniques such as copying on to negative film and solarization (see p. 138). Larger-than-life-size photograms can be made of small, finely branched or translucent subjects, such as leaves and feathers, by placing them on glass in the negative carrier. If color print paper such as Cibachrome is used, some exciting color photograms can be achieved.

◁ Cut glass
I laid a crystal sherry glass on its side on a sheet of printing paper beneath the enlarger as shown in the set-up above. The faceted glass bent the light rays from the enlarger to produce this range of tones.
Mag. on print ×1
Mag. on page ×1

Nylon net ▷
I created this abstract of colored nylon net by folding strips of red and green net at random between two sheets of glass which I bound together with scotch tape. In the dark room, I laid this glass sandwich on top of Cibachrome paper and exposed it for 25 sec. with the enlarger stopped down to f22.
Mag. on print ×1
Mag. on page ×1

◁ An umbel
I picked up this fennel head umbel and immediately laid it on black and white printing paper beneath the enlarger. I then made a photogram print before the tiny flowers began to wilt.
Mag. on print ×1
Mag. on page ×0.5

Leaf mosaic ▷
I placed a spray of Japanese maple leaves on print paper beneath the enlarger. The photogram shows the relative position of each palmate leaf in this distinctive leaf mosaic. Note how only the base of the leaves overlap each other.
Mag. on print ×1
Mag. on page ×0.3

Abstract forms

A photographer who has a "seeing eye" will find that abstract shapes and forms exist at all magnifications. Familiar objects viewed beneath rippling water or in a curved reflective surface (see p. 80) become abstract shapes. The interplay of light and shadow often provides simple but effective abstractions, especially in monochrome. By taking a subject and recording a portion of the whole, the identity becomes obscured, resulting in either a regular pattern or an abstract. Such images also occur when quite simple units are artificially grouped together by the photographer.

Long before photographers began to experiment with abstracts, artists had created abstract paintings. Techniques used to create deliberately photographic abstract images include defocusing the image, placing a prism in front of the lens, exposing or printing through a screen (see p. 130) and placing the subject between two polarizing screens (see p. 140). A blurred impression of movement can be produced either by moving the subject or the camera, or by changing the focus with a macro-zoom or a close-up zoom lens during a long exposure.

◁ **Sand ripples**
Walking up a sandy beach late one day, I turned into the light of the sinking sun to take my last glimpse of the sea and I saw this intriguing abstract which was made by the rippling waves in the sand. By photographing against the low-angled light, I recorded the raised parts of the sand ripples as highlighted patches. These contrast strongly with the shadowy water-filled hollows.
Lens Hasselblad 80mm + 1.0 Proxar
Mag. on film ×0.2
Mag. on page ×0.3

◁ **Sectioned sandstone**
For me this section of a sandstone block suggests a succession of receding hills in a landscape. I took the picture indoors beside a large window so as to make use of indirect available light.
Lens 80mm Hasselblad+32mm extension
Mag. on film ×0.3 Mag. on page ×1

Watery highlights △
I took this picture of highlights on water by defocusing the camera. Each highlight has taken on the pentagonal shape of the lens diaphragm, and in some the blades of the compur shutter are visible.
Lens 80mm Hasselblad+10mm extension
Mag. on film ×0.1 Mag. on page ×0.5

Rim-lit viewer ▷
I had the idea for this
picture when I saw my son
watching television with a
light behind him. I replaced
the light with a flash and
turned off all other lights in
the room to produce this
rim-lit profile of an intent
viewer.
*Lens 80mm Hasselblad+
0.5 Proxar
Mag. on film ×0.15
Mag. on page ×1.75*

Colorful mosaic ▷

While setting up my camera on a tripod above colored fiber optic Christmas tree lights I saw this picture. Each tiny pin-point of light has become magnified into a much larger colored highlight, so that it overlaps with neighboring ones to make an attractive mosaic. This picture was one of a series I took, keeping the magnification constant and varying the focus. Defocusing the lens still more produced even larger colored spots, which became reduced in size as I refocused the lens. Stopping down the lens to a smaller aperture also decreases the size of the highlights.

Lens 80mm Hasselblad+ 92mm (55+21+16) extension
Mag. on film ×1.2
Mag. on page ×7

THE
HUMAN IMPACT

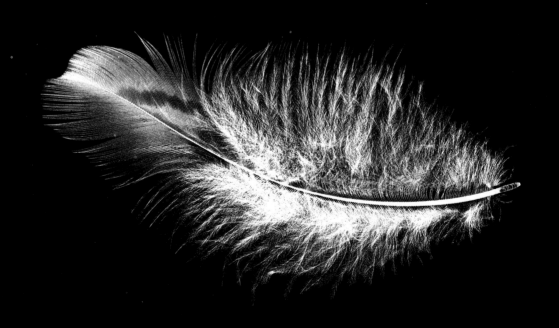

Choosing the viewpoint

The mood and impact of a picture can be completely altered by slightly changing the camera viewpoint up or down or from side to side. It is so easy to slip into the routine of using conventional viewpoints; yet a minor alteration may totally change the effect of the picture on the viewer. When photographing a baby's head, most people concentrate on the face – either from the front or in profile. In later years as the child matures, however, you may wish to record other features such as the shape of the ears, the curve of the jaw-line or even the back of the head.

It is surprising how often the viewpoint is governed by the type of viewfinder; for example, if you use a waist-level viewfinder, a lower viewpoint is more often selected than if the camera has a pentaprism and can therefore easily be held and focused at eye level. If you do not use a versatile camera support, such as a Benbo tripod or a Combistat (see p. 151), low or unusual viewpoints with rigid support of the camera may be impossible and so good pictorial opportunities missed. Rigid camera supports can also be useful for taking close-up photographs by remote control of molten metal or glass, which would otherwise be dangerous to work so close to.

Most often, I decide on the viewpoint as soon as I see the subject, but if I am at all undecided, I walk around it, crouch, lie, or climb on a chair, a ladder or on top of the automobile so I can view the subject from different angles. Even if the viewpoint seems right for the subject, it may be necessary to modify it slightly if the background is confusing (see p. 32).

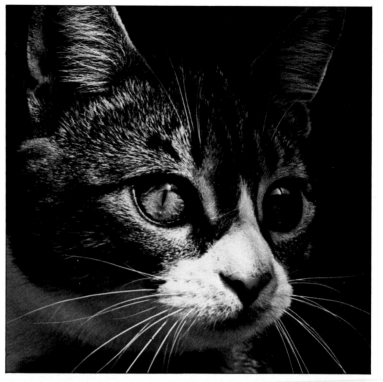

A low profile ▷
Intrigued by the regimental rows of tuning pins and their parallel wires inside a clavichord, I positioned the camera level with them. I moved lights around the room before deciding to use the ceiling light, and an anglepoise lamp through a diffuser on the right side of the clavichord (as shown in the set-up on the left). Aluminum foil on the back of the clavichord acted as a reflector.
*Lens Hasselblad 150mm+ 87mm (55+32) extension
Mag. on film ×0.5
Mag. on page ×2*

View from behind △
As hair begins to grow on a baby's head, a spiral growth pattern is clearly visible. I took this picture of the back of a 14-week-old baby as he lay on his mother's lap beside a large window.
Lens Hasselblad 80mm+32mm extension
Mag. on film ×0.35 Mag. on page ×0.8

◁ A mouse's-eye view
I lay on the floor to take this picture of a cat's head. To obliterate a cluttered background, I hung a piece of black velvet behind the cat. Direct sunlight helped to highlight the white whiskers against the dark background. Notice how the windows are reflected in the enlarged iris of each eye.
Lens Hasselblad 80mm+1.0 Proxar
Mag. on film ×0.2 Mag. on page ×0.9

Seen from the side ▷
I took this picture of a 20mm drill cutting into mild steel in an industrial workshop. Before the action started, I focused the camera on the side of the drill. The high speed of the drill dictated the use of electronic flash to freeze the moment when the spiraling swarf of metal reached the side of the drill.
Lens Hasselblad 150mm+32mm extension
Mag. on film ×0.2 Mag. on page ×2

Reflections

The problem when photographing shiny surfaces is how best to suppress unwanted reflections – by using indirect lighting, a dulling spray, or a polarizing filter. However, reflections *can* be used to make exciting close-ups. Polished automobile hub caps can provide creative reflected images. An animal will sometimes react curiously to its own reflection. I have seen a small bird aggressively attacking its reflection in an automobile mirror, believing it to be an intruder invading his territory. In the street, look out for the reflections of leaves, feathers or even garbage in puddles. Most photographers have taken beautiful pictures of a view mirrored in a still lake or pool, too few see exquisite miniatures created by a tiny plant or stick reflected in the water's surface. In the studio, water, mirrors or shiny metal can be used for photographing reflected subjects. The reflections can be distorted by making ripples on water, by using convex or concave mirrors, curvaceous glassware, or metal sheets that can be flexed into S-shapes.

A pair of mirrors, set up parallel to each other on either side of the subject, will produce repetitive reflections. The basis of a toy kaleidoscope is a triangular tube of mirrors which repeats images of colored fragments to produce exquisite repetitive patterns. You can make your own kaleidoscope by using a pair of front-silvered mirrors. Normal mirrors are silvered on the back, so they reflect from both the front and the back surface, creating a double image. The front-silvered mirrors are taped together so that they form a V-shaped trough. Changing the angle of the mirrors alters the number of reflective images; for example, six repetitive images are produced with an angle of 60°. The object is placed at one end of the glass trough and photographed with the camera looking at it from the other to achieve a symmetrical pattern.

Distorted self-portrait ▽
I used a polished electric kettle to reflect me with my camera for this bizarre portrait. The kettle was placed on the ground and I lay prone to take this hand-held picture by natural light. Although I held the 55mm macro lens just a few inches away from the kettle, its convex surface has produced a wide-angle-lens effect so that my arms and head as well as the sky and trees in the background are included. The extraordinary distortion has compressed my head and yet extended the grass and the lower half of the lens.
Lens 55mm micro-Nikkor
Mag. on film ×0.3
Mag. on page ×1.5

Perpetuating the image △
I used two unframed mirrors to take this picture of a
faceted glass paperweight and two glasses. The mirrors
were clamped vertically so that they were parallel to each
other and therefore reflected the glassware from one face
to the other, making each successive image progressively
smaller.
Lens Hasselblad 80mm+1.0 Proxar
Mag. on film ×0.15 Mag. on page ×0.6

Lighting glass

Glass is not an easy material to illuminate since it both reflects and refracts light. Clear glass can be photographed either against a white background so that the outline is silhouetted, or against a black background so that it is outlined in white. If clear glassware is lit directly it will reflect any nearby object. Professional studios light glass indirectly by placing the glass on a curved light table made from a single sheet of Plexiglass which is flexible, white and opaque. The lights are then shone either from beneath the glassware or behind it. A cheaper version of this set-up can be made by using a piece of glass and a large sheet of translucent acetate sheeting as shown in the diagram on this page.

A black background has to be placed well behind the glass to allow space for the light sources to be angled in at 45°. White card placed on each side in front of the glass will emphasize the white outline. A technique used to display cut and engraved glassware in department stores can also be used for photography. The glass is lit from below by positioning it over holes in a shelf which is covered with black velvet. Engraved glass can also be lit by "painting" with light. This involves moving a continuous light source up and down during a long exposure. Surroundings can be deliberately reflected in a smooth wide-based brandy glass by lining the glass with black paper. When using color film to photograph clear glass, you can create additional interest by means of colored lights, colored liquid, or an object such as a flower (see p. 14). The full impact of colored glass is gained only when it is lit from behind so that it glows.

Highlighting hop flowers ▽
I took this glass beer mug etched with hop flowers by grazing a single fiber optic down from the top of the mug.
Lens Hasselblad 80mm+32mm extension
Mag. on film ×0.5 Mag. on page ×1.5

◁ **Effective perspective**
I supported a piece of glass measuring 12 inches square on two supports, making sure they did not appear in the field of view. Then I arranged a large sheet of white translucent acetate paper so that it lay flush on the glass. By bending it through a gentle curve, it formed a continuous backcloth.
I then placed four liqueur glasses in a row on the center horizontal part of the sheet. A single Multiblitz Minilite 200, with a diffusing screen, was attached to a baby Benbo tripod as shown in the set-up above, so that it illuminated the glasses from behind. In this way the dark outline of the glasses stands out clearly against the white background. So much light was reaching the film that even when the lens was fully stopped down, I had to use a neutral density filter to get the correct exposure.
Lens Hasselblad 80mm+ 21mm extension
Mag. on film ×0.25
Mag. on page ×1.25

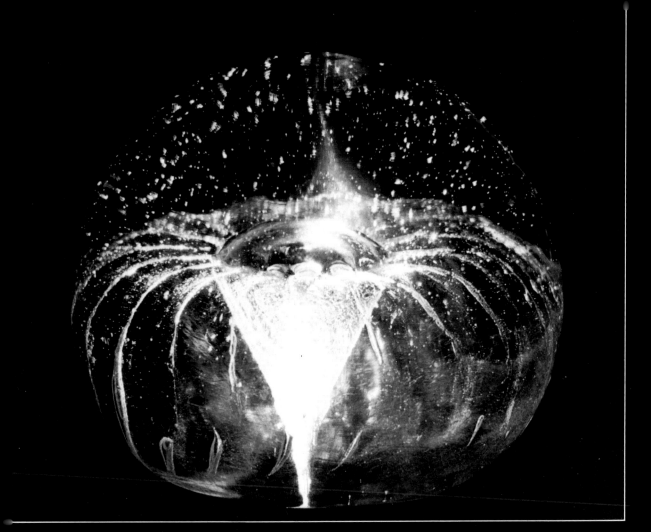

Bottom lighting △
I raised this glass
paperweight on a photo
rack (see p. 152) so I
could position a fiber optic
beneath it. I inserted a
piece of black velvet with a
hole cut out for the light to
pass through between the
paperweight and the light
source. This provided a
dramatic backcloth.
Lens Hasselblad 80mm+
16mm extension
Mag. on film ×0.3
Mag. on page ×2

Patterned glass ▷
Pictures of patterned glass,
which is textured to
obscure vision, can be
made quite simply by
means of a photogram (see
p. 72). I placed a piece of
printing paper beneath a
glass with a daisy pattern
and exposed it with the
enlarger lamp.
Mag. on print ×1
Mag. on page ×0.65

Facial features

At all ages, the human face provides a rich source for variable close-ups. With a standard lens and extension tubes, the subject-to-camera distance is too short for taking candid facial features. Use a long-focus lens with extension or a medium (90mm or 105mm) macro lens to increase the working distance and to gain a better perspective without any distortions.

For outdoor portraits, assess the natural lighting and, if necessary, control it with diffusers or reflectors (see p. 152). Direct sunlight creates harsh shadows which may dramatize some faces; otherwise use flash to balance it (see p. 42) and to eliminate distracting shadows. Indoors, both the lighting and the background can be selected to enhance a posed face. Window light can often provide a simple, natural light source. If you are using continuous light sources, move them around the subject to see the way the light and shadow areas change – even a silhouette can make an effective profile. When using flash, be sure to move it away from the lens, otherwise you may find the pupils appear red. So-called "red eye" occurs when the iris is wide open in dim light and the subject is looking directly into the camera so that the flash illuminates the retina at the back of the eye.

Improvized lighting ▽
I had to double-rate 50 ASA tungsten light color film to photograph this old lady in her small living room. I used a reading light and a Lastolite reflector on either side of her face and a bedside lamp to back light her hair.
Lens Hasselblad 150mm+8mm tube
Mag. on film ×0.15 Mag. on page ×0.2

Concentration ▷
I photographed my son with the sun behind him so that his ear was enhanced by the back lighting.
Lens Hasselblad 150mm+8mm extension
Mag. on film ×0.1 Mag. on page ×0.6

Clowning expressions
Matto the clown can rapidly change the expression on his face. I took these three pictures during a session in which I maintained a regular rhythm as I wound on the film and released the shutter. Matto changed his face as I was winding on to take the next shot, therefore each expression was held only briefly. The face was lit by natural light, and a reflector filled in the shadows.
Lens Hasselblad 150mm +8mm tube
Mag. on film ×0.1
Mag. on page above ×0.6; left ×0.25

Arts and crafts

Art and crafts fairs help to revive interest in some of the old country crafts. Indeed, these fairs are good places at which to meet craftsmen and to view their finished crafts. In our modern automated society, it is refreshing to find that there are still craftsmen who delight in using their hands to create beautiful or useful objects from natural materials.

Close-up photography is ideal for illustrating the intricacies of lace, stained glass, calligraphy and etching, and delicate gold and silver objects. Another approach for recording arts and crafts is to take a series of pictures illustrating craftsmen's hands at work. Only when you see the deftness of a basket maker's hands do you appreciate the complex manipulations required to create a basket. When the hands are moving very fast, or the available light level is low, the light will have to be boosted either by using photofloods or multiple flash heads. I find it preferable to watch a craftsman at work before I decide on the viewpoint and lighting. I may even make a preliminary visit before a photographic session to check out the available lighting and position of the electric outlets.

Tying a fly ▷
I used a pair of electronic flashes — one directed in from behind the right hand and another filling in from the front left — for this close-up of a fly fisherman tying a fly.
Lens Hasselblad 250mm+56mm extension
Mag. on film ×0.2 Mag. on page ×2

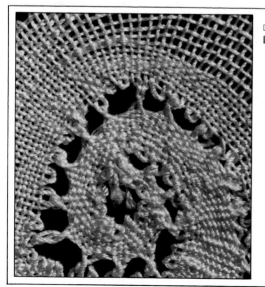

Lighting lace
Lace, like embroidery, is best lit using a single directional light source placed at 45° above the work (as shown on the left). This angled lighting — either with a spotlight or a flash — clearly picks out the individual stitches. A dark gray background is best for photographing white lace; shadows can be seen on a white background, while a black background will not clearly define the lace edge. Silver or gold threads must be lit separately by shining a second light onto a white reflector encircling the camera lens.
Lens Hasselblad 80mm+ 55mm extension
Mag. on film ×0.7
Mag. on page ×5

Highlighting hands ▷
I used two portable
floodlights to boost the
light on the basket maker's
agile hands.
*Lens Hasselblad 150mm+
1.0 Proxar*
Mag. on film ×0.2
Mag. on page ×0.3

◁ **Corn dolly**
I placed an English corn
dolly on a sheet of glass
above a white board
background. A piece of
aluminum foil bounced the
flash back onto the side of
the dolly opposite to the
flash so that it appears
evenly lit against a
shadowless background —
the shadow falls outside
the field of view.
*Lens Hasselblad 80mm+
21mm extension*
Mag. on film ×0.3
Mag. on page ×0.5

Setting off jewelry

Inspiration for setting off and lighting jewelry may be gleaned by looking at jewelry advertizements in magazines. But there can be no substitute for examining a piece by holding and rotating it beneath different light sources. While black, blue or even red velvet is often used by jewelers to display ivory, gold and silver, it is not an imaginative background for photography. The best natural backcloths for single pieces of jewelry are clothes or simply fabrics and, of course, bare skin. Other backgrounds include wood, cork, coal, crystalline rock and coral for pearls. If transparent gemstones are placed on a colored background, a small piece of white paper attached to the back of the stone prevents the colored background shining through.

As with crystalline rocks (see p. 116), direct lighting of faceted stones may cause problems if light is reflected back towards the camera. Although indirect lighting with a diffuser (see p. 152) between the light source and the subject or, with a light tent (see p. 152) around the subject, will eliminate reflections, gems will inevitably lose some of their natural sparkle. Gold and silver items can also be photographed inside a light tent or by indirect lighting by shining light sources on to a reflector encircling the camera lens. For gold objects, the reflector should be covered with gold-colored rather than aluminum foil.

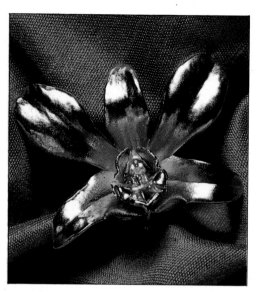

Enhancing a cameo ▷
This brooch has been carved out of a cameo shell, so I used such a shell to offset the brooch. I wanted only the cameo to be sharp, so I separated the two with matchsticks, wedged into modeling clay, as shown above.
Lens Hasselblad 80mm + 55mm extension
Mag. on film ×0.75
Mag. on page ×4

Lighting gold △
A Multiblitz Minilite 200 flash fitted with the light box diffuser gave soft, even lighting for this brooch made from a real orchid coated in gold.
Lens Hasselblad 80mm + 32mm extension
Mag. on film ×0.5 Mag. on page ×0.6

Highlighting opals ▽
Natural sunlight brought out the iridescent colors of the opals in this bracelet. I wedged it into deep folds of material (see right) to hide the wristband.
Lens 55mm micro-Nikkor
Mag. on film ×0.4 Mag. on page ×3

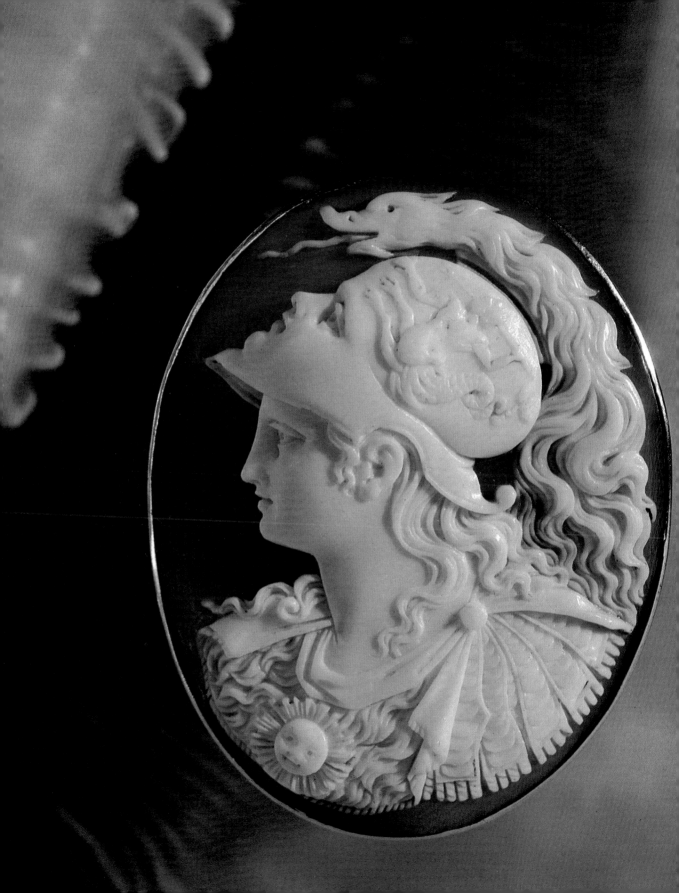

Abstracting the familiar

We recognize familar objects by their shape, color and context. Abstracting one characteristic and suppressing the others can create images that are often quite difficult to identify. Close-up photography, by enlarging an object or by illustrating a small portion, can produce effective abstractions, especially if it is combined with techniques which emphasize shape or color. Once part of the object is abstracted and the scale no longer known, it becomes difficult, if not impossible, to relate it back to the object as our eyes normally see it.

Abstraction can be achieved by blurring or defocusing the image (see p. 76), or by creative lighting (see pp. 58 and 140). All the pictures on these pages, however, are photographs of everyday household objects. By getting in close and omitting any other objects to give a scale, the ordinary object becomes extra-ordinary. In each of the pictures, quite simple lighting was used, but both this and the magnification scale were carefully thought out so as to produce the desired effect.

It is almost impossible to teach anyone how to photograph abstracts, since it is something you, as a photographer, either see immediately by some innate sense or else are totally blind to. There are some photographers, like artists, who become so infatuated with abstraction that they are unable to see and take a picture unless it appears as an abstract.

Series of abstract close-ups can be achieved by working with distinct themes. These can include water, lines, circles or a single predominate color. Darkroom manipulation, using techniques such as solarization and reticulation, is another way of abstracting familiar objects (see p. 138).

◁ **Snap fastener profile**
I separated a snap into two parts. I laid one on a piece of glass which was held in a clamp stand above a table covered with white board. A direct light source had reflected the snap in the glass; I therefore used a pair of Multiblitz Minilite 200 flashes pointing away from the glass. The light from each one bounced off a white umbrella and onto the glass at an angle of 45°. The camera was set up at a low angle so as to get the snap in profile.
Lens Hasselblad 80mm+103mm (55+32+16) extension
Mag. on film ×1.6 Mag. on page ×5

Perforations △
I used a block of four postage stamps for this greatly enlarged picture showing the surprisingly ragged edges of the perforations which border each stamp. I used scotch tape to stick the edges of the stamps onto a piece of glass so the block was completely flat. The glass was laid on top of a small table with a circular central hole, so that the stamps could be lit by dark field illumination as shown in the set-up on p. 55.
Lens Leitz Photar 25mm
Mag. on film ×4 Mag. on page ×17

Clothespins ▷
I cut a piece of cardboard
and clamped wooden
clothespins alternately on
opposite sides of it. In this
way I created an abstract
design of five pins, showing
part of the metal spring on
each one. By placing the
pins on the base of a
copying stand I could set
up the camera overhead
and get the film plane
parallel to them. The light
was provided by a single
anglepoise lamp with an
aluminum reflector on the
opposite side of the lamp.
Lens Hasselblad 80mm+
55mm extension
Mag. on film ×0.7
Mag. on page ×2.5

Door mat ▷
I bought a new Chinese
door mat for this textured
abstract. I laid the mat on
the baseboard of a copying
stand and set up the
camera above it. As I
wanted to graze the light
(see p. 50) across the mat's
surface, I used a snoot
attachment (see p. 158)
for the Multiblitz Minilite
200 flash to concentrate
the light into a narrow
beam. I was able to
preview the precise effect
of this lighting by means
of the built-in quartz
halogen modeling light.
Lens Hasselblad 80mm+
31mm (21+10) extension
Mag. on film ×0.35
Mag. on page ×0.7

Food grater ▷
I used a new flat food
grater to take this picture
showing some of the rows
of small raised cutting
edges. The highly polished
metallic surface is difficult
to light, since it easily
reflected any lights back
into the camera. I decided
to graze a pair of fiber
optics across the surface so
that only the raised portions
became highlighted and
stood out from the rest of
the shadowy unlit grater.
Lens Hasselblad 80mm+
97mm extension on bellows
Mag. on film ×1.3
Mag. on page ×4.4

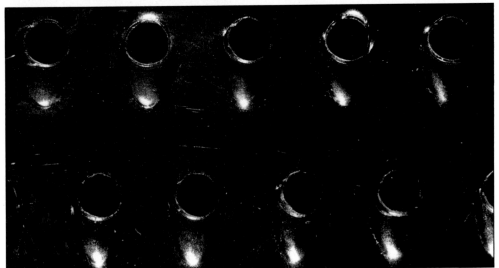

Highlighting food

Most professional food photographers favor large format, sheet film cameras with rising and falling, back and front movements which enable them to control the perspective and the depth of field. None the less, attractive food close-ups can be taken using smaller format cameras – especially if the arrangements are kept simple. A spoon or a fork, a sprig of parsley or a slice of fruit will add interest, as well as scale, to a close-up.

Attention must be paid to lighting, so that cold food appears cold, and hot food looks hot. The texture, as well as the tone, of the subject will determine which kind of lighting you use. To light highly reflective subjects, such as cutlery or silverware, use indirect bounced lighting, or light tents (see p. 152); use spotlights for matte surfaces; and back lighting for transparent or translucent subjects. The problems of lighting glass (see p. 82) also apply to lighting food in clear glass containers. Shiny plastic, metallic or glass surfaces can be dulled by rubbing them with putty, or by spraying them with a matte dulling spray, though this spray may dissolve plastic objects.

Certain prepared foods will only photograph well if the camera and lighting are set up so that the pictures can be taken in the few precious minutes before the color or condition of the food deteriorates. Since ice cream soon melts and hot souffles soon collapse, speed is essential. There are, however, several ways in which the life of freshly prepared food can be prolonged. For instance, dry ice packed around the base of a container holding ice cream will help keep it cool; citric acid applied to cut fruit will prevent a brown coloration developing; glycerine painted on sausages will increase their shine; and carbon dioxide will add gas bubbles to beer or champagne.

Other tricks of the trade include spraying fruit with a water and glycerine mixture to make them appear fresh, substituting aerosol shaving foam for whipped cream, and using crinkled transparent acetate for the ice in iced tea. However, it is more difficult to replace the precise color, viscosity and turbidity of a well-known liquid with a substitute. Whatever technique is used for a photograph advertising food, it must look authentic and make the consumer look twice.

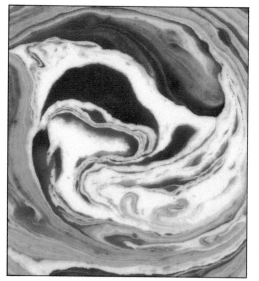

◁ Swirling soup
I placed a shallow soup dish on a photo jack which I moved up and down to bring the soup into focus. The heated oxtail soup was photographed, moments after cream was stirred into it, by using two Multiblitz Minilite 200 flash heads fitted with small clip-on diffusers.
Lens Hasselblad 80mm+ 40mm (32+8) extension
Mag. on film ×0.5
Mag. on page ×0.8

Assorted nuts ▽
These nuts were taken in a bowl and lit by sunlight which streamed in through the window.
Lens Hasselblad 80mm+ 32mm extension
Mag. on film ×0.4
Mag. on page ×0.7

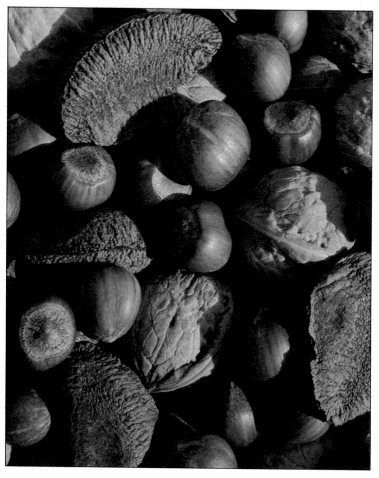

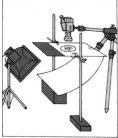

Back lighting △
Thin slices of kiwi fruit and strawberry were arranged on a glass plate and then laid on a piece of glass. This was lit from below by bouncing a diffused Multiblitz Minilite 200 flash off a white curved board as shown on the left.
Lens Hasselblad 80mm+ 8mm extension
Mag. on film ×0.3
Mag. on page ×1

Framing a portion ▷
I was tempted to fill the frame with the pink pulp of this watermelon. I decided instead to include a portion of the green rind to set off the pink center, and I lit the melon by available light from a window.
Lens 55mm micro-Nikkor
Mag. on film ×0.4 Mag. on page ×1.2

Variations on a theme

Perhaps the most obvious way of producing a thematic series of photographs is to take a single subject and to explore it in depth. Most simply a subject can be photographed at different magnifications, from different view-points, or, as is so often illustrated in photographic books, by varying the direction and type of lighting. More imaginatively, pictures may be seen as abstractions rather than replications of reality (see p. 90). I took my variations of the skin-print theme directly with the camera; other variations could have been produced by darkroom techniques (see p. 138).

An everyday subject such as water offers endless possibilities for photography – in both monochrome and color. In this book there are several graphic examples of different approaches which can be used to photograph such a basic liquid. Moving water can be portrayed either by using a slow shutter speed or a high-speed flash. Water droplets can be highlighted with strong side lighting or portrayed as simple lenses (see p. 15).

An alternative approach is to look for totally unrelated subjects which can be grouped because of their shape, color or texture.

Fixing a footprint ▷
This print of my son's foot was made without a camera. After stepping on a sponge soaked in hypo clearing agent, he pressed the foot onto unexposed print paper which I then exposed under the enlarger and developed.
Mag. on print and on page ×1

Revealing the invisible ▽
I dusted my fingertips with fluorescent powder so they glowed under ultra-violet light (see p. 56).
Lens Hasselblad 80mm+16mm extension
Mag. on film ×0.15 Mag. on page ×0.4

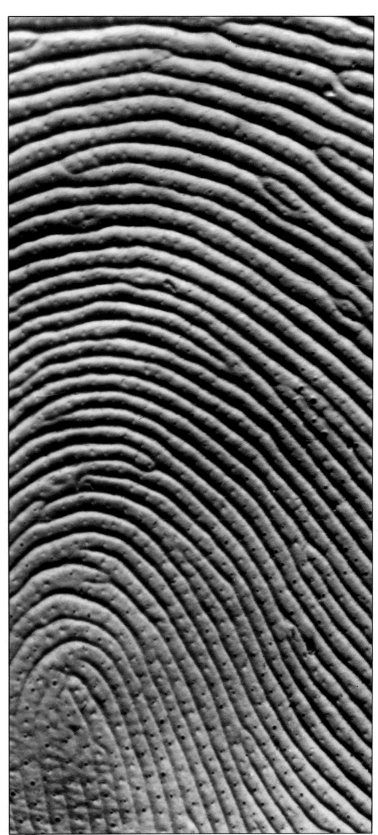

A fingerprint △
This fingerprint was made on white paper by first
pressing the finger onto a polished metal block covered
with a thin layer of black printer's ink. I photographed it
by indirect light using a light cone.
Lens Hasselblad 80mm+91mm (55+36) extension
Mag. on film ×1.5 Mag. on page ×5

An impression ▷
I made this impression of my husband's big toe by using
a liquid silicone rubber, known as Silfo dental plastic,
mixed with a few drops of catalyst. My husband pressed
his toe into the mixture, which was on a piece of glass,
for four minutes. I then transferred the glass, with the
plastic impression, onto a photo jack (see p. 152) so I
could bring it into focus beneath an overhead camera. I
lit the impression with a fiber optic so that the ridges and
the pores can clearly be seen.
Lens Leitz Photar 25mm
Mag. on film ×4 Mag. on page ×16

A moment of time

An impression of movement in large scale subjects can be created with a slow shutter speed, but this does not work so well in close-up. To avoid a blurred image, use either a fast shutter speed or an electronic flash to freeze and define a moving subject. However, unless you use a high-speed film, it will not be possible to use a fast shutter speed *and* stop down the lens when taking an action close-up; even then, a shutter speed of 1/1000th or 1/2000th sec will not be fast enough to record many actions. Electronic flash is an effective, convenient way of lighting and freezing fast movements at close range. With multiple flash heads, connect one to the camera and fire the rest with slave units.

Computerized flash guns with a variable power sensor allow you to adjust the power and hence the duration of the flash. All the images on these three pages illustrate moving liquids and have been taken using computerized electronic flash guns adjusted for speeds of between 1/10,000th and 1/25,000th sec. Even these small flash units are capable of recording an event which takes place too quickly for the naked eye to see. There is then the problem of precisely when to release the shutter. A light trip beam, or preferably a pair of crossed beams, connected to a motorized camera will ensure the shutter is released and a flash is triggered only when the subject breaks the beam. To get a succession of fast movements, use either a motor drive camera with a rapidly recharging flash, firing at a rate of several flashes per second; or a stroboscopic flash to produce multiple images on a single frame (see p. 114).

Ink injection ▷
Using a small, deep glass tank filled with water, I squirted a jet of red ink into the water. A pair of small flashes were directed in from each side of the tank to freeze the billowing ink cloud before it rapidly dispersed. I therefore had to empty the tank and refill it with clean water to take each subsequent picture. I found that the shape of the ink cloud varied every time, depending on the amount of ink and the force used to squirt it out.
Lens Hasselblad 80mm + 32mm extension
Mag. on film ×0.4
Mag. on page ×3

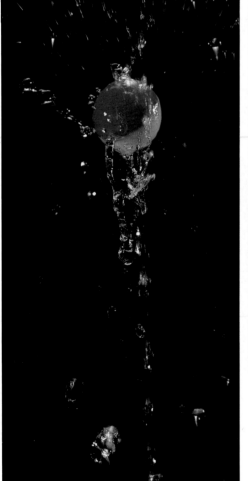

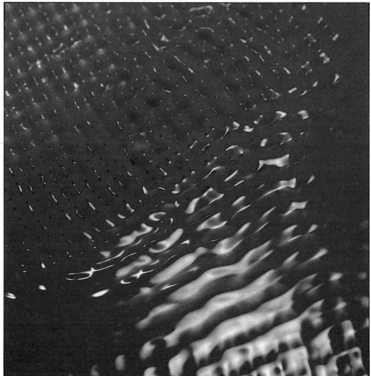

◁ **Juggling jet**
A high-speed flash of 1/25,000th sec froze the water fountain on this ingenious water toy. A ½ sec exposure gave an impression of the water spraying off the spinning ball, held aloft by the fountain.
Lens Hasselblad 150mm + 63mm (55 + 8) extension
Mag. on film ×0.8 Mag. on page ×1

Vibrating milk △
I poured a thin layer of blue-colored milk into a shallow plastic tray which rested on an aquarium aerator. The vibrating surface generated a wave pattern. A high-speed flash highlighted the crests of these miniature waves, while a large flash lit the surface.
Lens Hasselblad 80mm + 56mm extension
Mag. on film ×0.7 Mag. on page ×1.2

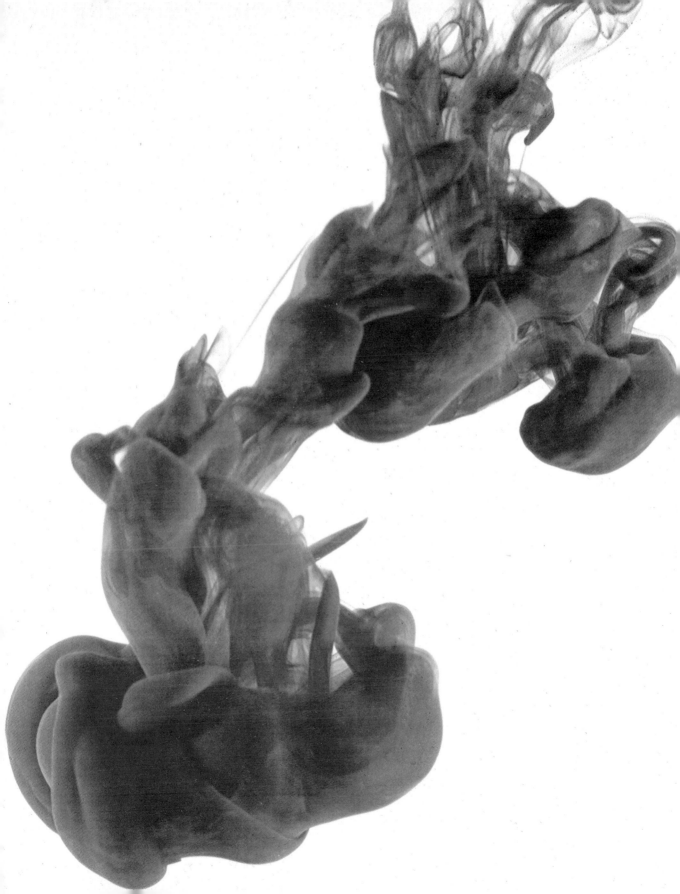

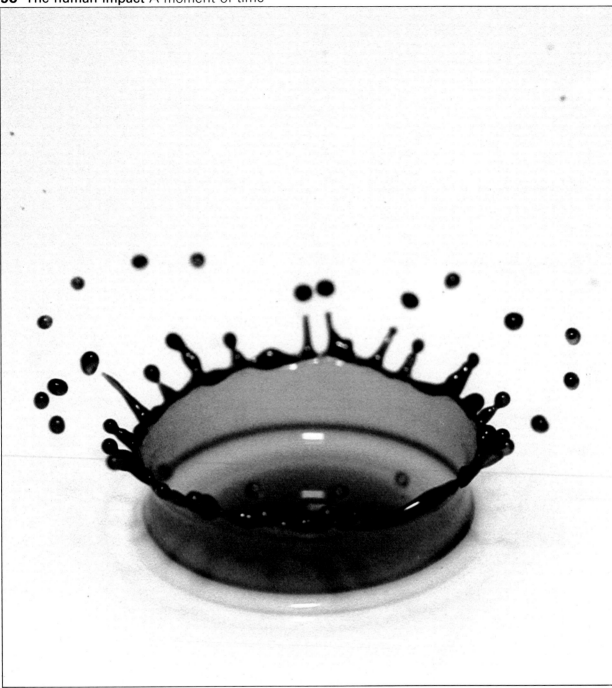

A coronet of ink △
This picture has recorded the moment when a splashing drop creates a beautiful coronet. Because I needed to be able to release ink one drop at a time, I attached a chemical burette to a clamp stand and filled it with ink. After many trials using Polaroid film, I set up a light trip beam so that the falling drop triggered a motorized Hasselblad which set off a high-speed flash as the ink splashed into milk.
Lens Hasselblad 80mm+55mm extension
Mag. on film ×0.7 Mag. on page ×6.5

THE NATURAL WORLD

Working at ground level

Ground level is the interface between the atmosphere and our planet. From our normal eye level, some five to six feet above the ground, it is easy to overlook the abundance of potential subjects for close-up photography so try bending down for a worm's-eye view. Mosses, lichens, fungi, seedlings and a multitude of small animals live on the ground and dead leaves, fruits and seeds fall to the ground as part of the cycle of growth and decay.

Fallen leaves, carpets of mosses and some alpines are best taken from overhead so that the film plane is parallel with the ground. A sturdy tripod with a reversible central column makes a good overhead support for photographing these flat objects; whereas smaller table-top tripods or ground spikes (see p. 150) are more suitable for side views of erect subjects such as small plants or seedlings. For any low-level photography you must be prepared to kneel – often on damp or muddy ground – to focus the camera. I always carry an old plastic sack for this purpose. If the ground is hard, the kneeling pads sold for gardeners are a boon. A right-angle or a waist-level viewfinder are useful accessories for focusing a low-level camera if you don't wish to lie prone.

◁ **Toad tattoo**
Many toads sport a disruptive pattern on their backs which helps them to blend in with their surroundings. For this picture of a leopard toad in South Africa, I decided to come in so close that the pattern itself became an abstract design. I used a Benbo tripod to support the camera (see the diagram below). The main problem was that the toad kept crawling out of the frame and had to be retrieved and repositioned in the field of view. I used only available light on an overcast day.
Lens 55mm micro-Nikkor
Mag. on film ×0.5
Mag. on page ×1.5

◁ **An overhead view**
For this bird's-eye view of mosses I used a baby Benbo tripod in the set-up drawn above, so that the camera was looking directly down on to the woodland floor. I framed the picture so that the dark green mosses were completely surrounded by the brown fallen leaves. This naturalistic background introduces a contrasting color and provides a natural scale.
Lens 55mm micro-Nikkor
Mag. on film ×0.15
Mag. on page ×0.6

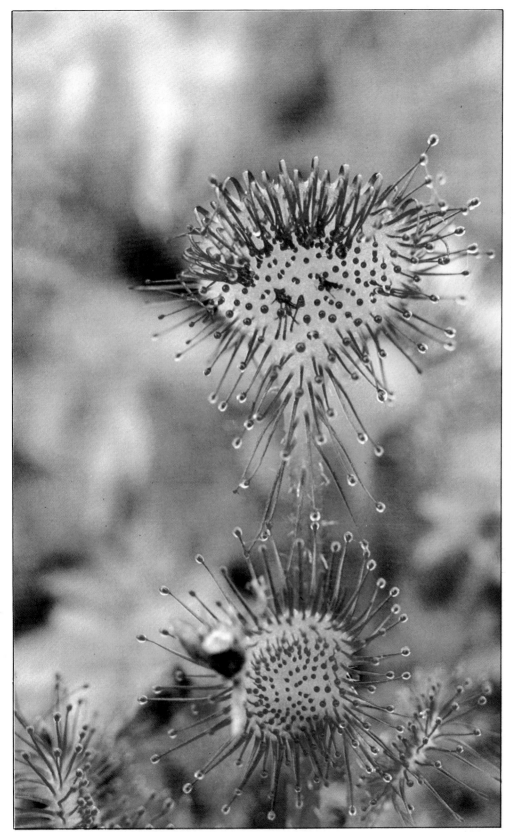

◁ **Differential focus at work**
I found this sundew growing out of a mossy carpet in boggy ground, so I knelt on a plastic sack and focused the camera using a right-angle viewfinder (shown above). Because I wanted to illustrate the radiating sticky tentacles of the insectivorous plant, I used the preview button on the camera to check carefully the depth of field. After completely stopping down the lens, I opened it up a couple of stops to ensure that the green mossy background was out of focus and so would not compete with the sundew leaves. Notice on the upper leaf how some of the tentacles have bent forward in response to an insect landing on the leaf. On this occasion, the lucky insect escaped the trap.
Lens 55mm micro-Nikkor+ auto extension ring
Mag. on film ×1
Mag. on page ×5.5

Bark patterns

Bark provides endless possibilities for a series of close-up subjects, since both the color and the texture are highly variable. Where the growing tree pushes out against its corky layer, a rough, cracked surface forms; if the bark continues to grow, it either retains a smooth finish or continually flakes off. Most exciting bark patterns can be found among trees on which the bark peels or flakes to reveal contrasting color patches in linear or random patterns.

Winter is an excellent time for photographing the bark of deciduous trees because the overhead branches are bare and allow more available light to reach the lower trunk. Since bark is a static subject, it can, if necessary, be photographed in very low light levels using a long exposure. Textureless, smooth-barked trees can therefore be taken on dull days; indeed, a bright reflection will appear in polished cherry barks if they are lit only by direct sun or flash. Better modeling of furrowed and rough-barked trees will, however, be gained by using side lighting to create shadows of the raised portions. Some barks change quite dramatically when wet, so I always keep a bottle of water in my automobile to alter the depth of color on the bark on dry days.

Linear harmony △
The simple repetitive linear patterns of the paperbark birch tree were lit entirely by indirect natural light.
Lens Hasselblad 80mm + 1.0 Proxar
Mag. on film ×0.15 Mag. on page ×0.4

Color contrast ▷
I framed the bark pattern of this New Zealand kauri pine to include the colorful lichen growths.
Lens Hasselblad 80mm + 0.5 Proxar
Mag. on film ×0.1 Mag. on page ×0.4

Flaking mosaic ▷
It was the dramatic contrast between the old dark brown bark and the freshly exposed orange patches of this keaki which caught my eye in a botanical garden. The orange color was further enhanced by a recent rain shower. I used a Benbo tripod to support the camera (illustrated in the diagram on the right); one leg was pushed into the ground and the other two rested against the trunk.
Lens Hasselblad 80mm
+ 21mm tube
Mag. on film ×0.1
Mag. on page ×0.3

A wintry world

Winter is a time of year when many photographers put away their equipment and ignore the pictorial opportunities of sunny wintry days. As the sun breaks through the mist there is a brief period before it melts the frosty rime which creates the frost fantasy close-ups. The sun makes the tiny ice crystals that coat the subject sparkle like miniature diamonds, and even if the air temperature is below freezing, the frost will begin to melt, so the best pictures usually have to be taken early in the day.

If there is no sun, a flash can be used to add highlights at any time of day. When taking close-ups of snow and ice, the overall impression is inevitably one of a whitish image so that it becomes especially important to exploit what little color is present. Search for red fruits or even late blooms, where some of the color shows through its icy coating. Look also for patterns and designs which arise from the angular nature of the ice crystals building up layer upon layer.

As well as frost patterns, close-ups can be found in iced-up ponds. Freshly fallen leaves may be fused within the ice, or air bubbles trapped beneath an icy covering. Alternating periods of thawing and freezing melt snow and create in its place glass-like icicles.

Winter is a good time for taking pictures of the delicate tracery of bare twigs. Finding a beautiful twig pattern is not always easy, and even if the pattern is right, it is often difficult to separate it from a confused background. Working on a misty day will help to isolate the subject by providing a uniform, muted backcloth which blankets out any distracting and unattractive features.

Although a blanket of snow acts like a huge reflector, a tripod will still aid winter close-ups. However, be sure to position and adjust the legs with great care, since a careless tap against a branch or a twig can so easily shatter the fragile ice pattern that was to have been the subject.

Cold temperatures can present problems with cameras which have through-the-lens metering, since the battery power quickly drains away in the cold resulting in underexposed pictures. A separate light meter with a selenium cell, such as a Luna-six, will be much more reliable under these conditions. Cold can also numb fingers, and they will then have little control over the shutter release, so be sure to keep your hands warm.

Adding sparkle with flash △
On a dull winter's morning I found this rose covered with hoar frost. The dark red petals provided a welcome splash of color in an otherwise white landscape. I decided to use a flash to give some additional sparkle, and also to help isolate the rose by creating a shadow in the distant, unlit background.
Lens Hasselblad 80mm+32mm extension
Mag. on film ×0.3 Mag. on page ×1.5

Geometrical ice shapes ▷
Fluctuating water levels alternating with periods of freezing created this striking abstract design in ice among reeds in a flooded water meadow. Since I could not walk out over the thin ice, I used a macro lens to give me a working distance of four feet. In the sub-zero temperatures, I used a soft release button (see diagram on the right) which screws into the cable release socket, making it much easier to release the shutter with a gloved hand.
Lens 105mm micro-Nikkor
Mag. on film ×0.1 Mag. on page ×0.5

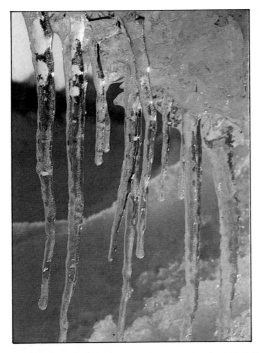

◁ Sunlit icicles
Driving down a narrow country lane banked by high walls of snow, I found these icicles that had formed as the snow drifts began slowly to melt. By digging my way into the snowy bank I was able to get the camera in behind the icicles so that the rays of the setting sun were reflected in them.
Lens 55mm micro-Nikkor
Mag. on film ×0.12
Mag. on page ×0.4

Selecting the viewpoint ▷
I used a low camera angle to gain a contrasting background color to this frost-encrusted hogweed seed head. The blue sky was further enhanced by using a polarizing filter. Within minutes of the sun striking the seed head, the frost began to fall away.
Lens 55mm micro-Nikkor
Mag. on film ×0.25
Mag. on page ×0.6

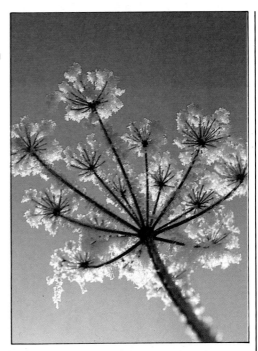

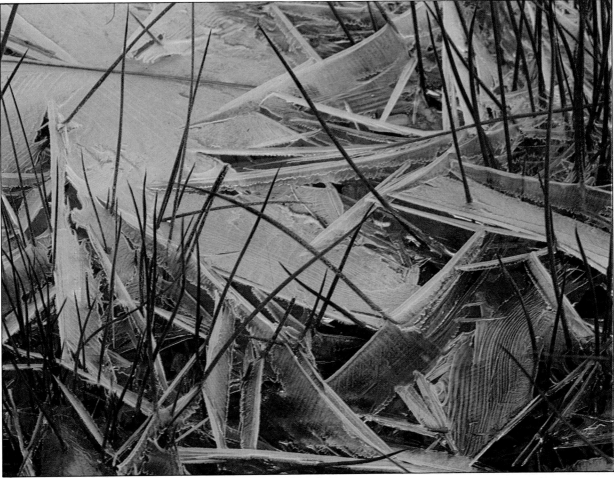

Living leaves

Look for leaf close-ups on trees, shrubs or flowers. For tree leaves I use a medium long-focus lens with some extension, or a long-focus macro lens so as to give me a reasonable working distance and still retain a close-up image. I am always on the look-out for an isolated leafy branch lit from behind by the sun. Venation patterns, as well as the structure of hairy and spiny leaves, are also best shown by back lighting – sun or flash. New spring leaves have a distinct color, which lasts for a few brief weeks; while the leaves of many tropical rain-forest trees open as a rich red color. Skylight reflections on shiny leaves can be removed by diffusing the natural light through a sheet of cheesecloth (see p. 152) or by using a polarizing filter on the camera. Such a filter may also be useful for darkening surface water and increasing the contrast between the floating leaves of water lilies. Many pot plants have striking leaves and, if the plants are positioned near a window, they can be lit by natural light, though flash or fiber optics will provide far more scope for creatively lighting portions of the leaves.

Venation pattern ▽
I took this detail of the underside of a *Caladium* leaf inside a greenhouse in Singapore's botanic gardens. Since the available light level was low, I had to use a tripod and 1 sec exposure to stop down the lens. I was therefore able to get both the pattern of the raised red veins and the leaf blade sharply defined.
Lens 55mm micro-Nikkor
Mag. on film ×0.5
Mag. on page ×3

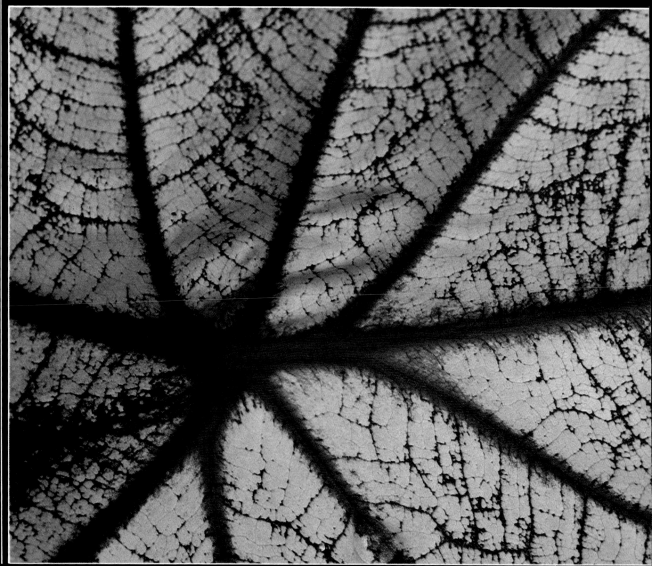

Intensifying the color ▷

To photograph this black gum in the fall, I searched for a camera position where I could use the sun from behind to enhance the rich golden color. I found this picture by walking beneath the overhanging branches and looking skywards. Where the leaves overlap one another the golden glow of each leaf combines to make a deep brown color and the solid twig appears as a silhouette.
Lens Hasselblad 150mm+ 32mm extension tube
Mag. on film ×0.3
Mag. on page ×0.6

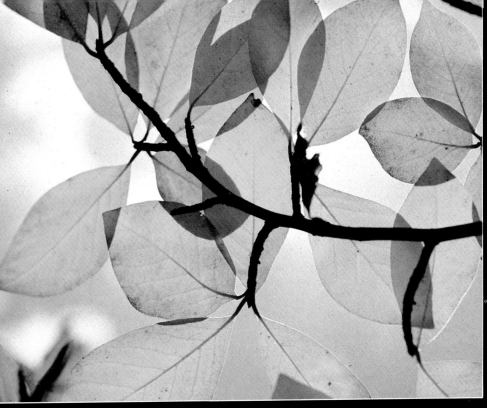

△ **Cross lighting for modeling**
This silversword grows only on the cinder slopes of Maui in the Hawaiian islands. The early morning side lighting helped to model the rosette of the spiraling leaves.
Lens 105mm micro-Nikkor
Mag. on film ×0.1 Mag. on page ×0.2

◁ **Back lighting to reveal structure**
Transillumination by direct sunlight has highlighted the parallel veins on this cabbage palm leaf. Cropping tightly focuses attention on the concertina folding.
Lens 105mm micro-Nikkor
Mag. on film ×0.1 Mag. on page ×0.3

Floral portraits

Close-ups of flowers can be taken outside or in the house at any time of year. Small flower clusters make intriguing repetitive designs, while large single blooms offer scope for impact images. As many flowers fade soon after they have opened, never postpone taking a perfect bloom. If the flower does not fill the frame, look carefully at the background – sky, water, grass, earth, or other plants – to make sure it enhances rather than competes with the subject.

Useful accessories for field photography are a plant clamp to steady long-stemmed flowers (see p. 152); aluminum foil to fill in shadows (see p. 160); a piece of cheesecloth to diffuse direct sunlight on white or pastel-colored flowers, and a wooden or metal spike topped with a flash shoe to support the flash remote from the camera behind a flower (see p. 158).

Electronic flash or a continuous light source can be used for studio portraits of cultivated flowers. If the electronic flash does not have a built-in modeling light, the lighting cannot be appreciated unless either a pen torch is taped onto the flash or an instant Polaroid print is taken. With a continuous light source such as a pair of fiber optics, the precise effect of the light and shadow falling on the flower can be viewed through the camera and finely adjusted before any exposures are made.

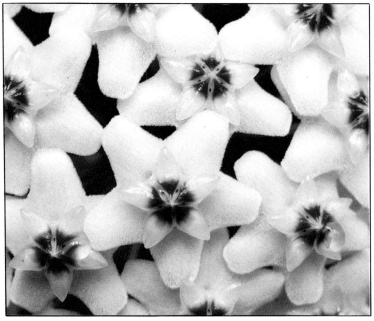

Floral cluster △
I photographed the waxy *Hoya* flowers in the soft light of the late afternoon. Since the flowers form a complete sphere, it was difficult to keep one side entirely in focus. Instead, I got in so close that most of the flowers were in a single plane.
Lens 55mm micro-Nikkor
Mag. on film ×1 Mag. on page ×3

Advertizing color ▷
I cropped in on this tulip so that the red appeared as a striking backcloth for the flower's heart.
Lens 55mm micro-Nikkor
Mag. on film ×0.5
Mag. on page ×4.5

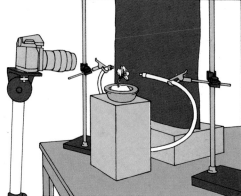

Spot lighting with fiber optics
I wanted to illustrate the internal parts of this *Alstroemeria* flower, so I removed one outer petal which was partially covering the stamens and stigma. The flower stalk was wedged into a florist's spiky base and placed in front of the black velvet background. The fiber optics were set up as shown on the left. The light passing through the petals was metered directly by the camera.
Lens 55mm micro-Nikkor
Mag. on film ×0.4
Mag. on page ×1.2

Plant anatomy

Close-up photography can highlight details in the external structure and, more especially, in the internal anatomy of plants. You can often reveal exciting shapes that are not obviously visible to the naked eye. Ideas for anatomical pictures have often come to me while preparing food in the kitchen. Next time you cut through a fruit or vegetable, take a close look at the way in which the seeds are arranged inside it – an apple, a pomegranate, a melon, or a kiwi fruit, for example – or observe how the fleshy leaf bases encircle one another in an onion or a leek. If the section is a thick one, it will have to be lit across the cut surface, but it may be possible to light a thin section from beneath by placing it on glass.

Dried seed heads and leaf sprays are also worth considering as close-up subjects, as are individual seeds. If there is a hook or a miniature parachute on the seed, then a photograph can illustrate the way in which structure relates to function. Seeds can be scattered onto glass and lit from below or packed tightly together in a shallow box to make what I call a seed mosaic (see p. 30). Seeds with a large wing or bract to slow down their rate of descent from the tree tops can be photographed using a repetitive stroboscopic flash (see p. 114).

Anyone who has grown a bulb above water in a glass container will have noticed the way in which the roots extend down into the water. If a bean or a pea is supported on a piece of card with a central hole above a small glass aquarium the roots will grow down into the water. Their delicate coating of root hairs can be photographed in the same way as the snail (see p. 124).

Cross-sections of tree trunks or branches will expose the concentric pattern of the annual rings. These can be photographed and then enlarged so that you can count the rings and determine the age of the tree.

A leafy skeleton ▷
I collected this dry magnolia leaf skeleton in winter and photographed it some months later in my studio. The leaf was flattened onto a piece of glass with adhesive tape and lit from below using two small flashes.
Lens Hasselblad 80mm + bellows
Mag. on film ×3.5 Mag. on page ×11

The heart of a fruit ▷
Using a very sharp knife I cut a thin slice from the center of a tangerine and placed it on a scrupulously clean piece of clear glass. The sheet of glass was then positioned on blocks of wood to raise it five inches above a square of black velvet laid smoothly on a table. I used four small electronic flashes to light it from below so that the translucent fleshy structure of the segments glowed against the black background. The thick outer rind was not translucent and so blocked out the light; it therefore appears as a dark band.
Lens Hasselblad 80mm+55mm extension
Mag. on film ×0.75 Mag. on page ×2

Beneath a frond ▽
At this magnification the circular orange sori, growing out from the underside of a green fern frond, are clearly seen as clusters of many sporangia, each with a darker thickened midrib. Although the frond was thin enough to be transilluminated, I chose to light it with a small flash directed down from the top left of the frame. The sori were then modeled by the shadows they cast.
Lens 55mm micro-Nikkor+bellows
Mag. on film ×2 Mag. on page ×10

Taking insects

Close-ups of moving insects present a greater challenge than static subjects. In the field, butterflies and dragonflies can be stalked using a medium long-focus lens and extension tubes or, ideally, with a 105mm or a 200mm macro lens (see p. 24). For available light work there will rarely be time before the insect moves off to set up the camera on a tripod, so a monopod (see p. 150) is a useful alternative support. Even this may be too cumbersome; it may be easier to mount the camera as a single unit onto a bracket with a pair of small flash guns, such as the macro flash (see p. 158).

It is worth spending time observing insects in the field. You will see, for instance, how butterflies are more active on warm sunny days. They often have favorite food plants so you can lure them into your garden by growing plants such as buddleia. Butterflies also need to drink; during a drought, they can be attracted to damp ground or a pool of water on which the camera has been prefocused.

If insects are collected or bred for studio photography, they should always be released outside afterwards. Active insects may have to be confined with their food plant within a glass box or a cuboid frame covered with clear acetate. Once they have come to rest, they can be photographed either directly through the glass (taking the same precautions as for aquarium photography on p. 125), or after gently removing the acetate cover. Studio lighting can be fiber optics or available light through a window for static subjects; or electronic flash. Photofloods are not suitable, since they generate too much heat. Recording the complete life cycle of a butterfly or a moth, including the egg, caterpillar, chrysalis and adult, makes a useful photo sequence, ranging from a magnification of many times life-size for the eggs, to maybe a half life-size portrait for the adult. Impact close-ups of insect parts can be taken in the studio – the head, the eyes, or even the scales on a butterfly's wing.

Head-on for impact △
I came in so close to this butterfly that the large compound eyes became the focus of attention. I used a pair of electronic flashes to light the picture.
Lens Hasselblad 80mm + bellows
Mag. on film ×3.5 Mag. on page ×12

Working with natural light ▷
I particularly like the way in which natural light, filtering through a light cloud cover, produced a muted green background for this resting birch sawfly. The green complements the brown and black coloration well and there are no harsh shadows. I carefully set up the camera on a tripod – making sure that I did not accidentally knock the leaf – so I could use an exposure of $\frac{1}{2}$ sec.
Lens 55mm micro-Nikkor
Mag. on film ×0.5
Mag. on page ×4

Using flash to arrest movement ▷
One night I found this large ant crawling over a sandy patch in the Peruvian rain forest. I used two small flash heads mounted onto a boomerang-shaped support which was screwed on to the base of the camera (see p. 158). I checked the focus first with a head lamp.
Lens 55mm micro-Nikkor
Mag. on film ×1 Mag. on page ×3

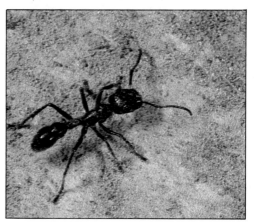

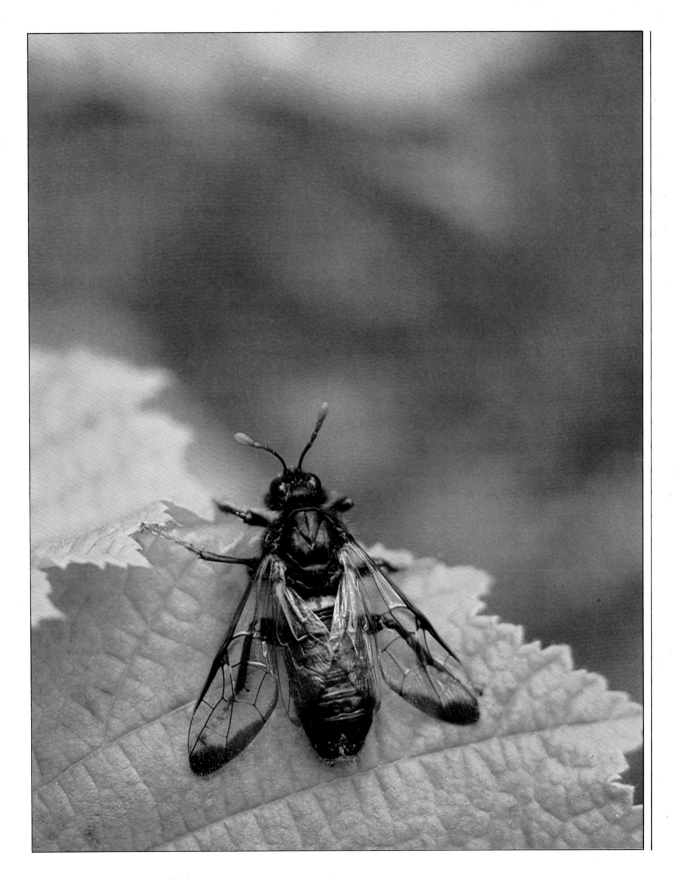

Recording movement

When taking close-ups at larger than life-size, the lens is further from the film plane than from the subject, so that the subject movement – however small – is magnified on the film. Therefore, if you wish this movement to be frozen, even greater care must be taken than when working at a distance.

Action can be conveyed in a still photograph in a variety of ways. Perhaps, most obviously, the instinct is to freeze action either by using a fast shutter speed or a flash. In low light levels the first solution is not ideal since it will of necessity dictate a fast film speed, which immediately reduces the sharpness of a close-up. On a sunny day, however, using a fast shutter speed with a motor drive camera may be the *only* way of achieving an action close-up.

Electronic flash is now a very convenient way of recording moving subjects both indoors and outside, but it may bring additional problems for some subjects. For example, it will produce highlights on any wet or shiny parts of a subject or, indeed, objects behind the subject. Due to the rapid fall-off in intensity of flash, it can create an unnatural nocturnal appearance to subjects remote from a background, unless the flash exposure is synchronized with the available light or an additional flash is used to illuminate the background.

One technique, which I often adopt for suggesting movement in a photograph, is to use a slow shutter speed (½ or 1 second). This is especially effective for conveying the impression of water flowing over stones, down a waterfall or along a stream. It can also be a means of providing exciting abstract images and designs with colored moving objects (see p. 58 and p. 96).

Movement can also be exaggerated by using a slow shutter speed and altering the focal length of a macro zoom lens during the exposure. When zooming is used in combination with a camera tilt or a pan, the image will be blurred in two directions – radially and laterally – thus providing a greater sense of depth.

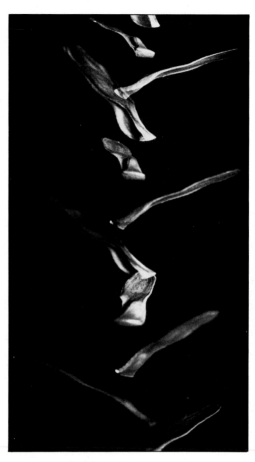

Fast repetitive flash △
I used a stroboscopic flash to produce this multiple image of a mahogany seed. The shutter of the motorized Hasselblad was triggered as the falling seed broke a light beam and was left open for ½ sec with the stroboscopic flash firing at 30 times a sec to capture 11 images on a single frame.
Lens Hasselblad 80mm+10mm extension
Mag. on film ×0.2 Mag. on page ×0.5

A vocal frog ▷
I found this reed frog calling at night beside a South African pond. I had to use electronic flash to provide the light source and also to freeze the movement of the inflated vocal sac. An assistant held a lamp for me to focus the camera and I used a flash set on automatic mode to obtain the correct exposure.
Lens 105mm micro-Nikkor
Mag. on film ×0.3 Mag. on page ×1

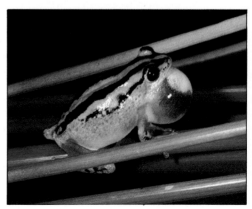

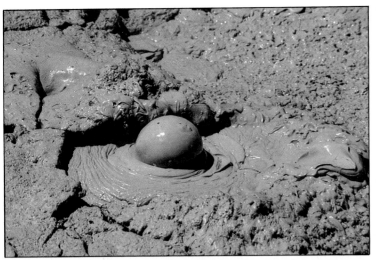

◁ A fast shutter speed

When I first saw the mud in New Zealand's thermal region repeatedly bubbling and plopping like boiling oatmeal, I was momentarily mesmerized. Even by using a shutter speed of 1/250th sec, I found it difficult to anticipate the precise moment to release the shutter so as to record the maximum expansion of the bubble before it burst. This was the best frame of several that I exposed.
Lens 200mm micro-Nikkor
Mag. on film ×0.1 Mag. on page ×0.3

A slow shutter speed ▽

Using a ½-sec exposure I was able to capture the essence of water flowing down a stream by recording the reflections of the sun as streaks of light instead of simple pin-points of light. The blurred highlights also contrast sharply with the static leaves trapped against an underwater branch.
Lens 55mm micro-Nikkor
Mag. on film ×0.1 Mag. on page ×0.6

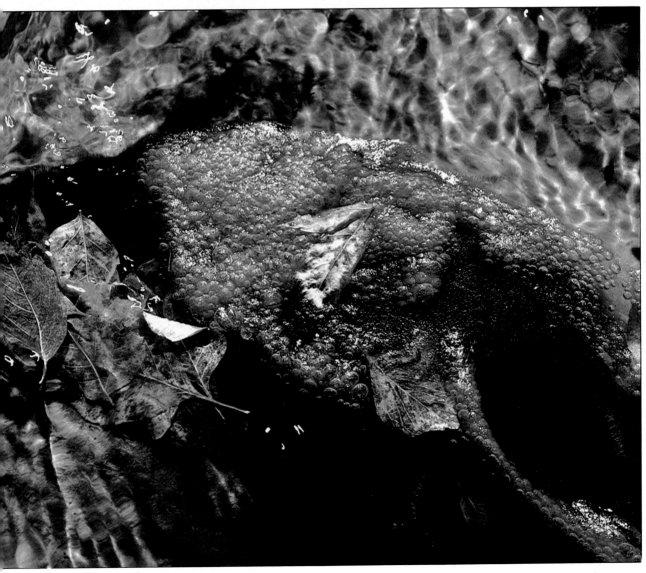

Rocks and minerals

Natural rock formations are built on such a large scale that they are best recorded with a standard or even wide-angle lens. Close-ups can be taken in the field to illustrate portions of rock or soil. You can take comparative pictures of different sized pebbles or different colored sands on a beach, while a volcanic area may provide scope for textural close-ups of rope lava. The best minerals are unlikely to be found by chance in the field, although it can be fun exploring an area at night with an ultra-violet lamp in search of fluorescing rocks.

I select the studio lighting for each specimen by turning it in my hand beneath continuous light sources. Crystals are most difficult to light because the internal surfaces of the facets reflect light. Black velvet is a good background for photographing strongly colored specimens on color film. In larger-than-life-size close-ups, specks of dust can be removed by pressing down and peeling off strips of scotch tape from the velvet. Gray or even white art paper may be a more suitable background for monochrome work.

A landscape replica ▷
As different colored muds settle to form sediments they build up multi-colored layers. If an upheaval then takes place, the linear arrangement of the layers may be disrupted to form an intriguing abstract resembling ruined buildings, known as "ruin marble". This piece, originating in Italy, has been sectioned and polished. As with any shiny surface, the main problem when photographing it is to overcome distracting reflections. I took this picture by indirect natural light after laying the section on black velvet on the floor of a sunroom early on an overcast day.
Lens Hasselblad 80mm +31mm (21+10) extension
Mag. on film ×0.4
Mag. on page ×2

Enhancing a rock specimen △
When viewed in ordinary light, calcite is a white crystalline rock, but after several minutes exposure beneath ultra-violet light, it fluoresces a spectacular pink color. I fastened a pair of "black" ultra-violet emitting tubes to the underside of a table top with a deep flange as ultra-violet wavelengths are harmful to the eyes. The rock was then placed on the ground on black velvet as shown in the set-up on the left. The picture was taken in a blacked-out room with a Wratten 12 (yellow) filter over the camera, which rendered the rock orange.
Lens Hasselblad 80mm+25mm extension
Mag. on film ×0.4 Mag. on page ×1.3

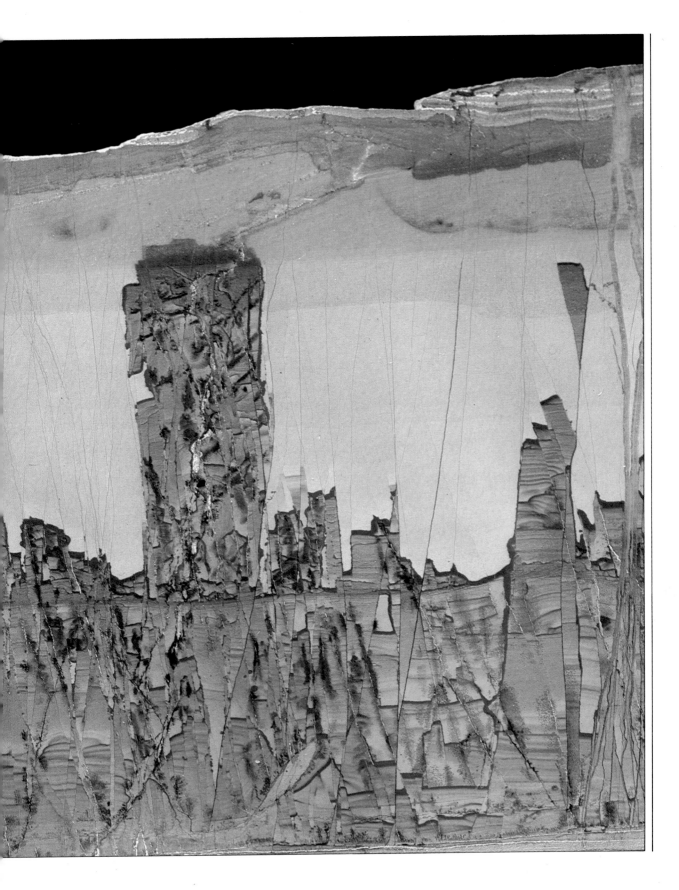

Fungal forms

Fungi exist in many forms: as toadstools on the ground; as shelf-like brackets on trees; and as molds on food. Except for perennial woody brackets, most fungi are short-lived, so never postpone photographing a perfect specimen. Old woodlands, where there are plenty of rotting tree trunks, are rich sites for fungi — especially when a rainy spell coincides with warm weather in the fall.

If you use available light outside make sure that it is not filtering down through colored leaves. When available light is poor, you may have to double rate the film speed to get a better depth of field. An aluminum foil reflector (see p. 152) will also help to boost low light levels and I have even used a small hand mirror for spotlighting tiny specimens in the shade. In dark situations you will have to use flash. Try to avoid using direct flash on pastel-colored fungi; bounce it off a white board, or diffuse it with cheesecloth.

If fungi are collected for indoor photography, and have to be kept overnight, put them inside a sealed box in a refrigerator; in a centrally-heated room they will soon dehydrate and shrivel.

◁ **A moldy close-up**
This is a close-up of the black spore sacs on the orange skin of a rotting carrot. A pair of flash heads gave me enough light so that the lens could be well stopped down for this magnified image.
Lens 55mm micro-Nikkor +PB4 bellows
Mag. on film ×2.5
Mag. on page ×12

Flush with the wall ▽
Inside a derelict house I found this dry rot fungus growing on the wall. The bracket changes color with age. The advancing outer edge is white, while the rust-colored spores are shed through the pores. Even though I was able to get the camera set up so that the film plane was parallel with the wall, only a small amount of window light reached the fungus, so I used a tripod for the ½ sec exposure.
Lens 105mm micro-Nikkor
Mag. on film ×0.1
Mag. on page ×0.4

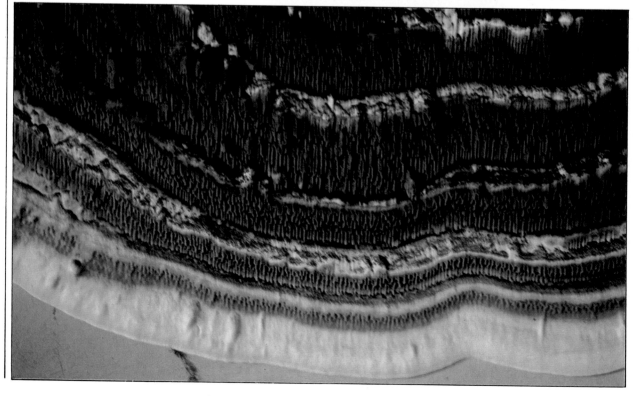

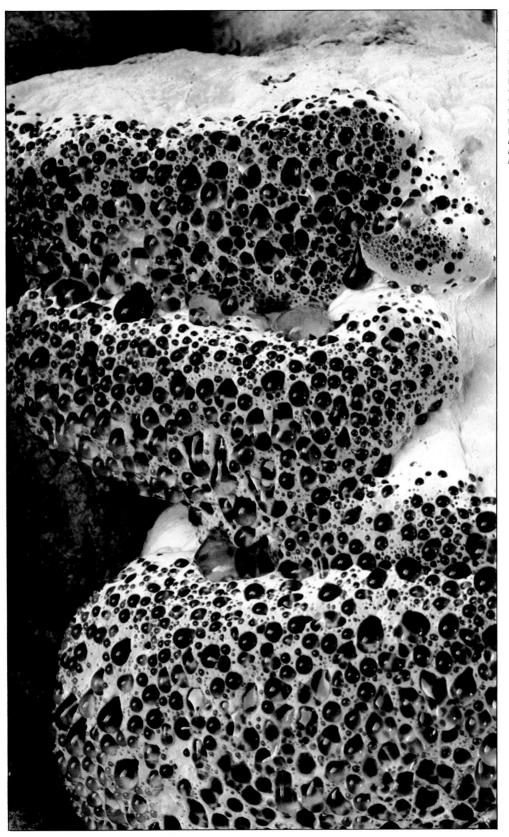

Natural sequences

Two or more pictures can be used to illustrate the successive stages of a flower opening, a seedling or a toadstool growing, an insect walking or flying, or a sea anemone opening out its tentacles. You may come across some actions – such as a predatory insect devouring its prey – quite by chance, and there may be little time for you to set up the optimum lighting.

Many successful photo sequences will be achieved only by careful planning of the framing and the lighting of the subject. The bud of a flower is much smaller than a fully opened bloom, so if you want to take all the pictures in the sequence at the same magnification, you must choose a magnification for the bud which allows plenty of space within the frame for the flower to expand into. The body of a burrowing animal, on the other hand, becomes obscured as it digs down into the sand. You should therefore aim to fill the first frame completely with its body.

Sequential pictures can be taken in the field. You may have problems though if they are taken over a period of several days or even weeks, when the weather and lighting can change dramatically. For close-ups, in particular, a studio set-up where the lighting can be controlled will often be preferable to working in the field. Flash will be essential for capturing fast movements – I prefer it to tungsten light for most sequences since it ensures crisp images with the maximum depth of field.

Recording a sequence which spans several days or weeks is known as time-lapse photography. A subject such as a flower opening can be taken on a series of separate frames, or, if the camera has the facility for recocking the shutter without winding on the film, as multiple images on a single frame. The life history of a butterfly will take several weeks to record.

A predatory plant
The Venus fly trap has highly modified leaves which function as effective insect traps. The picture below graphically illustrates an open trap ready and waiting for an unsuspecting insect, in this instance an unlucky dragonfly. When an insect lands and touches more than one trigger hair inside the trap, the two lobes suddenly close tight on the victim. Dragonflies are normally fast fliers, but the one which has been caught by the trap in the bottom right picture had badly damaged wings which were unable to power it away from the predatory plant. Both pictures were taken by available light.
Lens 105mm micro-Nikkor
Mag. on film ×0.3
Mag. on page ×2

Burrowing down
To take this sequence of a plains spadefoot toad burrowing into sand, I filled a baking pan with sand and placed it beneath an overhead copying stand. A pair of electronic flashes were set up on opposite sides of the tray. I prefocused the camera on a piece of wood the same thickness as the toad. As soon as the toad was placed on the tray it began to dig into the sand. I quickly checked the framing and focus before taking the first picture, and as the toad sank into the sand I had to adjust the focus.
Lens Hasselblad 80mm+10mm extension
Mag. on film ×0.75 Mag. on page ×1

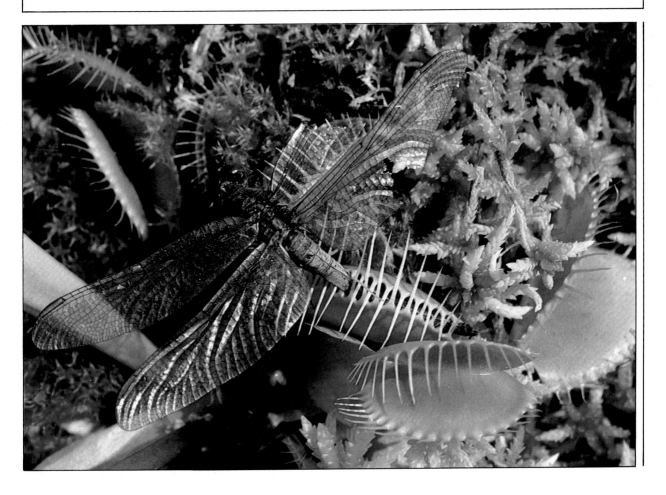

Tracks made by animals – notably birds and mammals – provide intriguing subjects for close-up work which are exploited by few photographers. Birds and mammals leave conspicuous tracks as they walk, run or land on sand, mud or snow. Crabs, insects, amphibians and reptiles also leave behind evidence of their presence in soft ground. Look for tracks on the seashore, estuary, sand dune, lakeside, riverbank and also in the garden. As bushmen well know, each track tells its own story, but it may last for only a few hours before being obliterated by a rising tide, a river in flood, rain, or warm weather melting snow.

All impressions show up best if they can be taken against a low-angled light, since this will cast a shadow in the track. Try to select a simple track which is not confused by others criss-crossing over it. In popular areas you must get up early to find the best tracks, before children run over a beach or dogs are exercised; also the low, early morning light is ideal for photographing tracks.

As animals move around and feed they leave behind other signs as well, including the remains of food. For example, in coniferous woodlands eaten pine cones are discarded by gray squirrels. Remnants of snail shells beside rocks will show that a thrush has been at work. During the rutting season deer make scrapes in the ground and they may also fray saplings by rubbing their antlers against the bark.

Food remains such as cones, nuts and shells can easily be collected and kept for photography in the studio at a later date. Comparative studies can then be made of the way in which different animals attack the same kind of food. The objects can either be laid directly on a gray background and lit by indirect light inside a light tent (see p. 154), or placed on a piece of glass raised up from the background as used in shell and fossil photography.

Impressions in the sand △
Shortly after the tide had ebbed down the shore, a herring gull walked over this stretch of wet, smooth sand.
Lens Hasselblad 80mm +1.0 Proxar
Mag. on film ×0.15
Mag. on page ×0.3

◁ **Meanderings in a rock pool**
Marine snails made this intriguing pattern on the sandy floor of a rock pool. used a polarizing filter on the lens to eliminate reflections (see p. 40).
Lens Hasselblad 80mm + 21mm extension
Mag. on film ×0.2
Mag. on page ×0.3

A snail's feeding trail ▷
I found this curious track – made by a snail browsing on a green algal film – on a white gate in our garden. The white areas mark where the snail has rasped away at the algae. I took the picture with available light on an overcast day.
Lens Hasselblad 80mm + 21mm extension
Mag. on film ×0.25 Mag. on page ×0.5

A landing in the snow ▷
I was walking through woodland after a light snowfall in late fall when I saw a squirrel jump down out of a tree. This picture illustrates how a thin layer of snow on darker ground and subdued lighting conditions can produce an impression with a stronger contrast than usual.
Lens Hasselblad 80mm +21mm extension
Mag. on film ×0.25
Mag. on page ×0.8

A trek across the mud ▽
The broad, webbed footprints of a swan walking across a muddy estuary are unmistakable. The impressions of these prints have been enhanced by taking them against the light.
Lens Hasselblad 150mm +10mm extension
Mag. on film ×0.1
Mag. on page ×0.4

Working with aquaria

Aquarium fish, as well as small invertebrate life, can be photographed in aquaria very successfully. Glass tanks are better than plexiglass ones for photography because they do not scratch so easily. Make sure there are no blemishes – scratches or air bubbles – in the pane through which the photograph is to be taken. As well as using ready-made aquaria, I make tanks by getting glass cut to order and bonding the edges with a special adhesive.

Photofloods quickly warm up water in a small aquarium, so I always use electronic flash, which also freezes the movement of active animals. Depending on the subject, I may use one, two or three flashes to light it. The color of the background and the position of the lights are selected after I have observed the subject for some time. A major problem with tank photography – particularly when using a black background – is the reflection of the camera and hands in the front glass. This can be eliminated by attaching a matte black mask to the front of the camera lens. Small active subjects can be confined to part of the tank by inserting a vertical glass partition.

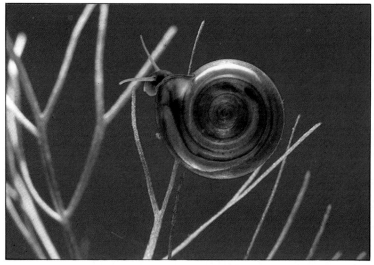

Revealing the anatomy of a water snail △
I waited until the flattened shell of this freshwater ramshorn snail was parallel to the film plane so that I could get the entire shell, the head and the tentacles in sharp focus. By using a pair of electronic flashes, each angled on to the back of the snail, I was able to show how the mollusc's body spirals round inside its shell. The dark patch is the snail's heart..
Lens 55mm micro-Nikkor
Mag. on film ×2 Mag. on page ×6

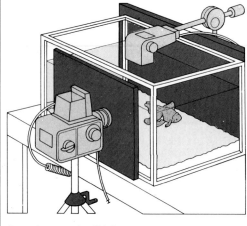

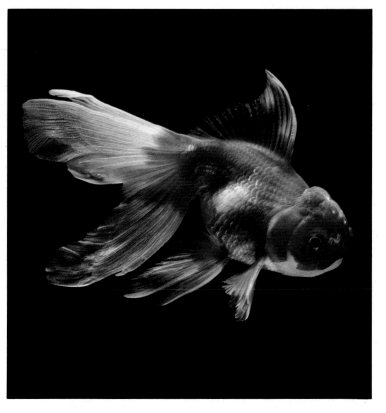

Portraying a moving fish ▷
I watched the behavior of this red liontail goldfish observing that it swam round in circles near the top of the aquarium. I then set up an electronic flash on a stand (see above) so that it shone down from the top of the tank and I pre-focused the tripod-mounted camera a few inches inside the front glass wall. I attached a matte black mask to the front of the lens to eliminate all reflections in the front glass. As the fish swam into the field of view I quickly checked the focus, before releasing the shutter. Fortunately, the flash recharged before the fish completed its next circuit.
Lens Hasselblad 150mm+42mm (21+21) extension
Mag. on film ×0.3 Mag. on page ×1

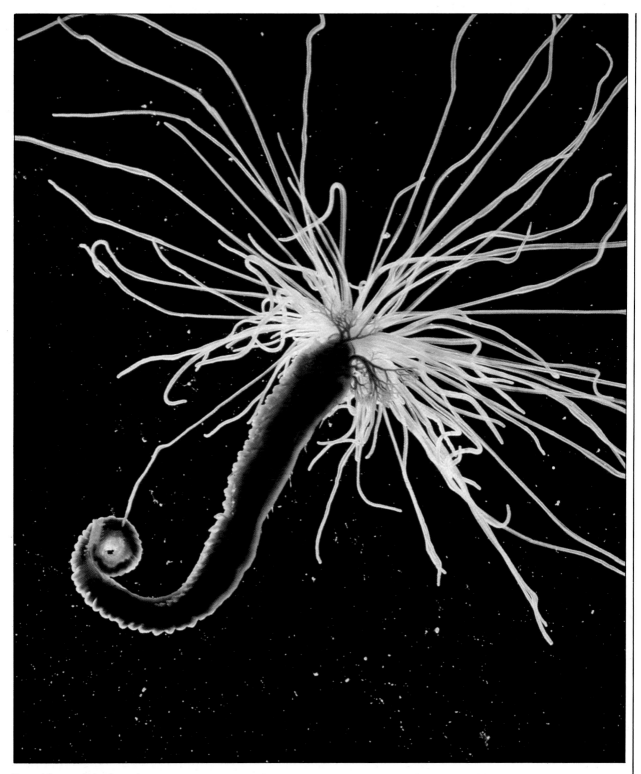

Dramatizing a writhing worm △
The only way to show the long writhing tentacles and
the red feathery gills of this marine worm was to place it
in a shallow dish over a central hole in a small table so
that I could light it from underneath by means of dark
field illumination. I used two small flashes angled up
from below to arrest the movement of the tentacles (see
set-up in diagram on p. 55).
*Lens Hasselblad 80mm+97mm (55+21+21) extension
Mag. on film ×1.25 Mag. on page ×5*

Shells and fossils

Shells and fossils can be photographed on location in their natural setting or in the studio. Fossil animals are much more common than plants, because hard shells and bones are more easily preserved than soft tissues. Fossil remains which contrast with the surrounding rock stand out quite easily, whereas the surface relief of fossils which blend in with the rock will have to be highlighted either by low-angled sun or flash.

The best place to find shells on the shore is along the tide line. They can be photographed in a natural grouping from above; or by using a low camera angle (see p. 100) for taking one or two larger shells. The color of a shell can often be enhanced by wetting it, though this may produce distracting highlights on shiny shells.

You can use similar techniques for taking both shells and fossils in the studio. Firstly, unless the fossil is completely surrounded by rock, the color and type of background must be selected. Black velvet is good for setting off colorful shells and many fossils, but it is not ideal for pastel-colored or white shells. Secondly, careful positioning of the lighting is as important as the background and should always be considered in conjunction with it. Shadows will merge in with black velvet but will not with pale-colored boards. However, if the specimen is raised up from the background on a sheet of glass, and lit by a pair of lights each angled down at 45° from above, the shadows of the specimen will be cast onto the background outside the field of view of an overhead camera. Grazed lighting (see p. 50) must be used to bring out surface relief and shell sculpturing. It may be necessary to place a reflector (white board, aluminum foil or a mirror) opposite the light source to ease very harsh shadows. Direct lighting of shiny objects will produce distracting highlights which can be eliminated by spraying them with a waxy spray. A light tent (see p. 154) will provide even lighting without any reflections. The internal structure of thin shells can be revealed by lighting them from behind. This will not be possible with thick shells, but they can be cut into transverse or longitudinal sections.

A sectioned shell ▷
I took this section of a blood conch by sticking the shell with modeling clay onto an upright piece of clean glass. Two tungsten halogen spotlights were angled in at 45° behind the glass to produce this rim-lit effect.
Lens Hasselblad 80mm+76mm (21+55) extension
Mag. on film ×1 Mag. on page ×5

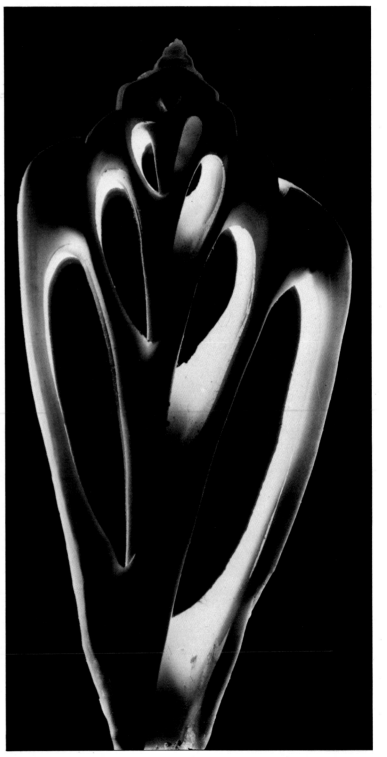

Lighting a fixed specimen ▷
As this ammonite was mounted on a wall in a museum, I had to photograph it *in situ*. I lit the fossil by using a pair of floodlights on stands — each angled in at 45° — as shown in the set-up above.
Lens Hasselblad 150mm+21mm extension
Mag. on film ×0.1 Mag. on page ×0.25

Modeling with grazed lighting ▽
The rock with fossil sea urchins was laid on a black velvet background and the camera was set up directly overhead. A single spotlight was placed level with the urchins near the upper left-hand corner of the stone, so that the tubercles on the urchin shell and its spines appear in sharp relief.
Lens Hasselblad 80mm+10mm extension
Mag. on film ×0.15 Mag. on page ×0.5

Highlighting the internal structure △

I knew that careful positioning of the lighting for this sectioned Nautilus shell was essential, so I decided to use a pair of small tungsten halogen spotlights. I could then see precisely the effect of these continuous light sources. Before positioning the shell and lights, I draped a piece of black velvet over an upright box and down onto the table (see the set-up on the left). Small pieces of modeling clay were used to keep the shell in an upright position. The lights were set up on the table behind the shell, each one angled in at 45° so that their combined light shone through the shell to produce a rich glowing color. In this way, the internal spiral structure is clearly seen, as well as the large chamber in which the animal lived.

Lens Hasselblad 80mm + 21mm extension
Mag. on film ×0.2 Mag. on page ×1

SPECIAL EFFECTS

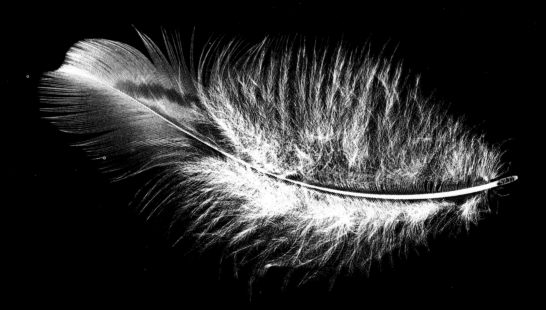

Using screens

Screens should not be used just for the sake of doing something different, but rather to enhance an image. The most popular photographic screens are the commercially produced texture screens used in the darkroom to produce a print with a texture image; screens placed over the camera lens will also alter a straightforward image. If cheesecloth or perforated zinc sheet is held flush with a wide open lens, it gives a soft, hazy appearance to a picture, while a soft screen filter with a clear center spot gives a soft focus surround to a sharp central image. A sand screen with a clear center can be used to separate a dark subject from a dark background by producing a white smoky surround to a clearly focused central image. It can also be used against a white background to give a soft-edge effect to any part of a subject which is abruptly cut off right to the edge of the frame.

Texture screens, which are underexposed negatives, are available in both 35mm and 2¼ inch square formats and can be used with both black and white and color negatives. Among the many available screens are tapestry, drawn cotton, gravel, dot screen, rough linen and craze. The screen is superimposed with a negative in the negative carrier so that each emulsion rests in contact with the other; though if you want differential enlargements, separate exposures must be made.

Depending on the subject, the density of the original negative and the aperture setting on the enlarger lens, quite different effects can be gained with a single screen, and the texture pattern can be softened by placing a small piece of glass between the negative and the screen – a glass transparency cover is ideal. Coarse screens will break up the image outline to a greater extent than fine screens. You can make your own screen by underexposing a patterned or textured surface by two stops, and underdeveloping the film to give a pale "ghost" image on the negative. Any flat, translucent material with an open weave, such as cheesecloth, or even clear patterned glass, can be used as a screen by placing it in contact with printing paper. To produce a texture surrounding, use one black mask to print in the screen and a second one to mask out the surround while exposing the central image.

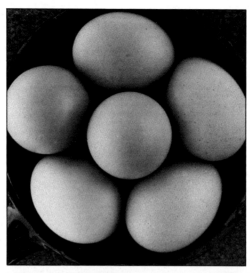

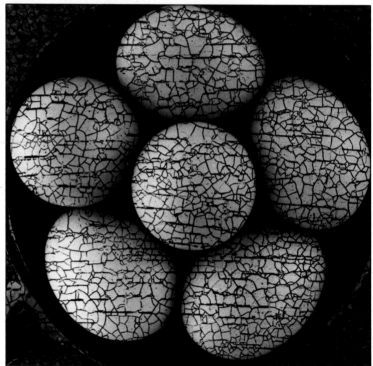

Crazed eggs △
A straight print of eggs in a bowl is shown at the top of the page. I then sandwiched the original negative with a crazed screen negative to produce a print which gives an impression of cracked eggs (above).
*Lens Hasselblad 80mm + 21mm extension
Mag. on film ×0.25
Mag. on page top ×0.5; above ×0.65*

Enhancing a photogram ▷
After making a larger-than-life-size photogram of this cherub figure, I removed the paper and the figure so that I could focus the enlarger with an "old master" screen negative. The paper was then exposed for a second time so that the cherub took on a textured appearance.
Mag. on print ×3 Mag. on page ×1

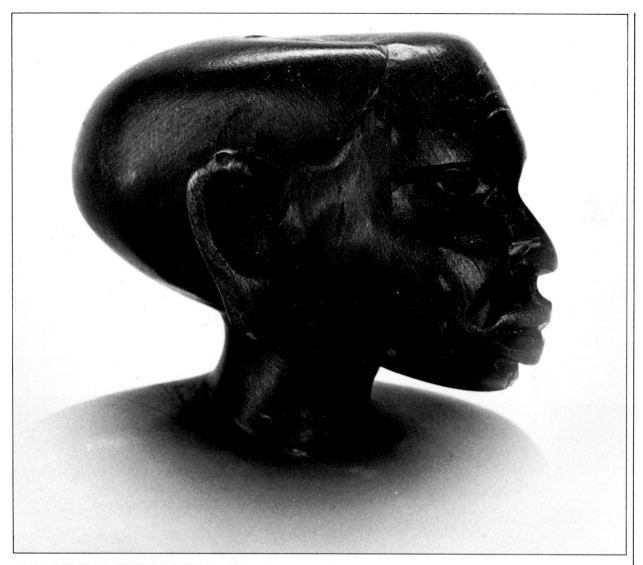

A sand screen vignette △
Using a sand screen filter, with a clear center spot, on the camera I took this carved head so that the shoulders blended into the background.
Lens 55mm micro-Nikkor
Mag. on film ×0.2 Mag. on page ×2

A reticulated image ▽
This picture, which resembles an old oil painting, was made by printing a negative of clustered walnuts with a reticulated grain negative screen.
Lens Hasselblad 80mm+32mm extension
Mag. on film ×0.4 Mag. on page ×0.85

Creative filters

Besides the more conventional filters which are used to improve the basic image (see p. 40), there are now a large number of special effect filters which alter the original image so dramatically that they totally falsify it. These filters can be brightly colored so as to produce a false color cast; completely clear with lines which turn highlights into crosses or stars; or they may be completely clear and have tiny grooves or facets which bend the light passing through them. False color filters come in many forms and they may be made up of one, two or three colors.

Clear glass filters which distort the image do so by diffusing or bending light. Diffusers produce a soft-focus image with muted colors (this effect can also be achieved simply by breathing on the lens). Diffraction filters have a fine grid pattern of prismatic grooves etched into their surface which dramatically bend points of light (including highlights) and split them into the colors of the spectrum.

The surface of multivision filters is cut into prismatic facets; the number of facets determines how many times the identical image of the subject is repeated in the frame. Some filters multiply the image around a circle (as with the rose on the right), while others repeat it in a linear way. The best effect appears when a light subject is photographed against a dark background using a large aperture.

Resist the temptation to over-use creative filters. The best results will be achieved by critically appraising the effect with and without such a filter and using it only when it enhances the basic image.

Repeating the image ▷
To create this multiple image of an iceberg rose, I used a five faceted multivision filter (see above). I carefully positioned the repeat images on the four compass points.
*Lens 55mm micro-Nikkor
Mag. on film ×0.2
Mag. on page ×1.2*

A rainbow effect ▽
This spectral abstract was achieved by photographing water as it trickled over a rock. The highlights in the moving water were diffracted by the 1270 ultra-fine parallel grooves engraved in the rainbow spot filter I used. I rotated the filter and varied the lens aperture before deciding to open up to f3.5 which gave me a shutter speed of 1/2000th sec.
*Lens 55mm micro-Nikkor
Mag. on film ×0.5 Mag. on page ×2.5*

Multiple exposures

Multiple images can be made at any stage from exposure to printing or projection. To take multiple exposures on a single frame, you must recock the shutter without advancing the film. Such a facility is found in all cameras with interchangeable film magazines, and a few which have a mechanism for disconnecting the film wind-on. Otherwise, you have to depress the rewind button when cocking the shutter.

If you want to record each image separately without overlapping in the frame, use either a black background or a double-exposure mask. If a black background is used, the subject can be moved around after each exposure, but with other backgrounds, use a double-exposure mask on the front of the lens so that only half the frame is exposed at a time. Multi-imaged pictures are more easily composed using a 2 ¼ inch square, or larger, format because the position of the subject can be sketched on the viewfinder screen after each exposure. Before attaching the mask, take a meter reading of the whole field of view and use this reading on a manual setting for both exposures. Objects with simple rounded outlines, such as eggs, effectively frame a smaller object when photographing a pair of overlapping images. Remember to adjust each exposure so that the negative or transparency has a normal density.

Multi-images combining unrelated subjects can be created in the darkroom. The simplest way is to sandwich two negatives or transparencies in the enlarger. A more creative method is to make separate exposures at different enlargements. Exciting montages can be built up by alternately exposing and developing a simple close-up image on resin-coated paper. To compose the picture, sketch the images on a piece of paper beforehand. This will help you to select the appropriate image size in the enlarger. For each exposure, use a mask to give a soft-edge effect and keep the paper in the print easel. Develop the exposed area by dabbing it with absorbent cotton soaked in developer and wedged on a pencil. Once the image has developed move the print easel for the next exposure.

Double printing ▽
I first took this dish of mustard and cress seedlings showing all the plants growing vertically (left). I took another shot after the seedlings had bent towards the light (right). The two negatives were then printed on one sheet of paper.
Lens Hasselblad 80mm+42mm extension
Mag. on film ×0.5 Mag. on page ×1

Triple exposure △
This picture was made by exposing a negative three times. I took the first exposure but before taking the subsequent exposures, I removed the Hasselblad magazine to recock the shutter without advancing the film.
Lens Hasselblad 80mm+32mm extension
Mag. on film ×0.4 Mag. on page ×0.9

Creative flash

The color of light emitted by a flash can be changed simply by taping colored gelatin filters to the front of small flash guns. Large studio flash heads have built-in filter holders for inserting the glass filters. Colored flashes can be used to light the subject, or to light up selectively the background while an unfiltered flash lights the subject. Exciting dynamic backgrounds can be achieved by precisely beaming a colored flash with a snoot attachment (see p. 158) onto a stream of rising air bubbles in an aquarium. A silhouette can be dramatized by shooting it against a background lit by a colored flash.

If you have only a single flash, or a background which is too large to light by flash, combine a pair of complementary color filters – one on the flash, and the other over the lens. For example, an orange filter covering the lens and a blue filter over the flash will render the background orange, yet a foreground close-up will be correctly balanced for color.

Projected images offer unlimited scope for studio backgrounds. The simplest technique is to back-project a slide onto a textureless, translucent screen. The camera is set up in front of the screen, directly in line with the subject and the projector. For most natural effects, position the flash to light the subject so it matches the lighting in the slide. Front projection is more complex to set up, since the background image is projected onto a silvered mirror along the camera axis. Special front projection units are now available in which the projector contains a flash and a modeling light for previewing the background.

Dramatizing foil
I used a pair of Multiblitz Minilite 200 flashes, each fitted with a snoot and a colored glass filter, to take these two pictures of crumpled aluminum foil. One flash was fitted with a red filter and the other with a green one. Using the built-in modeling lights, I was able to view precisely the effects of slightly moving the angle of each flash. On the right, the foil has been lit equally by the two flashes, whereas on the left there is only the slightest hint of red.
Lens Hasselblad 80mm + 64mm extension
Mag. on film ×0.8
Mag. on page left ×0.85; right ×3.25

◁ **Colorful kaleidoscope**
I discovered that a "dimension disk" reflects rainbow-colored lines. To preview the effect of varying the angle of light, I taped a lamp to a flash, which I then moved around. I defocused the lens and opened it up to full aperture to achieve this soft-focus effect.
Lens Hasselblad 80mm+55mm extension
Mag. on film ×0.7 Mag. on page ×0.8

△ **Oil and water mix**
I mixed some blue ink and water with corn oil and poured it onto a glass plate. I then scraped it off with a knife and took this picture by dark field illumination, using flash to freeze the constantly changing pattern as separate oil globules coalesced into oily patches.
Lens Hasselblad 80mm+159mm (56+55+32+16) extension
Mag. on film ×2 Mag. on page ×8

Darkroom manipulation

Straightforward images can be modified in the darkroom in a variety of ways. The addition of screens (p. 130) or the printing of multiple images (p. 134) do not involve any physical change to the image. Reticulation, however, results in permanent damage to the negative gelatin by causing it to wrinkle. Many modern films are designed so that reticulation will *not* occur, but it is possible to break up the emulsion into a craze by developing a film in cold developer and then plunging it into warm fixer solution.

Solarization is a technique where the image, either on the film or on the print, is fogged by exposure to white light so that the image is partially reversed. The light fogging is most pronounced on the parts of the emulsion which were originally exposed for the least time. If you discard a print before fixing it, solarization will take place. The main problem with this technique is that the extent of the reaction cannot be predicted with certainty, since it is difficult to control.

Bas-relief is the name given to a technique which resembles a low-relief sculpturing. Take a black and white negative and contact print it onto black and white film (this can be continuous tone or lith) and underdevelop so that the image is very flat. After drying, lay the two films on top of each other on a light box. By moving them slightly out of register, one side of the image becomes outlined by a dark shadow while the other side appears as a white highlight. Adjust the relative positions of the two films until you get the effect you want, then tape the films along their edges with clear scotch tape. You can then make as many identical enlargements as you want. Slightly different prints can be made by separating and repositioning the films. The type of film chosen to make the contact print will also affect the final result.

Combining a negative and a positive ▽
I made this composite print of honeycomb by contact printing a black and white negative onto negative film. I then placed the two films in the enlarger out of register so that they combined to produce a 3-D effect.
Lens Hasselblad 80mm+65mm (55+10) extension
Mag. on film ×0.8 Mag. on page ×5

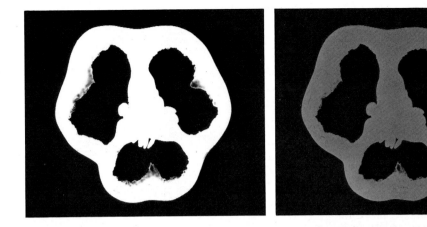

Solarizing the print
These pictures of a green pepper slice compare a negative print or photogram (far left) with a solarized one (left). I made the photogram by placing the slice on print paper beneath an enlarger and developing it normally. I repeated the process with another piece of paper. Half way through the print development, I briefly switched on a white light and then continued the development. This print solarization converts the white area to a gray color.
Mag. on print ×1
Mag. on page ×0.75

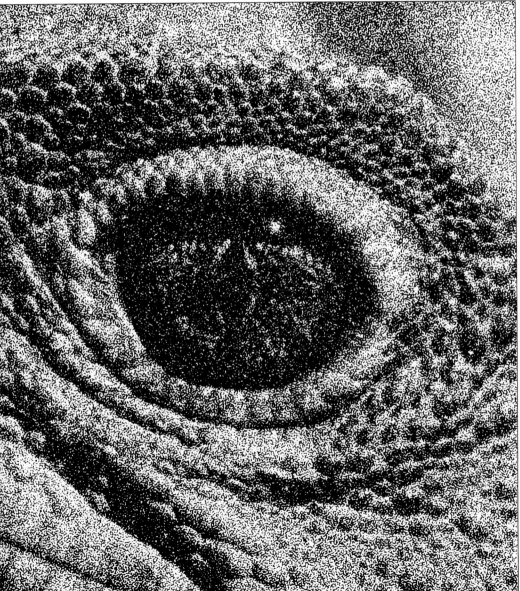

◁ **Adding a mezzotint**
This print of the head and eye of a tuatara — a primitive New Zealand reptile — was made from an original transparency. Firstly, a black and white internegative was made. A mezzotint screen was then placed in contact with the negative and the two were printed together. The screen has helped to emphasize the scaly reptilian pattern.
Lens 55mm micro-Nikkor
Mag. on film ×0.5
Mag. on page ×3.5

Polarized patterns

A pair of polarizing screens – one placed beneath the subject and the other above it – are used by scientists to enable them to analyze the positions of weak places in plastic objects which are subjected to stress. The technique – known as photoelastic stress analysis – involves making a scale model in clear plastic of the engineered structure under investigation. The model, with weights and clamps positioned to simulate the natural stress on the structure, is then placed between two polarizing screens. When unstressed plastic is viewed through two such screens, it still appears colorless; whereas spectacular color patterns appear in stressed plastic revealing the position where the maximum amount of stress occurred. The screen beneath the object polarizes the light reaching it, so that only some of the light waves pass through. Any parts of the plastic model which have been subjected to stress slow down part of the polarized light beam making two parallel beams, one of which travels faster than the other. The result, viewed through the second polarized screen, is that interference between the two beams creates the color patterns.

This technique can very easily be applied to create some exciting and unusual images of everyday plastic objects. Polarized light can also be used to reveal dramatic color patterns of crystallized substances by means of photomicrography. I took all the pictures shown on these pages in the same way. The light source was a color-corrected light box normally used for viewing color transparencies, so I was able to use Kodachrome 25 daylight filmstock. A piece of plastic polarized sheet measuring 7 × 7 inches was placed on top of the light box and the object laid on it. The camera was attached to an overhead copying stand so that the magnification could be quickly adjusted. By using a polarizing filter on the camera lens, as the second screen, I could see the effect of rotating it in relation to the lower screen by directly viewing through the camera. In each case, I metered the light passing through the object into the camera and I also took some exposures by bracketing (see p. 38) half a stop on either side. In most cases I found the metered reading was the preferred one, although for the petri dish (below left) I selected the exposure which was half a stop less than the metered one; this gave me a darker background. The intensity of the background changes dramatically from a pale gray to an intense blue as the polarizing filter is rotated on the camera.

An abstract design ▷
The clear acetate slipover sleeves used to protect 35mm color transparencies provided me with the subject for this abstract picture. I found that by folding the sleeves in half and allowing them partially to spring open, the angles of the acetate material could be varied to create a much more colorful image. The apparently haphazard arrangement is deceptive. It was achieved by repeated rearrangement and critical viewing through the camera until the best effect was found.
Lens 55mm micro-Nikkor
Mag. on film ×0.3
Mag. on page ×2.2

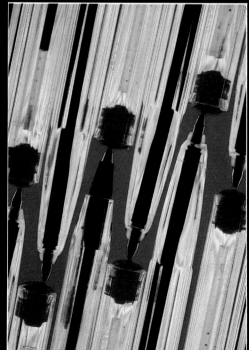

◁ **Polarized pens**
Everyday plastic objects such as these ballpoint pens become greatly enhanced when seen through two polarizing screens. I spent some time carefully arranging a boxful of pens into this abstract linear pattern.
Lens 55mm micro-Nikkor
Mag. on film ×0.5
Mag. on page ×1.75

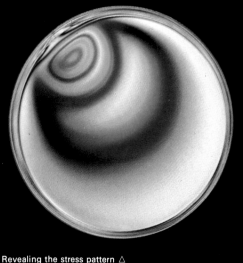

Revealing the stress pattern △
The base of a transparent petri dish, which I use for containing small subjects for photography beneath a microscope, is completely transformed when viewed through two polarizing screens. The colored pattern radiates from the point where the plastic was injected into the petri dish mold.
Lens 55mm micro-Nikkor
Mag. on film ×0.4 Mag. on page ×1.3

Photomicrography

This book covers ways and means of taking close-up pictures using a conventional camera system and extension tubes or bellows. With the exception of true macro lenses (see p. 148), it is difficult to take pictures at much greater than ×10 life-size without using a microscope. Photomicrography is the production of images by means of a microscope. This very specialized aspect of photography is really beyond the scope of this book, but a few pictures have been included to illustrate what this field offers beyond the close-up range.

Any 35mm SLR camera can be used to take photomicrographs, although a model with TTL metering will make exposure determination much easier if you do not have a special microscope exposure meter. Since magnification and focusing of the image are both done by the microscope, the lens is removed from the body of the camera which is then connected to the microscope above the eye piece by means of a light-excluding adapter. Some microscopes have optional film backs – a few for Polaroid instant film – which do away with the need for a camera body altogether. Without a camera viewfinder, the image is then focused onto an eye piece at right angles to the film back. In addition to the microscope itself, you will need petri dishes, microscope slides and glass cover slips. As for close-ups, the type and direction of the light source should be selected to suit the subject. If the microscope does not have built-in illumination, you will need to use a small-beamed light source such as a microscope lamp (see p. 157) for stationary subjects, or fiber optics (see p. 52) or an electronic flash for moving subjects.

To illuminate a specimen by bright field transmitted light, the light is shone onto a small, circular, adjustable mirror so that it passes up to the specimen on the stage via the sub-stage condenser. Dark field transmitted light is achieved by placing a circular glass disk with a black center (known as a dark field stop) beneath the condenser. Like the dark field illumination for larger subjects described on page 54, this illuminates a translucent specimen so that it appears to glow against a dark background. Opaque specimens have to be lit from above, and fiber optics provide a convenient localized light source.

Creative color photomicrographs are achieved with filters. A pair of polarizing screens can produce color abstracts of crystals.

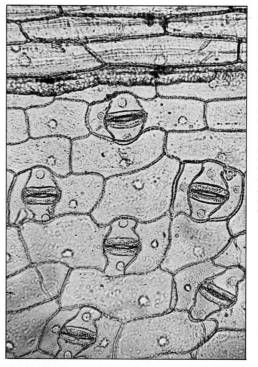

◁ **Closed stomata**
To show the pores or stomata of a leaf among the leaf cells, I peeled off the outer layer of a *Tradescantia* leaf in the evening at 9 p.m. and laid it on a clean microscope slide. Using bright field illumination, the cell walls surrounding each cell showed up clearly. In this picture, six pairs of swollen guard cells can be seen closing the stomatal openings thus preventing water loss into the atmosphere.
Microscope Wild M20
Mag. on film ×50
Mag. on page ×125

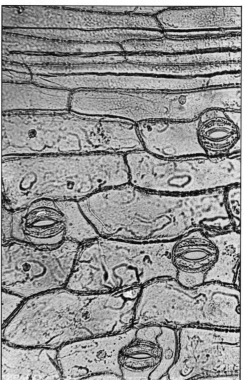

◁ **Open stomata**
I wanted to take a comparative picture of the *Tradescantia* leaf showing the stomata open. To do this, I peeled off the outer leaf layer at 8 a.m. on the following morning. The lighting was exactly the same as in the picture above. Early in the morning the guard cells contract, opening the stomata to allow gaseous exchange to take place.
Microscope Wild M20
Mag. on film ×50
Mag. on page ×125

Photographic grain △
I used a small portion of a negative from a Royal X Pan film which I had up-rated to 1250 ASA. I photographed it by bright field illumination down a microscope. At this magnification the grains of black metallic silver which comprise the image can be seen.
Microscope Wild M20
Mag. on film ×30 Mag. on page ×60

Pollen grains ▷
When ripe Korean fir cones were shedding their microscopic pollen grains, I sprinkled a thin layer onto a microscope slide which I lit by dark field illumination. The pair of air sacs on each grain can be clearly seen.
Microscope Wild M20
Mag. on film x30 Mag. on page ×180

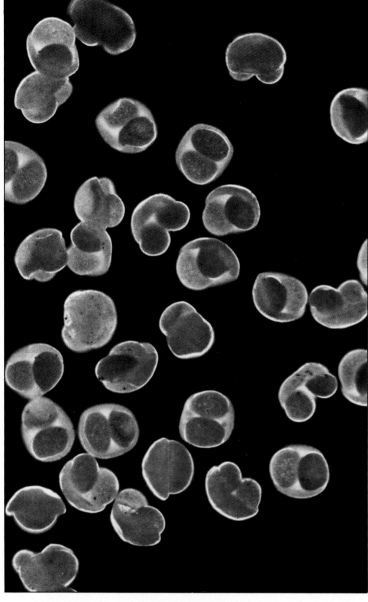

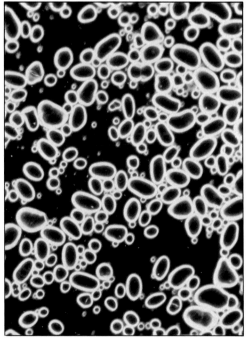

Starch grains △
To get some starch grains, I cut a raw potato in half, rubbed it onto a microscope slide and added a few drops of iodine. Dark field illumination was used to rim light the grains.
Microscope Wild M20
Mag. on film ×50
Mag. on page ×200

Etching detail ▷
In a book published in 1802, I found an etching of a lizard. I used a stereo microscope to photograph the lizard's eye lit with a single fiber optic.
Microscope Wild Photo-makroskop M400
Mag. on film ×16
Mag. on page ×48

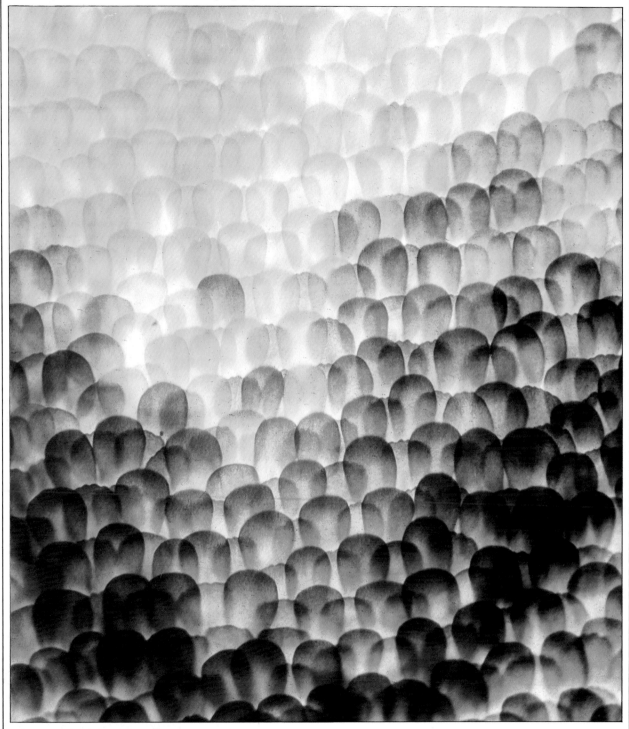

Using transillumination to reveal structure △
I collected a dead pearl-bordered fritillary and placed one
of its wings on a glass microscope slide. By lighting it
from below, I was able to show the way in which each
colored scale overlaps the two scales beneath it.
Microscope Wild M20
Mag. on film ×50 Mag. on page ×125

APPENDIX

Viewing subjects in close-up

Even those of us with good vision are limited in what we can see. The art and skill of close-up photography lies in the successful exploration of objects that are close to the lower limits of visual discrimination even for those with sharp vision. Therefore, in order to see the potential close-up subjects, you will find one of the many aids for magnifying objects a useful tool.

A variety of professional and skilled people use magnifying systems in their work. Jewelers use eyeglasses for examining the quality of small stones and for making delicate settings. Watchmakers, before the advent of the microchip, needed magnifiers for their type of miniature engineering. Dentists and ophthalmic surgeons performing intricate operations, and glass engravers working at minute scales, all need magnifying aids.

The invention of glass lenses in the seventeenth century led to dramatic advances in science and in the arts and literature. The wealthy Victorians, with plenty of leisure time, created miniature symmetrical designs and colorful floral patterns, only fractions of an inch in diameter, by painstakingly assembling collages of butterfly scales and diatoms. Even with a ×20 magnifying lens or dissecting microscope, the work was so tiring on the eyes that only a few scales could be positioned at a single session. Then, when the creation was completed, the exquisite nature of the work could only be fully appreciated with the aid of a magnifier.

For anyone exploring the delights of close-up photography, some sort of magnifier is an important accessory, otherwise so many potential pictures will be missed. I always carry a hand lens in my camera bag. This is used for the precise identification of flowers, mosses and insects which require the examination of characteristics otherwise almost impossible to see with the naked eye; and also for seeing a potential picture before I spend time setting up a camera with bellows. So I make no apologies for discussing this subject in a book on close-up photography, for what the eye does not see the camera often does not take.

Watchmaker's eyeglass ▽
This magnifying lens is held in place by the eye socket, like a monocle, so that both hands are free to hold and rotate the subject to be viewed. To find the correct focusing distance, you bring the subject up towards the lens until it is sharply focused. Eyeglasses, which are made in magnifications ranging from ×2 to ×10, are the same as those used by jewelers and watchmakers.

Folding magnifier ▷
A folding magnifier, or hand lens, is used for examining subjects held in the hand. When not in use, it can be hung round the neck. The magnification of hand lenses ranges from ×5 to ×20; some have two or three lenses which can be used separately or in combination.

Reading lens ▷
A reading lens is a robust magnifier consisting of a long handle connected to a circular magnifying glass, ranging in diameter from 2½ to 4 inches. The size of this lens makes it convenient for reading print without having to bend your head over the page. The lens magnifies up to twice life-size.

◁ **Illuminated magnifier**
This battery-powered illuminated magnifier is especially useful for examining specimens outside at night, but it can also be used for taking a closer look at stamps, coins, embroidery or tapestry. The bulb is lit up by a switch on the outside of the hollow handle.

Making a water-drop magnifier

Other magnifiers ▽
A reading glass is a slightly larger version of the reading lens, but it is attached to a base by a flexible arm. You can bend this arm into the most convenient position for viewing and this leaves your hands free to move or to sketch the object.
If you wish to look closely at a large and heavy object, you can put a magnifier on a sliding frame above it and slide the lens from side to side along the parallel bars.
A linen tester is a folding pocket magnifier designed originally for counting the number of threads in one inch of fabric. It is used by photographers and printers for critical examination of transparencies.
A transparency magnifier is a modern version of a watchmaker's eyeglass. It does not fit into the eye socket, but rests on a light box. I use this magnifier an enormous amount to view slides at all stages.
The pond-life magnifier is an ingenious cylindrical plastic magnifier with a lens at one end and a removable top at the other. Small aquatic organisms can be examined inside the tube.
Optipack is a versatile ×3 magnifier which can be held in the hand or clipped onto spectacles.

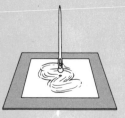

From a piece of card, cut out a 2-inch square. Then cut a hole ⅓ inch in diameter in the center of the card. Glue a piece of aluminum foil over the hole.

Use a needle or a pin to make a tiny hole in the center of the aluminum foil. Place a piece of card underneath so as not to damage the work surface.

Carefully spread a thin layer of vaseline around the pinhole on both sides of the aluminum foil. Make sure that you do not damage the foil.

Using a pipette or the blunt end of a darning needle, lower a drop of water onto the pinhole. The water should bulge out on both sides of the foil.

With a clothespin as a handle for your water-drop magnifier, hold it close to your eye for viewing specimens. With this simple water lens, you will be able to view a variety of subjects in the house or garden. When the water finally evaporates, drop more water into the hole to renew the lens.

Reading glass

Magnifier on sliding frame

Linen tester

Transparency magnifier

Pond-life magnifier

Optipack

A slide projector ▷
A projector is a useful way of enlarging a translucent or a finely perforated subject so that a number of people can view it at the same time on a screen. You will need some 35mm glass slide mounts for mounting the specimens, and they can then be projected in the same way as your transparencies. Subjects should be dry and not too thick to prevent them jamming the projector. In my lectures I have used feathers, dragonfly wings, pollen grains and partially decomposed leaf skeletons to add interest; but a piece of pantie hose or lace would be suitable subjects for viewing with a projector. Studying objects in this way will enable you to assess how appropriate they are for photographing by means of bright field illumination.

Close-up equipment

The simplest and cheapest way to get in close to a subject is to use a close-up lens (p. 20). Camera manufacturers name their close-up lenses in different ways. For example, the Hasselblad Proxars are referred to by their focal lengths, 0.5m (+2 diopter), 1.0m (+1 diopter) and 2.0m (+0.5 diopter), while the Nikon close-up lenses No. 0, No. 1 and No. 2 equal +0.7, +1.5 and +3.0 diopters respectively.

Some close-up lenses have a variable zoom focus. For example, the Hoya zoom close-up lens ranges from +2 to +10 diopters, which gives a magnification from ×0.2 to ×0.58 with a standard 50mm lens. The Zeiss Tessovar, an expensive variable zoom lens, gives a magnification from ×0.8 to ×12.6.

The advantages and disadvantages of extension tubes (p. 22), macro lenses (pp. 24–7) and bellows (p. 28) have already been described. Longer, non-automatic extension tubes — of any length — can be made from PVC plastic piping or cardboard mailing tubes. You will need to attach a T-mount to the base of the tube so it fits the camera body and a reversing ring for mounting the lens in the reverse position at the front. To eliminate internal reflections, paint the inside surface with matte black paint.

Reversing the lens
A standard lens is designed to give optimum results when the lens-to-film distance is smaller than the lens-to-subject distance. When magnifications greater than life-size are used, the lens-to-film distance is greater and the definition will be improved by using the lens in the reverse position. A reversing ring is also an inexpensive way of achieving greater than life-size magnifications without extension tubes. For example, when using a 50mm standard lens you will need 50mm extension to get a life-size (×1) magnification on the film, but if you reverse the lens without any extension, the magnification is slightly greater (×1.13). The main disadvantage of reversing the lens is that the lens diaphragm is no longer automatic, but it can be made semi-automatic by using a double cable release and a special ring — a Z ring.

True macro lenses
These specialist lenses are used by scientific photographers for gaining high resolution images at several times life-size. Their compact design makes them comparable with microscope objectives. They have no focusing mechanism, so they have to be used with a bellows extension, and the non-automatic diaphragm has to be stopped down manually. This means that they are most suitable for taking stationary subjects.

The six Leitz Photor lenses range from a focal length of 120mm to 12.5mm and provide magnifications from ×0.5 to over ×30. Each of the 50mm (f4), 25mm and 12.5mm lenses has an RMS thread which cannot be attached directly to a bellows unit, and must be screwed into an adapter.

Comparing close-up equipment ▷
I set up the camera on a Benbo tripod over an Afghan carpet, using the close-up equipment labeled A-F. Starting with a close-up lens (1), I took portions of the carpet at increasingly greater magnifications, using a macro lens (2), extension tubes (3), bellows (4), lens reversed on bellows (5) and a true macro lens (6). The precise magnification of each picture reproduced on the page can be found by tracing the line linking each picture to the magnification column on the right. With a close-up lens (1), the symmetry can easily be discerned on part of the border pattern at ×0.15 life-size, but at greater magnifications, the pattern, although still visible, becomes less pronounced, until at ×6 life-size (6), the individual threads dominate the picture and all trace of the pattern is lost. The vertical shaded bands show the magnification range which can be achieved with each illustrated piece of close-up equipment.

◁ **Swing and shift**
The lens carrier of the PB4 Nikon bellows can be shifted 10mm off center to the left or right. The lens can also be swung 25° to the left or right.

55mm macro lens
This macro lens focuses continuously from infinity to ×0.5. At close range the lens becomes extended as the built-in extension is racked out on the helical mount.

Extension tubes ▽
These are inserted between lens and camera to give increased magnification. Automatic tubes couple up with the automatic diaphragm in a lens.

Double cable release △
A double cable release gives semi-automatic diaphragm control when using PB6 bellows alone, or when using PB4 bellows with the auto ring. One end is inserted into the camera, and the other into the auto ring so that it stops down the diaphragm to the preselected aperture.

Splitfield and zoom close-up lenses ▷
The splitfield (left) allows close and distant subjects to be in focus at the same time, providing the close-up is not positioned in the center of the frame. The zoom close-up (far left) has a variable focus which provides a continuous magnification range.

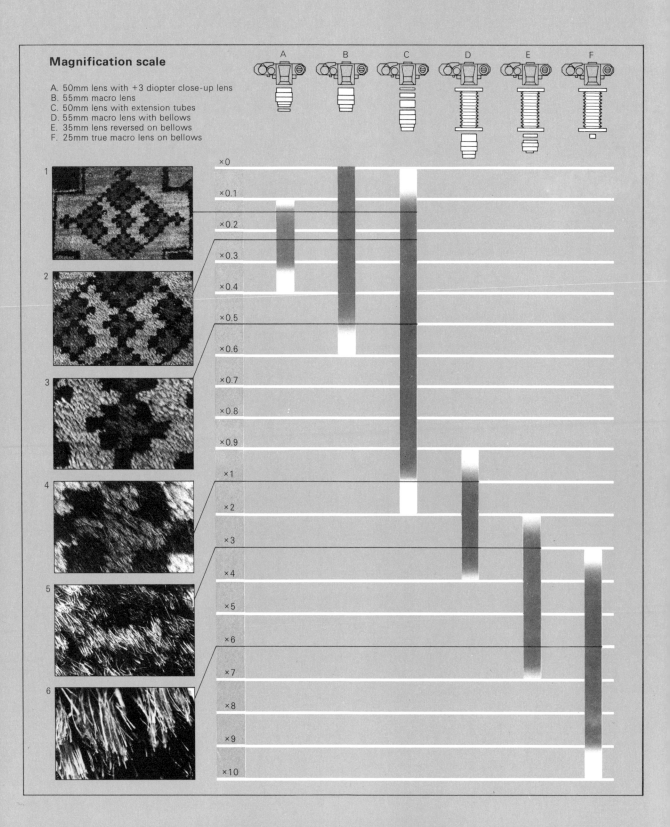

Magnification scale

A. 50mm lens with +3 diopter close-up lens
B. 55mm macro lens
C. 50mm lens with extension tubes
D. 55mm macro lens with bellows
E. 35mm lens reversed on bellows
F. 25mm true macro lens on bellows

A B C D E F

×0

×0.1

×0.2

×0.3

×0.4

×0.5

×0.6

×0.7

×0.8

×0.9

×1

×2

×3

×4

×5

×6

×7

×8

×9

×10

Camera supports for close-ups

When taking close-ups by available light, a rigid camera support is essential to ensure a sharply defined image. Camera movement can so easily ruin the definition of a photograph, but most especially a close-up one, when even the slightest movement becomes greatly exaggerated. Other reasons why an image appears unsharp are subject movement and vibration of the camera mechanism itself. The former problem can be cured by using a fast shutter speed or flash; the latter by locking up the mirror, a facility available on sophisticated SLR cameras.

The slowest shutter speed at which to hand-hold a camera, without risk of camera shake, is the shutter speed closest to the reciprocal of the focal length of the lens; for example, 1/60th second for a 50mm lens. When using extension tubes, however, this speed will not be fast enough to eliminate camera shake. Therefore, if you have no tripod or other conventional camera support, and you wish to hand-hold the camera for a close-up, it will help if you brace your arms on your knees, or brace one side of your body against a tree. Alternatively, if the ground is soft and dry, you may prefer to lie prone. A bag filled with dry beans or rice placed on the ground can be molded to fit the underside of a camera and its lens. However, none of these home-made supports is an ideal substitute for a rigid tripod. Without question the most robust and versatile of all the tripods is the Benbo. For the last decade I have worked with one in every type of terrain — forests, deserts, seashores, swamps and glaciers. I regard it as essential for any type of photography, but especially for close-ups. Many people flinch at the thought of carrying 8 lbs in weight, in addition to cameras and lenses, but it is pointless spending a lot of money on a good camera and a macro lens and making do without a tripod. The independent movement of the three legs and center column of the Benbo allows you to mount the camera at any angle from ground level to maximum extension — however rough and uneven the terrain. I

Universal camera support ▽
When clamped onto an automobile window, this support is useful for long-focus macro lenses, such as 200mm, or macro-zoom lenses. It can also be adapted to a table-top support.

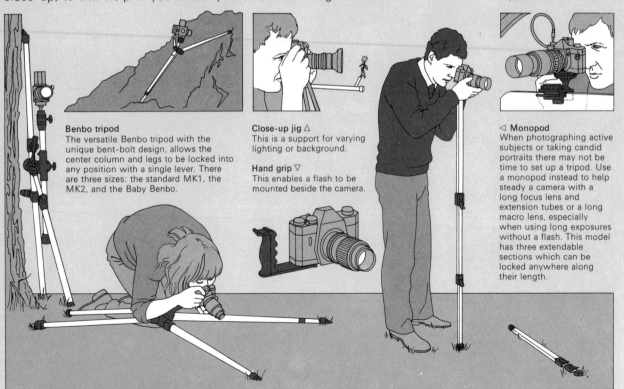

Benbo tripod
The versatile Benbo tripod with the unique bent-bolt design, allows the center column and legs to be locked into any position with a single lever. There are three sizes: the standard MK1, the MK2, and the Baby Benbo.

Close-up jig △
This is a support for varying lighting or background.

Hand grip ▽
This enables a flash to be mounted beside the camera.

◁ **Monopod**
When photographing active subjects or taking candid portraits there may not be time to set up a tripod. Use a monopod instead to help steady a camera with a long focus lens and extension tubes or a long macro lens, especially when using long exposures without a flash. This model has three extendable sections which can be locked anywhere along their length.

also use a pair of Benbo tripods to support flashes on uneven ground.

Before investing in a tripod, make sure you know its capabilities and its limitations. The main points to check when buying a tripod are that it is completely rigid, the center column can be reversed (or failing that, the head can be reversed on the column), and the legs can be adjusted and locked anywhere along their length. A ball and socket head will make fine adjustments in any direction more easily than a pan and tilt head. If you do not want to carry a large tripod in your hand, you can either strap it to the bottom of a backpack or attach a tripod strap for carrying it over your shoulder.

Large tripods and table-top models can also be used for studio work, but if you want to do any overhead copying work, you will find it easier to use a copy stand. This should also be rigid, and preferably equipped with a focusing slide for critical focusing. I often use table-top tripods for supporting small electronic flashes on close-up sets.

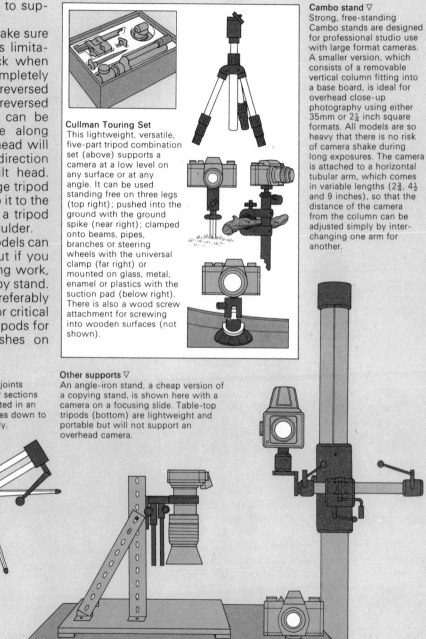

Cullman Touring Set
This lightweight, versatile, five-part tripod combination set (above) supports a camera at a low level on any surface or at any angle. It can be used standing free on three legs (top right); pushed into the ground with the ground spike (near right); clamped onto beams, pipes, branches or steering wheels with the universal clamp (far right) or mounted on glass, metal, enamel or plastics with the suction pad (below right). There is also a wood screw attachment for screwing into wooden surfaces (not shown).

Cambo stand ▽
Strong, free-standing Cambo stands are designed for professional studio use with large format cameras. A smaller version, which consists of a removable vertical column fitting into a base board, is ideal for overhead close-up photography using either 35mm or $2\frac{1}{4}$ inch square formats. All models are so heavy that there is no risk of camera shake during long exposures. The camera is attached to a horizontal tubular arm, which comes in variable lengths ($2\frac{3}{4}$, $4\frac{1}{2}$ and 9 inches), so that the distance of the camera from the column can be adjusted simply by interchanging one arm for another.

Combistat tripod ▽
A single lever arm locks and unlocks all three joints connecting the camera bracket and two upper sections of this tripod. The camera can then be supported in an infinite variety of positions. The tripod collapses down to a length of 21 inches and can be stowed easily.

Other supports ▽
An angle-iron stand, a cheap version of a copying stand, is shown here with a camera on a focusing slide. Table-top tripods (bottom) are lightweight and portable but will not support an overhead camera.

Useful accessories

I use many of the accessories illustrated on these pages to aid my close-up photography — both out of doors and in the studio. Some, such as the striped cable release, plant clamp, filter wrench, filter holder, light meter, right-angle viewfinder and white Lastolite reflector, are kept permanently in my backpack which I use for carrying my equipment on location. In addition, I also carry a set of watchmaker's screwdrivers, a lens cleaning brush, spare batteries for cameras and flash guns, glass filters in filter stacking caps and a pocket tape recorder.

When working on location I keep all my films—both exposed and unexposed—in a double-layered cooler box with a freezer pack. If I cannot find a shady place for the cooler box, I cover it with layers of old sacks and boxes. In hot humid climates films should be kept as dry as possible, preferably by laying them on dry (blue) silica gel crystals in an airtight box.

In my automobile I keep old plastic bags for kneeling on wet sand or boggy ground; a large umbrella for protecting the camera and tripod during rain showers; a pair of waders for walking out into rivers to photograph aquatic plants in midstream; and I find a pair of gardener's knee pads useful for protection on hard rocky ground.

If you are walking any distance out of doors you must find a convenient method of carrying all your equipment. When working only a short distance from the automobile, or any other base, I find a photographer's vest very useful for carrying a limited number of lenses and accessories. When working on snow or a wet beach, or in water where it is impossible to put equipment down on the ground, a vest is invaluable. Everything comes easily to hand without having to return to base to change a lens or retrieve a forgotten filter. A shoulder bag with a single shoulder strap is not comfortable or practical when I am walking any distance over rough ground; so I always use a backpack which cannot slip off my shoulders should I fall. Smaller packs attached to a belt are useful for carrying a basic kit including a camera with one lens, extension tubes, a cable release, films,

filters and a piece of aluminum foil as a reflector. Some wide camera straps have elastic loops for holding up to three 35mm films. If you are doing a lot of tripod work, a camera strap can get in the way, so it is worth getting one with quick-release clips.

I have often found through bitter experience that it is the small item which proves to be crucial to achieving the desired picture. This is why I now use a fisherman's tackle box (see p. 154) which is divided into compartments. This houses such essential items as multiple flash connectors, extension leads, slave units, $\frac{1}{4}$ inch to $\frac{3}{8}$ inch conversion bushing (for converting a $\frac{3}{8}$ inch continental tripod socket on a camera to a $\frac{1}{4}$ inch), flash ball and socket heads, lens socket heads, lens reversing ring, modeling clay, a pair of scissors, string, clear scotch tape, and 2 inch wide rolls of scotch tape in white and black for taping down anything from electric cables to flash extension leads.

Plant clamp
A home-made clamp with two spikes — one is pushed into the ground and the other steadies a stem.

◁ **Conspicuous cable release**
I have lost many cable releases outside, so I now mark them with bands of colored scotch tape.

Photographer's vest △
This Bulldog vest has 15 pockets, including four large front ones, two of which are padded.

Ewa-cape rain cover ▷
This transparent PVC rain hood covers the camera completely. The lens flap folds back for photography.

For use inside and outside

Interchangeable screens

Plain matte
Gives a clear overall image for close-ups.

Cross-hair matte
Good for photomacrography and photomicrography.

Matte with fresnel
Good for lenses with small maximum apertures – 120mm f4 Medical-Nikkor.

Ground glass with double cross-hair reticle
Gives a bright image in dim light. 1mm increments aid magnification determination.

Check pattern, matte with fresnel
Horizontal and vertical lines aid critical copying work.

Filter wrench △
These plastic filter wrenches can be used on any sized filter from 48-58mm in diameter. One wrench can loosen a filter jammed onto a camera lens, while two wrenches will be needed to separate one filter from another or a filter from a close-up lens.

Gelatin filter holder △
This filter holder screws into the filter mount of the lens. It has a safety catch which secures the gelatin and holds it flush with the front of the lens.

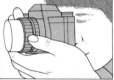

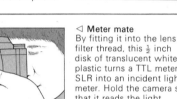

◁ **Meter mate**
By fitting it into the lens filter thread, this $\frac{1}{2}$ inch disk of translucent white plastic turns a TTL metering SLR into an incident light meter. Hold the camera so that it reads the light *falling* on the subject.

Luna-six light meter △
This sensitive light meter is useful for metering low light levels.

Viewfinder accessories ▷
A right-angle viewfinder gives an unreversed 1:1 image of the full viewfinder field. It can swivel through 180° for awkward angles, but normally it is used in the upright position. The eyepiece magnifier aids precise focusing by giving a ×2 magnification. For viewing the whole field, flip it up on its hinge.

Right-angle viewfinder

Eyepiece magnifier

Mirror on stand △
Sold as a still-life accessory, this 2 inch diameter mirror can be used to reflect light onto shaded parts of a tiny subject.

Spirit level ▷
This fits into the hot shoe to check vertical or horizontal levels.

Lastolite reflector

Balcar diffuser

◁ **Reflectors and diffusers**
The Lastolite reflector springs open from its twisted form, stowed in a compact 14 inch pouch, to a full 40 inches in diameter. Use a gold one for warming up colors, a silver one for cooler hues, or for normal colors, use the white one, which can also serve as a diffuser to soften harsh direct light. The faceted Balcar diffuser breaks down into two components; any number can be used to build a light box or even a complete wall.

For use inside

Photo jack ▽
This is a support to keep books level for copying, or for bringing a specimen into focus for overhead photography.

Clamp stand △
A clamp stand will support specimens, fiber optics, small flash guns, backgrounds, reflectors, etc.

Focusing slide △
The dual axis stage of this slide allows front, back and sideways camera movements.

Intervalometer ▽
This triggers a motorized Hasselblad at intervals from 2 sec to 14 mins.

Planning a close-up studio

Providing the lighting is kept simple, you do not need a spacious studio for taking close-up photographs. They can be taken anywhere inside — on a small table, a bench or even a windowsill. You can use available light from a window to light plants or cut flowers; tungsten halogen spotlights to boost the light on stationary subjects; or small electronic flashes to arrest moving insects or tropical fish. Many of the lighting techniques illustrated in this book were set-up on a spacious table in my kitchen, because my garden studio has no central heating.

Once you start to experiment with lighting, however, a small table is no longer adequate for supporting the lights, reflectors and diffusers, and if you are doing a lot of close-up photography, it will be much easier if a separate room — however small — can be used as a studio.

As with any functional area, the design of a studio should not be rushed. Since each photographer evolves his own style and favors his own particular equipment, it is invariably a mistake faithfully to reproduce another photographer's studio. While there are several essential items every photographer requires, the positioning of electric power points, benches and sinks is a matter of personal choice. Only by using a studio for a while will you know what is most convenient for you.

My own studio has fixed benches and some free-standing tables which can be pulled out into the center of the room so that it is easier to light the subject from any direction. The advantage of the fixed benches is that when they are fitted flush with the wall, apparatus does not fall down the back. I keep space beneath some benches so a stool can be stowed and so that the front tripod leg is not obstructed when the camera is flush with the front of the bench. Cupboards, drawers and shelves can be built beneath benches for storing additional equipment.

Not long ago, studio floors were festooned with snaking electric cables; but now overhead gantry systems allow lights to be suspended from the ceiling so the floor is free of cables, except when a low-level light is required.

Overhead lighting track
The Bowens Hi-glide light track system provides smooth-running overhead lighting. If studio flashes, such as the Multiblitz Minilite (see p. 159), are suspended from a counterbalanced lifting system, their height can quickly be adjusted and maintained at the level required for each lighting set-up.

Wet bench
All water and liquids should be confined to one area, preferably a complete bench with a laminated top. A sink provides a source of water and a place to wash up dirty containers. On the other end of the bench is an aquarium.

Ring flash
The Quadmatic ringlite flash is one accessory in the close-up system.

Light table
A light table, consisting of a metal framework which supports a curved sheet of flexible, white, opaque plexiglass, provides a continuous translucent background for lighting glassware from below. Beneath the table is an electrically powered flash with barn door attachments.

Fiber optics
I keep my fiber optics unit adjacent to the microscope so I can use the flexible arms for lighting close-ups or photomicrographs.

Using a light tent
A light tent is necessary for diffusing direct light sources used to illuminate highly reflective porcelain or metallic objects. If the object does not fit inside a commercial diffuser such as those illustrated on p. 153, you can make a three- or four-sided light tent using either rigid white opal plexiglass, Kodatrace sheet or even tracing paper.

Wild stereo microscope
When viewing and photographing a subject under a microscope, it is much more comfortable to sit on a stool. This microscope and the exposure meter both have to be plugged into the electricity.

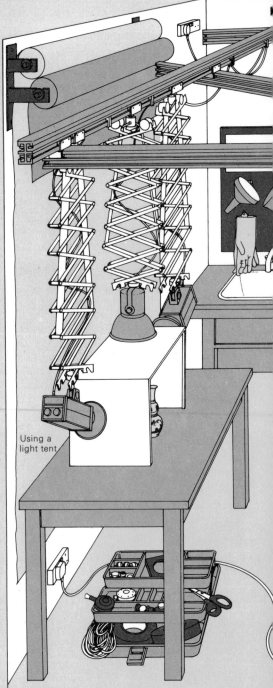

Using a light tent

Small accessories box
I use a fisherman's tackle box for storing small items such as slave units, extension leads, flash ball and socket heads, scissors, string and tape so that they are always readily available — both in the studio and on location.

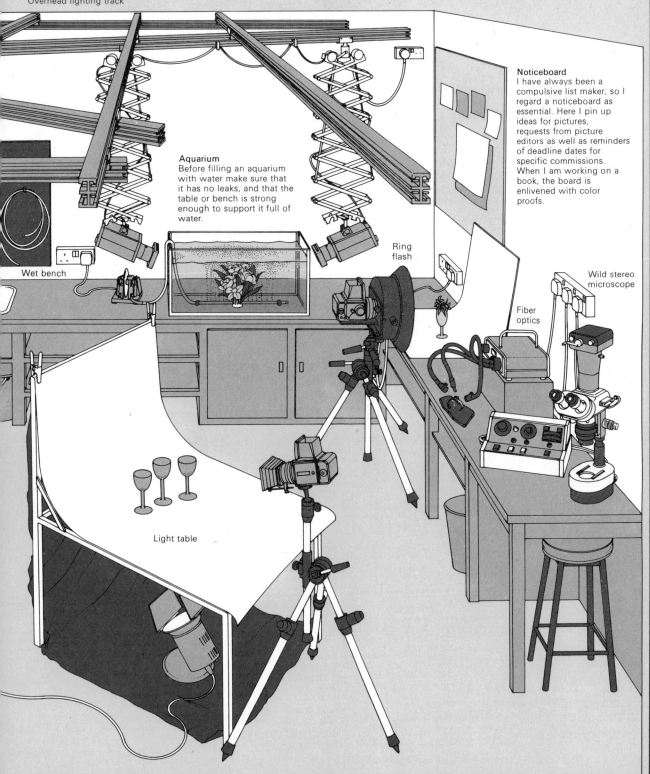

Overhead lighting track

Aquarium
Before filling an aquarium with water make sure that it has no leaks, and that the table or bench is strong enough to support it full of water.

Wet bench

Noticeboard
I have always been a compulsive list maker, so I regard a noticeboard as essential. Here I pin up ideas for pictures, requests from picture editors as well as reminders of deadline dates for specific commissions. When I am working on a book, the board is enlivened with color proofs.

Ring flash

Wild stereo microscope

Fiber optics

Light table

Continuous light sources

In 1877, the first studio to use electric light was opened in London, England. Exposures of between three and ten seconds were possible using a carbon arc lamp with a four-foot reflector. Today, many professional studios rely solely on a battery of electronic flashes with a range of diffusers and reflectors to simulate natural lighting. Continuous lighting, however, is very useful for viewing precisely where the highlights and shadows will fall on small, stationary subjects. This is not possible when using small flash guns without a built-in modeling light. An advantage of tungsten lighting is that, unlike flash (see p. 158), you are not limited to comparatively slow speeds with a camera which has a focal plane shutter. All the lights illustrated on these pages are electrically powered, but the recent growth in the video industry has led to the production of continuous portable light sources which can be used on location and run off their own power source, or off an automobile battery.

The large studio spotlights and flood lights used to light expansive studio sets are generally not suitable for lighting close-ups, since they give off too much heat. Less powerful lights are useful for making copies of original artwork, drawings, photographs and paintings. The range of subjects reproduced on pages 48–9, and the way I chose to light them, shows how careful thought must always be given to which light source will be most suitable for a particular subject. Many pictures in this book have been taken using fiber optics (see pp. 50–1).

Whatever type of lighting I select, I often have to improvize ways and means of controlling the light. For example, I make miniature snoots from black paper, miniature diffusers from collars and truncated cones from tracing paper or Kodatrace, and I use tiny mirrors or aluminum foil as reflectors.

Recording authentic color

When copying paintings, embroidery or tapestries for reproduction in books, it is clearly important to reproduce the colors as faithfully as possible. If the original is covered by a layer of protective glass which cannot be removed, use a matte black board mask to eliminate reflections of lights, camera and hands in the glass, cutting a hole out of the centre for the camera lens to poke through. Make a seal to cut out light by fixing a sleeve of black material to the hole and gathering the free end into an elasticated band so that it fits tightly over lenses of any diameter. Glare produced on the surface of a painting by polarized light can be eliminated by using a polarizing filter over the light sources and the camera lens.

Any slight shift in the original coloration of the subject itself can be detected by placing a Kodak Color Control Patch at the edge of the frame so that it does not intrude into the subject area. This 8 inch long paper strip has unvarnished standard color patches (as used in web offset printing) printed on it. These colors can be compared with their reproduction in a transparency or a color proof.

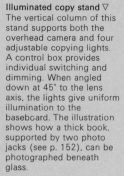

Illuminated copy stand ▽
The vertical column of this stand supports both the overhead camera and four adjustable copying lights. A control box provides individual switching and dimming. When angled down at 45° to the lens axis, the lights give uniform illumination to the baseboard. The illustration shows how a thick book, supported by two photo jacks (see p. 152), can be photographed beneath glass.

Filter insertion △
Gelatin or glass filters can be inserted into the front of the lamp, and held there by three protruding lugs.

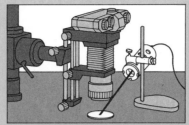

Incident lighting △
To light a solid specimen from above, a simple microscope lamp is positioned beside an overhead camera. This gives a harsh direct lighting with strong shadows, which can, if necessary, be filled in with a reflector.

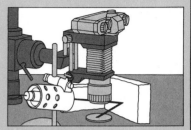

Reflected lighting △
One microscope lamp is directed onto an aluminum foil reflector which is curved around the specimen. It is lit by the light bouncing off the reflector in all directions. This gives lighting without any harsh shadows.

Microscope lamp
A microscope lamp is a precise light source for lighting small subjects. The lamp is mounted on a 9 inch stand. Both the height and angle of the lamp can be adjusted by means of locking screws. At the front of the lamp, there is a continuously variable diaphragm which is simply controlled by moving a lever up or down. The detailed close-ups of the front of the lamp show the diaphragm half-open (top right) and stopped right down (below right). I use a transformer to run two of these low voltage lamps off electricity.

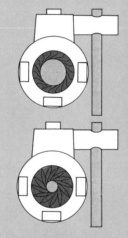

Diffuse lighting △
A white acetate collar acts as a miniature diffuser cone for a pair of microscope lamps. This translucent material diffuses the direct light to produce soft, even lighting, well suited to shiny subjects.

Transmitted lighting △
The specimen is placed on a raised glass sheet, so that a mirror can be positioned at 45° beneath the glass. The microscope lamp is directed onto the mirror and the light passes up through the translucent subject.

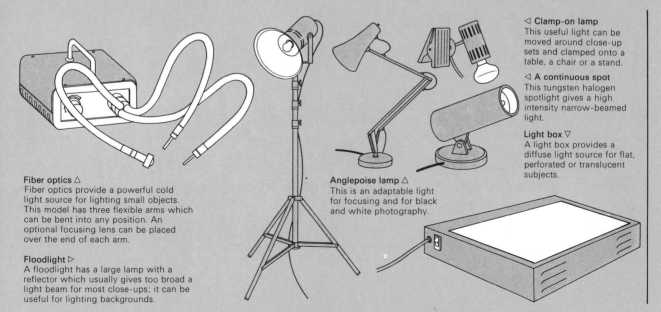

Fiber optics △
Fiber optics provide a powerful cold light source for lighting small objects. This model has three flexible arms which can be bent into any position. An optional focusing lens can be placed over the end of each arm.

Floodlight ▷
A floodlight has a large lamp with a reflector which usually gives too broad a light beam for most close-ups; it can be useful for lighting backgrounds.

Anglepoise lamp △
This is an adaptable light for focusing and for black and white photography.

◁ Clamp-on lamp
This useful light can be moved around close-up sets and clamped onto a table, a chair or a stand.

◁ A continuous spot
This tungsten halogen spotlight gives a high intensity narrow-beamed light.

Light box ▽
A light box provides a diffuse light source for flat, perforated or translucent subjects.

Using flash for close-ups

It is possible to take close-ups without using flash, which is a pity, since flash is an exciting tool. Electronic flash is balanced for use with daylight color films, so you can switch from using natural light to electronic flash on a single film.

Illuminating the background

A single lightweight electronic flash can illuminate a close-up outside, but since the intensity of a point light source rapidly falls off in inverse proportion to the square of the distance, a background just behind the subject will not be adequately lit. To avoid the picture having a nocturnal appearance, use another flash to illuminate the background.

Determining the flash exposure

The formula used for calculating the correct exposure with flash does not apply when taking close-ups. You can make a direct reading using a flash meter or use a fiber optic macro flash sensor plugged into a National flash gun. Otherwise you can determine the correct exposure for a given film speed by keeping the flash in a fixed position and varying the aperture for each magnification.

Once you start moving the flash away from the camera, however, you will need to calculate the correct combination of flash-to-subject distance and aperture. Firstly, if the guide number (GN) for a given film speed is not known, it can be calculated with the following formula:

$$\text{New GN} = \text{Quoted GN} \times \frac{\sqrt{\text{New film speed}}}{\sqrt{\text{Quoted film speed}}}$$

If a flash has a GN of 50 for 100 ASA film, and you wish to use 25 ASA film

$$\text{New GN} = 50 \times \frac{\sqrt{25}}{100} = 50 \times 0.5 = 25$$

By using the GN for the relevant film speed, you can calculate the flash-to-subject distance (in centimeters) for different magnifications as follows:

$$\text{Flash-to-subject distance} = \frac{\text{GN} \times 100}{\text{f stop} \times (\text{magnification} + 1)}$$

You will need to calculate the distance for different magnifications for each aperture, the most useful for gaining maximum depth of field being f16 and f22.

Flash diffuser △
A clip-on flash diffuser will give a soft light without harsh shadows.

Reflector ▽
Some electronic flashes, such as the Vivitar, have optional reflector holders for bouncing the flash.

◁ **Single flash bracket**
This Novoflex bracket allows a small electronic flash to be mounted anywhere around the lens axis. The camera and flash can then be moved toward the subject as a single unit. When the flash is moved closer to the subject, this compensates for the light loss resulting from the increase in the amount of extension.

◁ **Macro flash**
This unit consists of three flashes (two only illustrated here), which can be used to illuminate a subject photographed with a macro lens or a standard lens with extension tubes. Two flashes are mounted independently of each other on adjustable arms clipped onto rings. These can be rotated around the lens axis, so the position of each flash can be quickly adjusted. A third flash can be mounted on a long arm to illuminate the background.

Twin flash bracket △
This boomerang-shaped bracket allows a pair of small electronic flash guns to be mounted on either side of the camera. I reduce the output of one gun by covering it with a diffusing screen.

Multiblitz Minilite 200 system

This versatile, portable, studio flash system can be carried in a compact case. Each basic electrically powered unit has a color corrected flash tube, a halogen modeling light, a built-in slave unit and a socket for a reflector umbrella (right).

The interchangeable heads can be quickly fitted to the bayonet mount. When several Minilites are used, only one is connected to the camera; the others are triggered by their built-in slave units.

Light box

Reflector umbrella

◁ **Snoot attachment**
This provides a narrow-angled beam. The color can be changed by inserting a glass filter into the filter holder.

Barn door attachment ▷
The angle of a direct light beam can be precisely controlled by using the clip-on barn door attachment (right). Another clip-on accessory is a small diffuser screen (not shown). A light box (above) provides a large diffusing light source for illuminating highly reflective subjects.

Filter holder

Snoot

Vivitar 4600 modular system

This dedicated modular flash is the first 35mm system to have completely interchangeable heads. The standard flash head (right) has horizontal and vertical bounce, rotation through 270° and variable tilting positions (below).

Standard flash head

Bulb head

◁ **Bare bulb head**
This is an electronic substitute for an incandescent light bulb.

Zoom head ▽
The power zoom head has four settings for use with different focal length lenses. When it is in the 50mm position, it gives extra power and so boosts the guide number (below). A power pistol grip (not shown) supports the flash away from the camera and shortens the flash recycling time.

Power pack

Dedicated module

Power zoom head

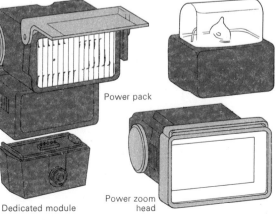

Open flash

If you have only a single flash you can use it to paint light on a stationary subject using the open flash technique. You will need to work in a dimly lit room, using a slow-speed film and a small aperture. Position the flash on a stand and release the shutter on the B setting using a locking cable release to keep the shutter open. Hold a black card in front of the lens while repositioning the flash. Remove the card and fire the flash manually, and finally close the shutter.

Remote triggering

Firing the camera by using a remote trigger may be the only way you will get a photograph of a timid animal in the wild. Most simply this can be done using a long air release and setting up the camera at a site which has been baited. The only way to ensure the subject is sharply focused is to set up a pair of crossed light beam triggers and to prefocus the camera at the point where they intersect. When working at night, use a red or an infra-red light beam instead of normal white light, so that nocturnal animals cannot detect it.

Use a camera with a motorized body to avoid unnecessary disturbance when recocking the shutter by hand.

⊲ Slave units
Light-sensitive slave units are used to fire cordless flash guns which are not attached to the camera. The light emitted from the main flash, which is connected to the camera, is instantaneously detected by each slave unit, which triggers off its own flash. A slave unit may be fitted with a suction disk for attachment to a flash (left), a flash shoe (below left) or a tripod bush thread (not shown). The synchro-cord from the flash must be plugged into it. Optical slave units cannot be triggered by sunlight or tungsten light.

⊲ Hot shoe to flash cable adapter
If your camera has a hot shoe connection for firing a flash, and no separate flash synchronization socket, you will not be able to use a flash remote from the camera without this adapter. After it has been inserted into the camera hot shoe, a flash extension lead is plugged into the side. A flash can then be moved anywhere around the lens axis. If you wish to use multiple flashes, either insert a multiple flash connector into the adapter, or use slave units on the additional flash guns.

Minolta Flash Meter III

This versatile meter gives precise readings of incident or reflected ambient light or tungsten light, a combination of both, or of pulsed light. The booster II accessory (above) will read directly off the focusing screen or the film plane. Here the meter is connected to the eyepiece of an SLR camera with bellows, where it can make TTL readings of flash exposures.

Multiple flash connectors △
If you do not have slave units for firing several flash units at once, there is a cheaper alternative — a multiple flash connector. Plug this into the camera flash synchronization socket and attach an extension lead from each flash to the connector. Above from left to right are double and quadruple connectors.

Automatic synchro-cord △
This cord can be used to fire a "dedicated" automatic flash remote from the camera. One end is inserted into the camera hot shoe, the other into a flash shoe on a bracket or a light stand, for connection to a flash.

Flash ball and socket head △
This head has a $\frac{1}{4}$ inch tripod thread at the base, and a flash shoe at the top. They allow quick adjustment of a flash remote from the camera.

Technical data

Depth of field table

Except for abstract images, at least some part of a close-up picture should be sharply focused. It is important to remember that when taking a close-up, the depth of field extends equally on either side of the point of focus; unlike general photography when it extends about twice as far behind the plane of focus as in front of it. The sharpness of an image also depends on the definition of the lens and the resolution of the film emulsion.

This table gives the depth of field (see p.30) for various magnifications ranging from ×0.1 to ×5 for apertures of f5.6, f8, f11, f16 and f22. From this it can be seen that the depth of field decreases as the image size increases or if the lens aperture is opened up. However, at high magnifications diffraction causes light to spread out as it passes through a small aperture, which results in a reduced resolution of the image. The table can be used for any lens except wide-angle or long-focus lenses.

Magnification table

This table shows the range of magnifications which can be obtained using various Nikon close-up accessories with different focal length lenses. Notice how the greatest magnification is gained with the shortest focal length lens (35mm) mounted on the bellows in the reverse position. The three so-called micro lenses (55mm, 105mm and 200mm) are, in fact, macro lenses (see pp. 24 and 26) all of which can be focused to give a half life-size (×0.5) without any additional close-up accessories. The 55mm micro Nikkor lens is illustrated on page 148.

All the major 35mm camera systems produce similar magnification tables which are applicable to their own close-up accessories. Using such a table you can quickly assess which close-up accessory you require for gaining a particular magnification. Alternatively, tables which show a continuous extension scale (in millimeters) can be used to read off the precise magnification after a picture has been taken.

Depth of field table for 35mm format

Mag. on film	f5.6		f8		f11		f16		f22	
	in	mm	in	mm	in	mm	in	mm	in	mm
×0.10	1.4	36.4	2	52.0	2.8	72.8	4.19	106.0	5.86	148.4
×0.15	0.7	16.8	1	24.0	1.4	33.6	2	49.0	2.8	68.6
×0.20	0.35	10.1	0.56	14.0	0.79	19.6	1.125	29.0	1.6	40.6
×0.25	0.26	6.7	0.375	9.6	0.525	13.4	0.75	19.0	1.05	26.6
×0.33	0.17	4.1	0.25	5.9	0.35	8.3	0.5	12.0	0.7	16.8
×0.50	0.09	2.0	0.125	2.9	0.175	4.1	0.25	5.8	0.35	8.12
×0.75	0.04	1.0	0.06	1.50	0.09	2.1	0.125	2.98	0.2	4.17
×1.0	0.02	0.7	0.03	0.96	0.04	1.3	0.69	1.92	0.09	2.69
×1.5	0.014	0.4	0.016	0.53	0.022	0.74	0.05	1.07	0.07	1.50
×2.0	0.010	0.25	0.014	0.36	0.02	0.5	0.03	0.72	0.04	1.01
×3.0	0.006	0.15	0.008	0.21	0.01	0.3	0.02	0.43	0.02	0.60
×5.0	0.003	0.08	0.005	0.12	0.007	0.17	0.01	0.23	0.01	0.32

a. Depth of field is almost equal on each side of the plane of focus.
b. Data are based on a 0.03mm (0.0012in) circle of confusion.

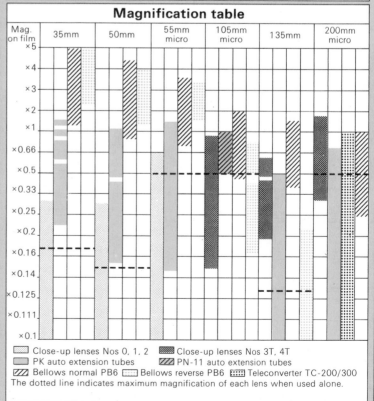

Magnification table

Close-up lenses Nos 0, 1, 2 Close-up lenses Nos 3T, 4T
PK auto extension tubes PN-11 auto extension tubes
Bellows normal PB6 Bellows reverse PB6 Teleconverter TC-200/300
The dotted line indicates maximum magnification of each lens when used alone.

Viewing transparencies

As soon as your transparencies are processed, you will want to view them to assess their worth. A hand slide viewer is a cheap way of quickly previewing slides, but it is not convenient for showing slides to several people at the same time. Models which run off electricity give a better quality image than battery-operated viewers, although the latter can be useful in remote areas where there is no electricity.

Slides in plastic or cardboard mounts can be assessed by projecting them one at a time in a non-automatic model, or by preloading the whole film into a magazine for use in an automatic projector. Viewing slides with a slide viewer or a projector will show whether or not each frame is correctly exposed and sharply focused. Try to be hard-hearted and reject incorrectly exposed or unsharp slides (unless an image was deliberately defocused) — they will not improve with keeping. Neither a viewer nor a projector will enable you to compare consecutive exposures where you may have varied the lighting or background. The best way of making a critical comparison between different exposures or magnifications is to lay the whole film on a light box and view it with a ×10 magnifier, indeed this is the only way you can view unmounted transparencies. I examine all my films on a light box, checking for emulsion scratches or other processing faults. Such frames immediately get banished to the trash can. I also use light boxes for selecting pictures to send to clients and for checking used transparencies.

The way in which you choose to view your slides is likely to be determined by the way you store them and the number you take. For instance, if you keep them in their processing boxes it is easy to place them in a slide viewer with a gravity-fed magazine. Transparencies can be stored in projector magazines, although these will take up much more space than a slide box or flat PVC pocketed sheets. Once your transparency collection extends to a few thousand slides, you will need to adopt some method of cataloging. PVC pocketed sheets can be labeled at the top. A

◁ **Slide viewer**
This battery-operated viewer has a large bright screen for viewing 35mm transparencies at three times the original film size. The slides are inserted one at a time into the viewer, which can either be held in the hand or placed on a table. When the fold-away foot is pulled out, the viewer can be tilted for easy viewing on a flat surface.

Slide viewer with magnifier △
This model has a magazine into which 20 to 30 slides (depending on the thickness of the mount) can be loaded. The retractable magnifier doubles the magnification on the ×3 screen image.

◁ **Ring binder**
A ring binder is a useful method of storing limited numbers of slides in clear PVC pocketed sheets with punched holes. Each of these sheets holds twenty 35mm slides, and can be removed for viewing on a light box. Small slide collections can be stored in ring binders.

Hanging sheet △
Each pocketed PVC sheet is filed vertically in a conventional filing cabinet, suspended from a metal bar which slides through the top of the sheet. One sheet holds twenty 35mm slides.

system based on ring binder files will be much cheaper than a filing cabinet which houses suspending vertical filing sheets, although over 5000 slides can be stored in a single cabinet drawer. A portable case is a useful way of storing and carrying up to 1000 slides in hanging sheets.

When a transparency collection reaches a size which makes it commercially viable to run as a photo library, then each transparency must be cross-referenced so that it can be quickly retrieved. It is also important that the best images can be viewed by any client at a moment's notice, so that a large capacity slide cabinet, with a built-in light box, is essential. The one illustrated here is part of the integrated Multiplex System 4000. The compact design makes it especially attractive for use where space is limited. Many other designs are available, including Abodia cabinets which house 5000 or 10,000 slides.

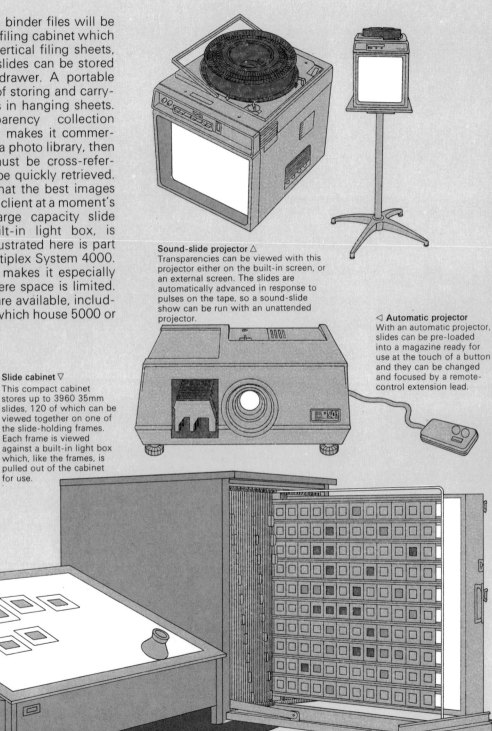

Sound-slide projector △
Transparencies can be viewed with this projector either on the built-in screen, or an external screen. The slides are automatically advanced in response to pulses on the tape, so a sound-slide show can be run with an unattended projector.

◁ Automatic projector
With an automatic projector, slides can be pre-loaded into a magazine ready for use at the touch of a button and they can be changed and focused by a remote-control extension lead.

Slide cabinet ▽
This compact cabinet stores up to 3960 35mm slides, 120 of which can be viewed together on one of the slide-holding frames. Each frame is viewed against a built-in light box which, like the frames, is pulled out of the cabinet for use.

Tilting light box ▽
This light box has a tilt-top which adjusts up to 12° from the horizontal for convenient viewing and for sorting slides while sitting.

Making copies

Close-up techniques form the basis for copying transparencies, documents, paintings, line drawings and maps.

Duplicating slides

With care, the quality of a duplicate transparency can very closely match — in some cases even surpass — an original. An out-of-focus original, however, cannot be corrected by duplication.

You may wish to make straight duplicate slides for family or friends or make a black and white negative from a color transparency. Starting with a 35mm original, you will need to get at least a life-size (×1) magnification to obtain a full-frame 24×36mm duplicate, or even greater if you wish to crop in on part of the original. You will also need a holder to position the original transparency parallel to the film plane.

If you have no bellows, a cheap way of copying slides is to use a slide duplicator attached "end-on" to a camera lens which is mounted on extension tubes. Other models have built-in optics; some even have a zoom facility for obtaining variable enlargements from ×1 to ×3 life-size. Better quality duplicates, however, will be made by attaching a slide copying adapter to a bellows extension. This adapter has an opal acrylic screen which diffuses the light source illuminating the transparency. The Nikon PB4 bellows unit (see p. 148) can be shifted from side to side and allows selective enlargements of the transparency to be copied on either side of the central axis.

Whatever kind of copier you use, the camera body should be supported on a tripod. To reproduce the colors of an original slide as accurately as possible, the light source must be carefully chosen. If photofloods are used, then you will need to use tungsten light film. By far the best light source is electronic flash, because the color temperature remains constant and you can make duplicates on daylight color film. All the duplicators designed for bulk production, such as the Multiblitz slide duplicator and the Bowens Illumitron, have a built-in electronic flash for exposing the film and a continuous focusing light. To reduce the contrast on

1. Film holder (variable sizes)
2. On/off switch
3. Halogen focusing light switch
4. Flash ready light

Multiblitz slide duplicator

The Multiblitz slide duplicator copies slides and makes black and white or color negatives from an original transparency ranging in size from $2\frac{1}{4} \times 2\frac{1}{4}$ inches to 35mm. The camera with bellows is shown here attached to a Novoflex Macro stand, which is an optional extra. A halogen light is switched on for focusing the slide, while a built-in flash makes the exposure. Selective enlargements can be made from portions of $2\frac{1}{4} \times 2\frac{3}{4}$ inch transparencies; underexposed slides can be corrected and color filters can be used to make creative abstracts by making double exposures or by sandwiching two transparencies together.

Vivitar instant slide printer

An instant color or black and white print, or a black and white negative, can be made from a 35mm mounted slide using this battery-powered printer. Because Polaroid film is not proportional to a 35mm format, part of the slide has to be masked out using the frame selector on the viewing panel. After the slide is pushed into the slide slot, the instant print film is exposed by depressing the print button. Development begins as soon as it is pulled out of the film holder. A timing button on the printer is then set and it gives an audible signal when the film has been processed. An instant print is then peeled off from the negative.

1. Film holder
2. Slide shot
3. Filter holder
4. Viewing panel
5. Exposure control
6. Print button
7. Framing selector

a duplicate, you can fog the film slightly before, or during, the exposure.

Colored filters can be used to correct the color balance of the original slide — I have reduced the blue-green cast of underwater pictures taken without flash by duping them with a CC10 red filter.

Flat copy

Documentary copy, such as maps and line drawings, must be set up so that they are as flat as possible and the film plane is parallel to the copy surface. This can be checked by placing a spirit level on the baseboard and on the camera. If the subject has a range of half tones, such as a photographic print, it can be copied on panchromatic film, although a continuous tone copy film is preferable. Line copy, such as the artwork in this book, must be copied onto special lithographic films, which reproduce the image as pure black and white without any intermediate gray tones. Techniques for copying an original mounted beneath glass are described on page 156.

Copy stand △
This rigid 24 inch support has a secure mechanism for locking the camera in an overhead position. Exact markings for centering the copy are printed on the heavy-duty baseboard. The anglepoise lamps can be adjusted to give 45° lighting.

◁ **Copipod**
This lightweight portable stand has four telescopic legs and attaches to 49mm or 52mm threads of the camera or close-up lens.

Portable copy stand △
The design of this Gitzo stand is based on tripod components. Three adjustable legs support the camera while a pair of lights are connected to a horizontal bar on jointed arms. The advantage of this stand is that it can be quickly assembled and used anywhere, providing there is an electricity source.

Index

Acknowledgments

The production of this book would not have been possible without help from many people, and I would like to thank everyone who so willingly gave their time to answer my queries – often at very short notice. I would especially like to thank two people – Sally Smallwood, the Art Editor, and Charyn Jones, the Project Editor – whose professionalism throughout made it such a pleasure for me to work with them.

Many people kindly provided subjects for photography, notably: Janet Atkins (her cat); Hilde Avenell (lace maker); Barbie Blanchard (her son); Helen Blanchard (creative food); Dr Leslie Bowcock (sunflower seed-head); Mrs A. M. Brittain (for allowing me to reproduce her tapestry on pages 18–19); Carlton Berkeley (Rolls Royce emblem); Dick Gayner (dry fly tying); Hale Ltd of Farnham (for electrical services); A. Harris and Sons of Farnham Potteries; N. W. Hutchings of Farnham (industrial drill); Liberty of London (for the loan of their silk scarf with a peacock feather design); Mastercraft Papers Ltd (for supplying hand-made paper with a distinctive watermark); H. C. More (basket maker); Carole Parker (her baby); Jenny and Ken Powell (their dog); Mary Stafford Smith, Elizabeth Wardle (for posing); Matthew Ware (Matto the circus clown).

I would also like to extend my thanks to Julie Dorrington for a reprint of her paper 'Macrophotography of the skin' describing the technique for making plastic imprints of the skin which I used for the toe print on page 95; Express Design Service for processing my Ektachrome films so speedily; Peter Hobson for designing and building the photo-trip; Berj Kantarjian for Cibachrome printing; Martin Page for researching in the early stages; Peter Macdonald for giving so freely of his advice on the photography of small, fine-art items; Nikon (UK) Ltd for loaning equipment and supplying information; and Kennett Engineering Co. Ltd for supplying Benbo tripods, macro flash and a universal clamp.

Special thanks go to my own team who work willingly at whatever task I set them: Julie Burchett and Kate West for their typing; Romilly Lockyer for researching both information and subjects as well as assisting my photography; Vere Lees for helping in many ways and Janet Atkins for her courier service. Without them I could never have met my deadline. My son, Giles, happily posed and trod in a hypo-soaked sponge, while my husband, Martin, as always gave me tremendous support and encouragement.

Dorling Kindersley would like to thank the following people and organizations for their help in producing this book:
F E Burman Ltd
Vic Chambers
Negs Photographic Services Ltd
Tony Wallace
For design and illustrations:
David Ashby
Hayward & Martin Ltd
Andrew MacDonald
Coral Mula
Jim Robins
John Woodcock